Bruce Nauman

Bruce Nauman Theaters of Experience

Deutsche Guggenheim

Published on the occasion of the exhibition:
Bruce Nauman: Theaters of Experience
Curated by Susan Cross
Deutsche Guggenheim, October 31, 2003–January 18, 2004

Bruce Nauman: Theaters of Experience
© 2003 The Solomon R. Guggenheim Foundation, New York.
All rights reserved.
All works by Bruce Nauman © 2003 Bruce Nauman.
Used by permission. All rights reserved.

ISBN: 0-89207-299-7
ISBN: 3-7757-1408-1 (German-speaking countries only)

Deutsche Bank & Solomon R. Guggenheim Foundation

Guggenheim Museum Publications
1071 Fifth Avenue, New York, New York 10128

Deutsche Guggenheim
Unter den Linden 13–15, 10117 Berlin

Available through
D.A.P./Distributed Art Publishers
155 Sixth Avenue, 2nd floor, New York, New York 10013
Tel.: (212) 627-1999 Fax: (212) 627-9484
Distributed outside the United States and Canada by
Thames & Hudson, Ltd., London

Available in German-speaking countries through
Hatje Cantz Verlag
Senefelderstrasse 12, D-73760 Ostfildern-Ruit
Tel.: +49 (0) 711/4 40 50 Fax: +49 (0) 711/4 40 52 50
www.hatjecantz.de

Design: COMA Amsterdam/New York
Production: Tracy L. Hennige
Editorial (English): Meghan Dailey, Elizabeth Franzen, Stephen Hoban
Translation: Philipp Angermeyer, Bernhard Geyer, Russell Stockman
Editorial (German): Heidi Ziegler

Printed in Germany by Cantz

Front and back covers: Bruce Nauman, *Walk with Contrapposto*,
1968. Courtesy Electronic Arts Intermix (EAI), New York

Contents

Inhalt

Deutsche Guggenheim ◩

Deutsche Guggenheim is a unique joint venture between a corporation—Deutsche Bank—and a nonprofit arts foundation—The Solomon R. Guggenheim Foundation. Designed by American architect Richard Gluckman, the 510-square-meter gallery is located on the ground floor of the Deutsche Bank headquarters in Berlin. Since opening in fall 1997, Deutsche Guggenheim has presented three to four important exhibitions each year, many of which showcase a specially commissioned work by an artist. The exhibition program and day-to-day management of the museum is the responsibility of the two partners.

Deutsche Guggenheim joins the Solomon R. Guggenheim Foundation's other existing locations: the Solomon R. Guggenheim Museum in New York; the Peggy Guggenheim Collection in Venice; the Guggenheim Museum Bilbao; and the Guggenheim Hermitage Museum in Las Vegas. Deutsche Bank regularly supports exhibitions in renowned museums, and since 1979 has been building its own collection of contemporary art under the motto "art at the workplace." The Deutsche Guggenheim initiative further represents a milestone in Deutsche Bank's advancement of the arts.

Exhibitions at Deutsche Guggenheim since its founding in 1997:

1997 *Visions of Paris: Robert Delaunay's Series*

1998 *James Rosenquist: The Swimmer in the Econo-Mist* / From Dürer to Rauschenberg: A Quintessence of Drawing. Masterworks from the Albertina and the Guggenheim / Katharina Sieverding: Works on Pigment / After Mountains and Sea: Frankenthaler 1956–1959*

1999 *Andreas Slominski* / Georg Baselitz—Nostalgia in Istanbul / Amazons of the Avant-Garde: Alexandra Exter, Natalia Goncharova, Liubov Popova, Olga Rozanova, Varvara Stepanova, and Nadezhda Udaltsova / Dan Flavin: The Architecture of Light*

2000 *Sugimoto: Portraits* / Förg—Deutsche Bank Collection / Lawrence Weiner: Nach Alles/After All* / Jeff Koons: Easyfun–Ethereal**

2001 *The Sultan's Signature: Ottoman Calligraphy from the Sakip Sabanci Museum, Sabanci University, Istanbul / Neo Rauch—Deutsche Bank Collection / On the Sublime: Mark Rothko, Yves Klein, James Turrell / Rachel Whiteread: Transient Spaces**

2002 *Bill Viola: Going Forth By Day* / Kara Walker—Deutsche Bank Collection / Chillida/Tàpies / Gerhard Richter: Eight Gray**

2003 *Kazimir Malevich: Suprematism / Richard Artschwager: Back and Forth/Up and Down / Tom Sachs: Nutsy's / Bruce Nauman: Theaters of Experience*

*Commissioned work by Deutsche Guggenheim

Das Deutsche Guggenheim ist ein einzigartiges Joint-Venture zwischen der Deutschen Bank und der Solomon Guggenheim Foundation. Die vom amerikanischen Architekten Richard Gluckman konzipierte, 510 Quadratmeter große Ausstellungshalle des Deutsche Guggenheim befindet sich im Erdgeschoss des Hauptsitzes der Deutschen Bank. Seit der Eröffnung im Herbst 1997 werden jährlich drei bis vier hochkarätige Ausstellungen gezeigt, von denen je eine als Auftragsarbeit an einen Künstler vergeben wird. Das Ausstellungsprogramm sowie der tägliche Betrieb werden in gemeinschaftlicher Verantwortung von beiden Institutionen organisiert.

Neben der Peggy Guggenheim Collection in Venedig, dem Guggenheim Museum Bilbao, den Häusern in New York und dem Guggenheim Hermitage Museum in Las Vegas ist das Deutsche Guggenheim einer der Ausstellungsorte der Solomon R. Guggenheim Foundation. Die Deutsche Bank unterstützt kontinuierlich Ausstellungen in namhaften Museen und baut seit 1979 unter dem Motto «Kunst am Arbeitsplatz» eine eigene Sammlung zeitgenössischer Kunst auf. Mit der Initiative «Deutsche Guggenheim» realisiert die Deutsche Bank nun einen weiteren Meilenstein innerhalb ihres Kunstkonzepts.

Ausstellungen im Deutsche Guggenheim seit der Gründung in 1997:

1997 *Pariser Visionen: Robert Delaunays Serien*

1998 *James Rosenquist: The Swimmer in the Econo-mist* / Von Dürer bis Rauschenberg: Eine Quintessenz der Zeichnung. Meisterwerke aus der Albertina und dem Guggenheim Museum / Katharina Sieverding: Arbeiten auf Pigment / Helen Frankenthaler: Mountains and Sea und die Jahre danach 1956–1959*

1999 *Andreas Slominski* / Georg Baselitz – Nostalgie in Istanbul / Amazonen der Avantgarde: Alexandra Exter, Natalja Gontscharowa, Ljubow Popowa, Olga Rosanowa, Warwara Stepanowa und Nadeschda Udalzowa / Dan Flavin: Die Architektur des Lichts*

2000 *Sugimoto: Portraits* / Förg – Sammlung Deutsche Bank / Lawrence Weiner: Nach Alles/After All* / Jeff Koons: Easyfun – Ethereal**

2001 *Siegel des Sultans, Osmanische Kalligrafie aus dem Sakip Sabanci Museum, Sabanci Universität, Istanbul / Neo Rauch – Sammlung Deutsche Bank / Über das Erhabene: Mark Rothko, Yves Klein, James Turrell / Rachel Whiteread: Transient Spaces**

2002 *Bill Viola: Going Forth By Day* / Kara Walker – Sammlung Deutsche Bank / Chillida/Tàpies / Gerhard Richter: Acht Grau**

2003 *Kasimir Malewitsch: Suprematismus / Richard Artschwager: Auf und Nieder/Kreuz und Quer / Tom Sachs: Nutsy's / Bruce Nauman: Theaters of Experience*

*Auftragswerk des Deutsche Guggenheim

Preface

Drawing in visitors and offering them a new, vital art experience, which enfolds in real space and in real time, this has been one of the goals we have consistently pursued for the program of the Deutsche Guggenheim. *Bruce Nauman: Theaters of Experience* thus constitutes another high point in the series of installations previously presented by, among others, Dan Flavin, Bill Viola, Gerhard Richter, and Tom Sachs.

Bruce Nauman has significantly broadened the field of traditional artistic practice and influenced many younger artists. Throughout his career his work has been embraced by a German audience, including artists, collectors, and museums. The Konrad Fischer Gallery, Düsseldorf, held the first exhibition of the artist's work in Europe as early as 1968, and since then Nauman has been the subject of countless exhibitions in Germany and throughout Europe. In 1990, he was awarded the distinguished Max Beckmann Prize by the City of Frankfurt, and in 1997 became a member of the Akademie der Künste in Berlin. However, Nauman has never had a solo exhibition in Berlin, thus we are particularly pleased to present this exhibition. The city is especially fortunate, as in 2004 the Hamburger Bahnhof will present the Flick Collection which boasts a significant assemblage of Nauman works.

The exhibition at the Deutsche Guggenheim focuses on the theatrical elements of Nauman's oeuvre and consequently, the associated aspects of self-awareness and role-play. Viewers are involved in the performance actively and passively at the same time; as the most elementary physical, emotional, and psychic states are performed and experienced. The experimental dance and film as well as the avant-garde music of the 1960s are among the influences that intensified Nauman's interest in the integration of everyday experiences in an artistic context. In the exhibition, this continuous, central theme is depicted using thirteen exemplary works dating from 1966 to 1990 from the Guggenheim Museum's Panza Collection and additional private and public collections. Environments, sculpture, film and video, holography, and neon are presented together to facilitate comparisons and connections between the various media and periods.

We open the *Theaters of Experience* to our visitors and invite you to investigate your roles as both spectator and participant.

Dr. Tessen von Heydebreck
Member of the Board of Managing Directors of Deutsche Bank AG

Einführende Bemerkung

Den Besucher einzubeziehen, ihm wiederholt ein neues Kunsterlebnis zu bieten, das sich im realen Raum und in der realen Zeit entfaltet – dieses Ziel haben wir im Programm unserer Kunsthalle Deutsche Guggenheim kontinuierlich verfolgt. *Bruce Nauman – Theaters of Experience* setzt damit einen weiteren Höhepunkt in der Reihe der Rauminstallationen, in der wir zuvor u.a. Werke von Dan Flavin, Bill Viola, Gerhard Richter und Tom Sachs präsentierten.

Bruce Nauman hat das Spektrum der traditionellen Kunstpraxis wesentlich erweitert und viele Künstler der jüngeren Generation beeinflusst. Seit Beginn seiner Karriere zählen deutsche Künstler, Sammler und Museen zu seinem Publikum. Bereits 1968 zeigte die Galerie Konrad Fischer in Düsseldorf die erste europäische Einzelausstellung des Künstlers und seither ist sein Werk in zahlreichen Ausstellungen in Deutschland und ganz Europa zu sehen. Im Jahre 1990 ehrte ihn die Stadt Frankfurt mit dem Max Beckmann-Preis und 1997 wurde er Mitglied der Akademie der Künste in Berlin. Wir freuen uns nun ganz besonders, Naumans erste Einzelausstellung in Berlin zu präsentieren. Es ist uns eine Ehre, dass die Flick-Collection im Jahre 2004 im Hamburger Bahnhof ihre umfangreiche Sammlung der Werke Naumans zeigt.

Die Ausstellung im Deutsche Guggenheim konzentriert sich auf theaterbezogene Elemente seines Oeuvres und damit verbundene Aspekte von Selbsterfahrung und Rollenspiel. Sowohl Darsteller als auch Zuschauer werden, aktiv und passiv zugleich, in die Performance einbezogen; grundlegendste physische, emotionale und psychische Zustände vorgeführt und erfahren. Der experimentelle Tanz und Film sowie die Avantgarde-Musik der 60er Jahre zählen zu den Elementen, die das Interesse von Nauman an der Integration von Alltagserfahrung in einen künstlerischen Kontext verstärkten und beeinflussten. In der Ausstellung anschaulich wird dieses durchgehende zentrale Thema des Künstlers anhand von dreizehn Schlüsselwerken von 1966 bis 1990 aus der Panza Collection des Guggenheim Museums sowie privaten Sammlungen. Lichtprojektionen, Film, Holographie, Video und Neonleuchten werden in einer Ausstellungsarchitektur präsentiert, die jedem Werk seinen angemessen Raum gibt, gleichzeitig aber auch Vergleiche und Verbindungen zwischen den unterschiedlichen Medien und Phasen ermöglicht.

Das «Theater der Erfahrung» haben wir somit für Sie geöffnet. Betreten Sie es und spielen Sie darin die Rolle, die Sie mögen.

Dr. Tessen von Heydebreck
Mitglied des Vorstands der Deutschen Bank AG

Foreword

From the beginning the Guggenheim Museum has been characterized by its commitment to collecting the work of individual artists in depth. Complimenting the encyclopedic spine of the collection, which provides an overview of the major achievements in Modern and Contemporary art, the museum's extensive holdings of works by selected early-twentieth-century masters such as Vasily Kandinsky and postwar innovators like Bruce Nauman allow for a greater understanding of an artist's overall development or of a certain aspect of his or her career. This acquisition philosophy is shared by our partner Deutsche Bank, evidenced in their own impressive collection, as well as by Dr. and Mrs. Giuseppe Panza di Biumo, whose extraordinary assemblage of Minimal and Conceptual art was acquired, in part, by the museum in 1991 and 1992. The current exhibition falls in the footsteps of collection-inspired exhibitions such as *Dan Flavin: The Architecture of Light* (1999) and *On the Sublime: Mark Rothko, Yves Klein, James Turrell* (2001) and features selections from the unparalleled grouping of Nauman works from the 1960s and '70s in the Guggenheim Museum Panza Collection and is augmented by important loans, including several from the Panzas' private collection.

While the museum acquired nearly thirty Nauman works from the Panzas, through purchase and a generous gift, the artist's work had entered the collection as early as 1969. On the occasion of the first Theodoron Award, a grant that helped the museum purchase the work of emerging artists, Nauman was among the group selected. In 1971, Nauman was included in the *Sixth Guggenheim International Exhibition*, which brought together some of the most significant new artists of the day. The museum's early recognition of Nauman's work manifested itself into a firm commitment to the artist with the acquisition of the Panza Collection. I am delighted that we are able to share with the Berlin audience works from our Nauman collection, and with the assistance of generous lenders, trace the artist's transformation of the art experience and his approach to artmaking into a literal and conceptual stage for mental and physical action and analysis from the earliest stages of his career and into later works.

I would like to express my gratitude to Deutsche Bank AG whose ongoing collaboration and partnership is a cornerstone of the museum's contemporary programming and acquisitions strategy. We are truly fortunate to have befriended an organization so forward-thinking and committed to the support of the arts. My deepest appreciation goes to Dr. Tessen von Heydebreck, Member of the Board of Managing Directors for his continued enthusiasm and cooperation.

Thomas Krens, Director
Solomon R. Guggenheim Foundation

Vorwort

Das Guggenheim Museum ist seit seiner Gründung bemüht, repräsentative Werkübersichten einzelner Künstler zu erwerben. Als Ergänzung zum enzyklopädischen Kern der Sammlung, der die Hauptströmungen der modernen und zeitgenössischen Kunst dokumentiert, gewähren konzentrierte Schwerpunkte tiefere Einblicke in den Entwicklungsweg eines Künstlers oder in eine spezifische Schaffensphase. Dieser Ansatz berücksichtigt sowohl eine Auswahl von Vorkriegsmeistern wie Wassily Kandinsky als auch Nachkriegsneuerer wie Bruce Nauman, dem diese Ausstellung gewidmet ist. Ähnliche Ziele verfolgt die rege Sammlertätigkeit der Deutschen Bank und des Ehepaars Panza di Biumo, dessen Fundus an Werken des Minimalismus und der Konzeptkunst 1991 und 1992 zum Teil in den Besitz des Museums übergegangen ist. Die gegenwärtige Schau greift wie eine Reihe von Vorläufern – darunter *Dan Flavin: Die Architektur des Lichts* (1999) und *Über das Erhabene: Mark Rothko, Yves Klein, James Turrell* (2001) – primär auf die Bestände des Museums zurück. Arbeiten der 60er und 70er Jahre aus der Panza Collection werden durch Leihgaben ergänzt, mehrere davon aus der Privatsammlung der Panzas.

Die beinahe 30 Werke Naumans, die das Guggenheim Museum durch Kauf oder Schenkung von der Familie Panza übernahm, waren nicht die ersten Werkbeispiele der Museumssammlung. Der Künstler zählte zu den Preisträgern des ersten Theodoron Award 1969, der dem Museum Mittel zum Ankauf von Werken aufstrebender Künstler zur Verfügung stellte. Zwei Jahre später war er in der *6th Guggenheim International Exhibition* vertreten, einer Bestandsaufnahme des aktuellen Kunstgeschehens. Das Museum anerkannte Naumans Werk schon früh und sein Engagement führte zum Kauf der Panza Collection. Wir freuen uns, dem Berliner Publikum Glanzpunkte der Nauman-Sammlungen des Museums und seiner großzügigen Leihgeber präsentieren zu dürfen. Das Projekt soll den Einsatz von Performance-Strategien von den ersten Anfängen bis ins Spätwerk nachzeichnen.

Bitte gestatten Sie mir abschließend ein aufrichtiges Dankeswort an die Deutsche Bank zu richten, ohne deren anhaltende Unterstützung unser Ausstellungs- und Ankaufsprogramm nicht in dieser Form realisierbar wäre. Die Partnerschaft mit einer Institution, die sich mit derartigem Eifer und Verständnis für die Kunst einsetzt, ist zweifelsohne ein Glücksfall. Wir danken dem Vorstandssprecher der Deutschen Bank, Dr. Tessen von Heydebreck, für die hervorragende Zusammenarbeit.

Thomas Krens, Director
Solomon R. Guggenheim Foundation

Introduction and Acknowledgments

It has been both a pleasure and an honor organizing an exhibition of Bruce Nauman's works for the Deutsche Guggenheim. Undoubtedly one of the most influential artists of the twentieth century, Nauman has been making thought-provoking art for four decades. His work continues to challenge and engage viewers, and the museum is pleased to present a selection of works in diverse media to visitors for whom this might be an introduction as well as to those already familiar with Nauman. While the artist is known for his difficult-to-categorize production, throughout his career he has continuously explored the most basic drives and behavior that inform who we are and how we understand our world and our experience. It also might be said that a deliberate lack of resolution characterizes much of Nauman's work, both literally and metaphorically, and seems to articulate his conception of both the nature of the self and the human condition in general.

This focused exhibition, which features highlights from the Guggenheim's permanent collection as well as key loans, looks at Nauman's varied use of performance strategies as a vehicle for heightened awareness of our often contradictory physical, psychological, emotional, and perceptual states. Like philosopher Ludwig Wittgenstein, whose writings influenced the artist, Nauman often finds the investigation more important than its conclusion. His open-ended inquiries often leave the viewer feeling as if he or she has walked into a performance already in progress with little chance of deciphering the plot or finding relief in a final conclusion. Knocking his viewers slightly off-balance, creating confusion and sometimes discomfort, Nauman helps us see both our private and public selves in a new light—one that can be both humorous and harsh. The exhibition traces some of the theatrical elements in Nauman's oeuvre, as well as his manipulation of the performer-spectator roles, from the early stages of his career through their evolution in select later works. We follow the artist's trajectory from performer to director behind the scenes and conclude with *Raw Material—BRRR* (1990), a work that marks the artist's return, after twenty years, as primary subject of his work. My catalogue essay addresses individual works in the exhibition in addition to more recent works which further illuminate this investigation. Independent curator Christine Hoffmann, who coorganized the exhibition *Samuel Beckett/Bruce Nauman* for the Kunsthalle Wien in 2000, adds to our discussion with a fresh look at some of the affinities between the artist and the influential playwright.

First, I would like to thank Bruce Nauman for his inspiring body of work as well as his generosity and his helpful comments during the preparation of the exhibition and catalogue. Juliet Myers at the Nauman studio has been especially generous with her time, energy, and knowledge, and I am most grateful for her kind, humorous, and patient assistance on this project as well as with my many inquiries over the years.

I am particularly indebted to the lenders. Dr. and Mrs. Giuseppe Panza di Biumo, Udo Brandhorst, J. W. Froehlich, and the ZKM / Center for Art and Media, Karlsruhe, who have augmented the scope of this study with their generous loans.

Of course, the exhibition would not have been possible without the enthusiasm of our colleagues from Deutsche Bank. I offer special

Einführung und Dank

Wir empfinden es als besondere Freude und Ehre, diese Ausstellung mit Werken von Bruce Nauman in den Räumen des Deutschen Guggenheim präsentieren zu dürfen. Nauman – unbestritten einer der einflussreichsten Künstler des 20. und beginnenden 21. Jahrhunderts – fordert sein Publikum bereits seit vier Jahrzehnten dazu heraus, Kunst neu zu denken und zu erleben. Wir hoffen, mit dieser Auswahl von Skulpturen, Filmen, Neonarbeiten, Hologrammen und Videoinstallationen sowohl Kennern als auch Novizen einen interessanten Querschnitt durch das Schaffen des Künstlers zu bieten. Obwohl dessen vielseitige und vielschichtige Natur keine vereinfachende Kategorisierung zulässt, zieht sich die Erforschung der elementaren Triebe und Verhaltensweisen, die uns zeigen, wer wir sind und wie unsere Welt und Erfahrung zu verstehen ist, wie ein roter Faden durch Naumans Lebenswerk. Einen ähnlichen Stellenwert beansprucht die Unschärfe (im direkten und übertragenen Sinn), mit der Nauman bewusst seine Auffassung vom Ich und der menschlichen Existenz artikuliert.

Diese konzentrierte Schau zeigt anhand von Schlüsselwerken aus der Guggenheim-Sammlung, ergänzt durch wichtige Leihgaben, wie wir im Bann von Naumans Performance-Strategien widersprüchliche Körper-, Geistes-, Gefühls- und Wahrnehmungszustände bewusster erfahren. Wie Ludwig Wittgenstein, dessen Schriften ihn beeinflusst haben, legt Nauman größeren Wert auf den Prozess des Untersuchens als auf das gefundene Resultat. Das offene Format der Recherche vermittelt dem Besucher das Gefühl, dass er mitten in ein laufendes Stück hineingestolpert ist, dessen Handlung er nie völlig verstehen wird und das keinen befreienden Schluss zulässt. Dieses Verwirrspiel, das uns aus der Fassung bringt und beklemmt, lässt unser inneres und äußeres Ich in einem neuen Licht erscheinen – das sowohl sarkastische als auch humorvolle Schattierungen aufweist. Exponate aus allen Schaffensperioden protokollieren die Entwicklung einzelner theatralischer Elemente, den Rollentausch zwischen Schauspieler und Zuschauer sowie Naumans Wandel vom aktiven Performer zum Regisseur hinter den Kulissen. Den Schlussstein bildet die Installation *Raw Material – BRRR (1990)*, in der uns der Künstler zum ersten Mal seit 20 Jahren wieder in eigener Person gegenübertritt. In meinem Essay rezensiere ich einzelne Werke der Ausstellung sowie weitere Werke jüngeren Datums, die zum tieferen Verständnis dieses Themenkreises beitragen. Christine Hoffmann, unabhängige Kuratorin und Mitorganisatorin der Ausstellung *Samuel Beckett/Bruce Nauman* für die Kunsthalle Wien im Jahre 2000, erweitert unseren Katalog mit neuen Aspekten zu einigen Verbindungspunkten des Künstlers und des Dramatikers.

Meine Danksagung beginnt selbstverständlich beim Künstler selbst. Wir danken Bruce Nauman nicht nur für seine Kunst, die uns auf so vielen Ebenen anspricht, sondern auch für seine Anregungen während der Vorbereitung für diese Ausstellung und diesen Katalog. Ein besonderes Glück war es auch, dass wir mit Juliet Myers eine stets freundliche Ansprechpartnerin im Atelier des Künstlers hatten, die dieses Projekt nach Kräften unterstützt und meine Anfragen über Jahre hin geduldig beantwortet hat.

Ebenso herzlich bedanken wir uns bei den Leihgebern der Exponate, die diese Schau ganz wesentlich bereichern: Dr. Giuseppe Panza di Biumo und dessen Gattin, Udo Brandhorst, J. W. Froehlich

gratitude to Dr. Tessen von Heydebreck, Member of the Board of Managing Directors, for his endorsement of this project, as well as Dr. Ariane Grigoteit and Friedhelm Hütte, Global Heads of Deutsche Bank Art, who have offered encouragement from the very inception. I am also grateful to Svenja Gräfin von Reichenbach, Gallery Manager; Sara Bernshausen, Gallery Assistant, and Jörg Klambt, Retail Manager for their collaboration and their congeniality. Uwe Rommel, Head Art Handler and Exhibition Technician and his crew must be acknowledged for their oversight of the complex installation and construction. I would like to recognize too the assistance of Sabine Ebner, Kathrin Conrad, and Ulrike Heine as well as Elisabeth Bushart, Deutsche Bank Conservator, and Frederike Beseler, Associate Conservator; and Fabienne Lindner, Project Manager, Surface Gesellschaft für Gestaltung.

Many individuals at the Solomon R. Guggenheim Museum contributed to the success of this undertaking. Thanks must go to Lisa Dennison, Deputy Director and Chief Curator, and Nancy Spector, Curator of Contemporary Art, for their support and advice. Very special thanks must go to Paul Kuranko, Media Arts Specialist, for his management of the technical aspects of the exhibition; Carol Stringari, Conservator, for her unmatched perseverance and dedicated research; Derek DeLuco, Technical Specialist, and Jeffrey Clemens, Associate Preparator, for their extraordinary contributions; Ana Luisa Leite, Manager of Exhibition Design, for her diligent problem-solving, and David Heald, Chief Photographer, for both his time and his skill. I am also grateful to Melissa Pomerantz, Curatorial Intern, who has been of unfailing assistance and who was responsible, among her many tasks, for compiling the bibliography for the catalogue. I would also like to express my gratitude to Meryl Cohen, Head Registrar; Brendan Connell, Assistant General Counsel; Marion Kahan, Exhibition Program Manager; Hannah Blumenthal, Financial Analyst for Museum Affiliates; Jill Kohler, Associate Registrar; David Bufano, Chief Preparator; Stephen Engelman, Technical Designer/Senior Exhibition Fabricator; Liza Martin, Preparator; Kim Bush, Manager of Photography and Permissions; Jennifer Chiu, Digital Imaging Specialist; and Rebecca Blanchard and Sandra Kulik, Curatorial Interns, all of whom have contributed to the realization of this exhibition.

The completion of the catalogue as a whole was made possible by the museum's outstanding Publications Department, in particular Elizabeth Levy, Director of Publications; Elizabeth Franzen, Managing Editor; Meghan Dailey, Associate Editor, and Tracy Hennige, Production Assistant. They consistently make the impossible possible. I would also like to express my appreciation to Christine Hoffmann for her insightful and innovative essay, as well as to Laura Morris, Editor, for her meticulous and astute editing. The excellent translations into both English and German are courtesy of Philipp Angermeyer, Bernhard Geyer, and Russell Stockman, and the editing of the German texts are courtesy of Heidi Ziegler. The elegant design of the book is the thoughtful work of Cornelia Blatter and Marcel Hermans of COMA.

Many institutions and individuals have been crucial to the success of this project, and for their kind assistance I offer sincere thanks to Giuseppina Panza, Renate Blaffert of the Brandhorst Collection; Anita Balogh of the Froehlich Collection; Professor Peter Weibel and Dr. Ralph Melcher of ZKM; and Professor Dr. Carla Schulz-Hoffmann, Director of the Pinakothek der Moderne; Dorothee Fischer and the Konrad Fischer Gallery, Düsseldorf; Angela Westwater, and the

sowie das Zentrum für Kunst und Medientechnologie.

Wie immer war es ein phantastisches Erlebnis, mit unseren Kollegen von der Deutschen Bank zusammenzuarbeiten. Ihre Partnerschaft und ihr Engagement sind von unschätzbarem Wert für unser Museum. Speziellen Dank schulden wir Dr. Tessen von Heydebreck, Vorstandssprecher der Deutschen Bank, der seine Zustimmung zu dieser Ausstellung gegeben hat. Von Anfang an haben sich auch Dr. Ariane Grigoteit und Friedhelm Hütte, weltweite Leiter der Kunstabteilung der Deutschen Bank, enthusiastisch für diese Unternehmung eingesetzt. Ebenso konstruktiv und anregend waren die Beiträge von Svenja Gräfin von Reichenbach, Managerin der Galerie des Deutsche Guggenheim, Sara Bernshausen, Galerieassistentin, und Jörg Klambt, Leiter der Museumsgeschäfte. Uwe Rommel und sein Team waren für die Verpackung und den Transport der Kunstwerke und für die Ausstellungstechnik zuständig. Wir gratulieren ihnen zu ihrer hervorragenden Arbeit beim Bau der Korridore und bei der komplexen Ausstellungsinstallation. Nicht unerwähnt bleiben dürfen außerdem ihre Kollegen Sabine Ebner, Kathrin Conrad und Ulrike Heine sowie Elisabeth Bushart, Restauratorin der Deutschen Bank, und deren Assistentin Frederike Beseler.

Der Stab des Solomon R. Guggenheim Museum hat ebenfalls entscheidend zum Gelingen dieser Ausstellung beigetragen. Höchste Anerkennung gebührt Lisa Dennison, stellvertretende Direktorin und Chefkuratorin, und Nancy Spector, Kuratorin für zeitgenössische Kunst, für ihre Anregungen und Ratschläge. Besonders hervorheben möchte ich außerdem Paul Kuranko, Spezialist für Medienkunst, der alle technischen Aspekte der Schau koordiniert hat, Carol Stringari, Restauratorin, für ihre souveräne Fachkenntnis; Derek DeLuco, Fachtechniker, und Jeffrey Clemens, Assistent der Ausstellungsvorbereitung, die bei allen Aufgaben ihr enormes Können unter Beweis gestellt haben; Ana Luisa Leite, Leiterin der Ausstellungsgestaltung, für ihr geschultes Auge und ihre kreativen Problemlösungen; und David Heald, Cheffotograf, der keinen Zeit- und Arbeitsaufwand gescheut hat, um Naumans Kunst richtig ins Bild zu setzen. Schließlich muss hier noch Melissa Pomerantz, kuratorische Praktikantin, erwähnt werden, die uns allen eine große Hilfe war und unter anderem die ausgewählte Bibliografie für diesen Katalog zusammengestellt hat. Entscheidende Vorarbeit geleistet haben ferner Meryl Cohen, Leiterin der Registratur, Brendan Connell, stellvertretender juristischer Berater, Marion Kahan, Managerin des Ausstellungsprogramms, Hannah Blumenthal, Finanzberaterin für Partnerorganisationen, Jill Kohler, stellvertretende Registrarin, David Bufano, Leiter der Installationsvorbereitung, Stephen Engelman, Technikdesigner/leitender Ausstellungsgestalter, Liza Martin, Ausstellungsvorbereitung, Kim Bush, fotografische Leitung und Veröffentlichungsrechte, Jennifer Chiu, Spezialistin für Digitalbilder, und Rebecca Blanchard und Sandra Kulik, kuratorische Praktikantinnen.

Damit sind wir bei der vorliegenden Publikation angelangt, die wir der routinierten Produktionsabteilung des Museums verdanken. An deren Spitze profilierten sich Elizabeth Levy, Direktorin der Publikationsabteilung, Elizabeth Franzen, Redaktionsleiterin, Meghan Dailey, stellvertretende Redakteurin, und Tracy Hennige, Produktionsassistentin. Ihre außerordentlichen Leistungen werden geschätzt. Höchste Anerkennung verdienen zudem Christine Hoffmann für ihren innovativen Essay sowie Laura Morris, Redakteurin, für ihre exakte Textbearbeitung. Für die Übersetzung in die englische und deutsche Sprache zeichnen Philipp Angermeyer, Bernhard Geyer und Russell Stockman verantwortlich; Heidi Ziegler hat den deutschen Text redigiert. Die

Sperone Westwater Gallery, New York; Donald Young and Sarah Nelson of the Donald Young Gallery; the Leo Castelli Gallery; and Ydessa Hendeles. I am also indebted to Jacob Fishman of Lightwriters Neon, Inc., for making room for our project in his busy schedule and for his expert fabrication of *Mean Clown Welcome* (1985), Stephen Sugarman, Holographer, St. Paul, Minnesota, for his unique expertise and for the holographic copies that were produced in the Bethel College Department of Physics and Engineering Lab, under the guidance of Physics Professor Dr. Richard Peterson. I would also like to acknowledge the contributions and cooperation of Electronic Arts Intermix (EAI), New York, in particular John Thomson and Sabrina Gschwandtner. I am grateful to everyone who helped make this project come to life.

Susan Cross, Associate Curator

elegante Buchgestaltung stammt von Cornelia Blatter und Marcel Hermans von COMA.

Eine Ausstellung wie diese erfordert die Mitwirkung vieler Personen und Institutionen. Wir danken Giuseppina Panza, Renate Blaffert von der Stiftung Brandhorst, Anita Balogh von der Froehlich Collection, Prof. Peter Weibel und Dr. Ralph Melcher vom ZKM, Prof. Dr. Carla Schulz-Hoffmann, Direktorin der Pinakothek der Moderne, Dorothee Fischer und den Angestellten der Galerie Konrad Fischer, Angela Westwater, der Sperone Westwater Gallery, New York, Donald Young und Sarah Nelson von der Donald Young Gallery, der Leo Castelli Gallery und Ydessa Hendeles. Ein besonderer Dank geht an Jacob Fishman von Lightwriters Neon, Inc. in Chicago für seinen geschätzten Einsatz zur Herstellung von *Mean Clown Welcome* (1985), und Stephen Sugarman, St. Paul, Minnesota, für sein einzigartiges Fachwissen sowie für die Hologrammkopien, die im Bethel College Department of Physics and Engineering Lab unter der Leitung von Dr. Richard Peterson, Professor für Physik, hergestellt wurden. Abschließend bleibt mir noch ein letztes Dankeswort an die Mitarbeiter von Electronic Arts Intermix (EAI), New York, insbesondere John Thomson und Sabrina Gschwandtner. Mein Dank geht an alle, die zu diesem Unternehmen beigetragen haben.

Susan Cross, Stellvertretende Kuratorin

Bruce Nauman
Theaters of Experience

Bruce Nauman
Theaters of Experience

Bruce Nauman's *Lighted Center Piece* (1967–68, plate 1), a polished, aluminum square, its center lit by four 1,000-watt lamps attached to its sides, functions as a miniature stage. While the work's industrial materials and geometric form bring to mind the contemporaneous sculptures of Donald Judd or the floor pieces of Carl Andre, as with many of Nauman's works, it suggests a performative action yet to begin or that has just ended. Nauman, like many of his peers at this time, was expanding artistic practice and its reception by introducing performance strategies into his work. Influenced by experimental and what is now often termed "Minimal" dance, music, and theater, Nauman moved away from static, self-contained art objects to create an art of real experience.[1] "Sculpture was always involved in performance in the sense that it involves the spectator," Nauman once said, "because the spectator has to walk around it. In that sense you become a participant or a performer."[2] Expanding on this notion, at different periods in his career Nauman cast himself as actor or emphasized the viewer's role as both performer and spectator.

In this way, Nauman's work might be read in reference to Michael Fried's seminal critique of Minimalist sculpture "Art and Objecthood" (1967). With *Lighted Center Piece*, Nauman seems to exaggerate and make literal[3] Fried's notion of a Minimalist work's "stage presence"—the theatricality that the critic predicted would be the "negation of art."[4] Nauman embraced what Fried had rejected—a "preoccupation with time ... the duration of experience," and what Fried found "paradigmatically theatrical"[5] was the very concept that would in fact define the process and performance work that dominated the arts in the 1970s.

What Fried had described as the "*complicity* [italics mine] that the [Minimalist] work extorts from the beholder"[6] is something Nauman would explore further in his corridor pieces and large-scale environments and was made explicit in his *Lighted Performance Box* (1969, shown above), a work closely related to *Lighted Center Piece*. Again the viewer is confronted with what at first appears to be a straightforward Minimalist object. The metal rectangle, which we soon realize is hollow, contains within it a single halogen lamp that creates a spotlight on the ceiling above and suggests that the real focus lies outside the artwork itself. Indeed, the "performance" of the work's title has been interpreted as that of the viewer, whose eyes move back and forth between the physical sculpture and the illuminated area. Moreover, the anthropomorphic dimensions of the box provokes the viewer to mentally project the image of the artist or even his or her own body into the space as a theatergoer might project personal experiences onto a character on stage.

While *Lighted Performance Box* foreshadows Nauman's subsequent corridor works and increased focus on the viewer, its human scale also references the artist's own role as performer. Nauman first experimented with performance as a graduate student at the University of California at Davis in the early 1960s. In 1965 he created two performative works using his body as a sculptural tool,

Lighted Performance Box, 1969

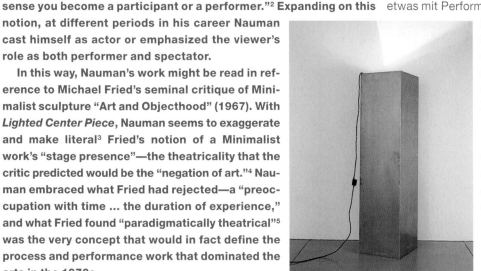

Bruce Nauman errichtet mit *Lighted Center Piece* (1967–68, Kat.Nr. 1) eine Miniaturbühne: Vier an den Außenseiten befestigte 1000-Watt-Lampen bestrahlen das Zentrum eines polierten Aluminiumquadrats. Während die Industriematerialien und die geometrische Form an zeitgleiche Plastiken Donald Judds oder an Bodenskulpturen von Carl Andre erinnern, bringt *Lighted Center Piece* – typisch für Nauman – zusätzlich eine Handlung ins Spiel, die in Kürze beginnen wird oder gerade geendet hat. Der Zugriff auf Performance-Strategien zur Erweiterung der künstlerischen Praxis und Rezeption ist charakteristisch für Nauman und seine Künstlergeneration. Unter dem Einfluss experimenteller, heute oft als ‹minimalistisch› bezeichneter Tendenzen in Tanz, Musik und Theater verabschiedete sich Nauman vom statischen, selbstbezogenen Kunstobjekt zugunsten einer Erfahrung, die sich in Zeit und Raum entfaltet.[1] «Die Skulptur hatte immer schon etwas mit Performance zu tun, weil sie den Betrachter miteinbezieht», argumentiert der Künstler. «Du musst um sie herumgehen und wirst dabei selbst zum Teilnehmer oder Akteur.»[2] Nauman hat in verschiedenen Stationen seiner Laufbahn selbst den Schauspieler gemimt und die Doppelrolle des Betrachters als Zuschauer und Darsteller herausgestrichen.

In diesem Zusammenhang lohnt es sich, Naumans Œuvre im Licht von Michael Frieds Kritik der minimalistischen Plastik, *Kunst und Objekthaftigkeit* (1967), zu betrachten. *Lighted Center Piece* scheint die dort beschriebene «stage presence» einer minimalistischen Schöpfung, die aus Sicht des Autors zu einer «negation of art»[3] führen kann, auf die Spitze zu treiben und wörtlich zu nehmen.[4] Nauman greift auf, was der Kritiker verworfen hatte. «Das literarische Interesse an der Zeit ... an der Dauer der Erfahrung», alles was Fried als «beispielhaft theatralisch»[5] brandmarkte, wurde zur konzeptuellen Basis der Process und Performance Art der 70er Jahre.

Nauman hat Frieds Satz von der «*complicity* that the ‹Minimalist› work extorts from the beholder»[6] in seinen Korridor-Installationen und Environments analysiert und in *Lighted Performance Box* (1969, oben) in plastische Form gefasst. Auch dieses Werk, in vieler Hinsicht ein Gegenstück zu *Lighted Center Piece*, tritt uns in einer minimalistischen Maske entgegen. Ein Metallrechteck, das sich als Hohlraum entpuppt, birgt einen Halogenscheinwerfer, der sein Licht an die Decke wirft und dadurch signalisiert, dass der eigentliche Brennpunkt außerhalb des Kunstwerks liegt. Ganz folgerichtig wurde die im Titel angesprochene ‹Performance› dem Betrachter zugeordnet, dessen Auge zwischen Plastik und Lichtfeld hin und her pendelt. Darüber hinaus verleitet das anthropomorphe Format der Box den Betrachter dazu, den eigenen Körper geistig in den Raum zu projizieren, gleich dem Theaterbesucher, der seine Erfahrung auf die Bühnenfigur projiziert.

Die *Lighted Performance Box* nimmt zwar die Korridorstücke und die schärfere Konzentration auf den Betrachter späterer Werkphasen vorweg, thematisiert durch ihr menschliches Maß zugleich aber auch die Rolle des Künstlers als Performer. Nauman startete seine Performance-Experimente Anfang der 60er Jahre als Student an der

manipulating a fluorescent tube like an appendage in one piece, and bending and leaning his body against a wall in the other. Nauman would later re-create both for the camera, and they would set the stage, so to speak, for many of his subsequent works that used performance as a conduit for heightened self-awareness (for both Nauman and viewer). The artist's early formal treatment of the body quickly evolved into a deeper psychological investigation of the self and human experience. Between 1966 and 1970 Nauman made numerous photographs, films, and videos which recorded his activities and various daily routines in the studio—such as pacing or drinking coffee—or scripted tasks like those described by titles such as *Walking in an Exaggerated Manner Around the Perimeter of a Square* (1967–68, facing page). Merce Cunningham (who influenced Nauman and for whom he designed a stage set in 1969) and John Cage, another influence, had likewise incorporated the movements and noise of the everyday into their performances, as had members of the Judson Dance Theater and others. In these performances, simple tasks, such as sweeping the floor, were treated as dance movements often executed by nondancers.

Many of Nauman's own "dances," as he called his works, were conceived as live performances though the occasion to present them to a public audience did not often arise. His studio became a sort of lab-theater where he performed and recorded works such as *Bouncing in the Corner, No. 1* (1968, plate 7), which was in fact later staged as a live performance for the 1969 *Anti-Illusions* exhibition at the Whitney Museum of American Art, New York. In the video, Nauman can be seen falling backward into a corner of his studio, breaking the "fall" by putting his hands against the wall. He repeats this action (and sound) again and again for one hour. Looped continuously, the lack of resolution in the scenario becomes, like other similar works in Nauman's oeuvre, a poignant metaphor for the social condition. The artist has described his own presence in his work as "an attempt ... to go from the specific to the general ... making an examination of yourself and also making a generalization beyond yourself."[7] In the video Nauman's head is seen from the side and is also cropped at the top of the video frame; thus, the artist becomes anonymous—an abstracted body—and a surrogate for the viewer (much like *Lighted Performance Box* does).

Nauman's work has often been compared to that of Samuel Beckett, who similarly captured a sense of life's maddening yet humorous continuum in plays like *Waiting for Godot* (1953). "My problem was to make tapes that go on and on without beginning or end," Nauman has explained. "I wanted the tension of waiting for something to happen, and then you should get drawn into the rhythm of the thing."[8] Nauman's use of repetition was directly inspired by the early films of Andy Warhol, who offered splices of real life recorded in real time, as well as the music of Steve Reich, Terry Riley, and La Monte Young, whose "idea was that the music was always going on and you just had to tap into it during the performance."[9] Despite the focus on repetition and repetitive motions in his work, Nauman has indicated that he "wasn't interested in a boring situation" and wanted "to include enough tensions [through] either random error or getting tired and making a mistake ... that there always was some structure programmed into the event."[10] In this sense, Nauman's studio activities conceptually mirror those of anyone's everyday life—the vital yet often pointless rituals that simultaneously impart and are assigned meaning and give shape to time.

In the performance related to *Bouncing in the Corner* staged at the Whitney, the tension in the piece was multiplied with the introduction

University of California. 1965 schuf er zwei Arbeiten, in denen er den eigenen Körper als skulpturales Werkzeug einsetzt. In der einen hantiert er mit einer Leuchtstoffröhre als Körperfortsatz, in der anderen biegt und lehnt er sich gegen eine Wand. Nauman hat beide später vor der Kamera wiederholt und als Ausgangspunkt für weitere Performances verwendet, die auf die gesteigerte Selbsterfahrung des Künstlers und Betrachters abzielen. Die zu Anfang formale Behandlung des Körpers verdichtete sich rasch zu einer psychologischen Untersuchung des Ich und der menschlichen Erfahrung. Eine Serie von Fotografien, Filmen und Videos zwischen 1966 und 1970 dokumentierte Tätigkeiten und Routineabläufe im Atelier (auf und ab gehen, Kaffee trinken usw.) oder geplante Aktivitäten wie *Walking in an Exaggerated Manner Around the Perimeter of a Square* (1967–68, gegenüberliegende Seite). Merce Cunningham (Nauman entwarf für den Tänzer, der ihn stark beeinflusst hat, 1969 ein Bühnenbild), John Cage, ein weiterer wichtiger Einfluss, das Judson Dance Theater und andere haben Bewegungen und Geräusche des Alltags in ihre Vorführungen einfließen lassen. Einfache Gesten (z.B. Boden kehren) wurden als Tanzfiguren adaptiert und oftmals von Laien ausgeführt.

Viele «Dances», wie Nauman seine Performances bezeichnet hat, waren für ein öffentliches Publikum bestimmt, wenngleich sich nur selten Gelegenheit dazu ergab. Das Atelier mutierte zum Theater-labor, in dem Werke aufgeführt und aufgezeichnet wurden. *Bouncing in the Corner No. 1* (1968, Kat.Nr. 7) gelangte 1969 im Rahmen der Schau *Anti-Illusions* im Whitney Museum, New York, zur Aufführung. Das Video zeigt, wie Nauman hintenüber in eine Ecke des Ateliers fällt und sich dabei mit den Händen an der Wand abfängt. Die Aktion (mit Ton) wird eine Stunde lang wiederholt und als Endlosschleife abgespielt. Die niedrige Auflösung wird, wie in anderen Stücken seines Reper-toires, zur prägnanten sozialen Metapher. Nauman beschrieb seine Präsenz innerhalb des Werks als «Versuch … vom Besonderen zum Allgemeinen zu gelangen … sich selbst zu untersuchen und gleich-zeitig über sich selbst hinaus etwas Allgemeines zu artikulieren».[7] Der Kopf erscheint im Seitenprofil, abgeschnitten vom oberen Bild-schirmrand. Der Künstler wird – seiner Individualität beraubt – zum abstrahierten Körper und (wie schon in *Lighted Performance Box*) zum Stellvertreter des Betrachters.

Nauman wurde häufig mit Beckett verglichen, der in Texten wie *Warten auf Godot* (1953) dem absurden und doch komischen Trott des Lebens ein Denkmal gesetzt hat. «Mein Ziel war Bänder zu machen, die immer weiter und weiter gehen, ohne Anfang oder Ende», erklärt Nauman. «Man sollte mit Spannung erwarten, dass irgendwas pas-siert, und sich dann im Rhythmus der Sache verlieren.»[8] Diese Wieder-holungstechnik geht auf die frühen Filme Andy Warhols zurück, mit ihren in Echtzeit aufgenommenen Realitätssplittern, wie auch auf die Kompositionen von Steve Reich, Terry Riley und La Monte Young, deren «Musik unausgesetzt weiterläuft … man muss sich während des Konzerts nur davon mittragen lassen».[9] Trotz der Präferenz für Wiederholungen und repetitive Bewegungen war Nauman «nicht an einer langweiligen Situation interessiert». Vielmehr wollte er «genü-gend Spannungsmomente bieten durch Fehler, die mir entweder unabsichtlich oder durch Übermüdung unterlaufen … damit immer eine gewisse Struktur in das Event einprogrammiert ist».[10] Naumans Atelierstücke halten dem Alltagsleben einen Spiegel entgegen, der jene Rituale in sich fasst, die Sinn machen und geben und der Zeit eine wahrnehmbare Form verleihen.

In der Whitney-Performance *Bouncing in the Corner* steigert ein vergrößertes Ensemble die Spannung. Nauman, seine Frau Judy und

of additional performers. Nauman, his wife Judy, and dancer Meredith Monk—whom he had met in 1968 and whose choreography had influenced him—all performed the same falling action in the corners of the gallery space. Facing the audience, they enacted the same motion, but naturally moved out of sync with each other. Thus action and reaction (movement and sound) seemed to be divorced from each other. The confusion was magnified by the fact that the audience could not see Judy Nauman, but could hear only what seemed to be an inexplicable third thump. Nauman would use strategies of doubling, desynchronization, and disorientation in many of his works, which inspire a similar sense of alterity and challenge rote responses.

The routines Nauman scripted for himself and, eventually, his audience, were essentially investigations of the self and one's relationship to reality. "An awareness of yourself," the artist has said, "comes from a certain amount of activity."[11] Given the artist's interest in word play (a large portion of his work playfully addresses the plastic and mercurial nature of language), it is difficult to dissociate his focus on deliberate activity or actions from the word "action" and its root—"to act," the dual meaning of which is often collapsed in Nauman's work. When one "acts" with a level of self-consciousness, one becomes an "actor." Nauman's four-part film installation *Art Make-Up, Nos. 1–4* (1967–68, [plates 3–6]) emphasizes this point by recording the artist putting on makeup as an actor would. "Painting" himself, Nauman makes a reference to the artist as medium, the performative aspects of "making up"—as well as masking—one's identity.

The mask would return in many guises in Nauman's oeuvre, particularly in his use of clowns and mimes, the wax heads that resemble death masks he began casting in 1989, and in his *First Hologram Series: Making Faces* (1968, [plate 8]). In these holographic works Nauman pushes, pulls, and tugs at his face to create exaggerated expressions or what he has referred to as "social attitudes."[12] The phantom-like, three-dimensional images are reminiscent of fun-house distortions and similarly inspire an uncertainty of what is "real" or fixed. In the *Second Hologram Series: Full Figure Poses* (1969, [plate 9]), Nauman's physical twists and bends are conceptually mirrored by the viewer's movements of his own head or body to gain different perspectives. Seeing the artist's body contorted to "fit" within the frame of the image, the viewer can almost imagine him enclosed inside *Performance Box*. For *Walk with Contrapposto* (1968, [plate 10]) Nauman enacted a related kind of posturing and videotaped himself parading down a long, narrow corridor in the stylized manner characteristic of classical sculpture. His hands on his head, his torso angled away from his hips, Nauman struck a pose whose historical function was to create the illusion of movement in a static figure. Nauman was perhaps making the point that in art that allows for real action, such devices are unnecessary. This convention of "representation" may also be read as a reference to the conventions that inform "being." The corridor represents the exterior forces that determine behavior and identity. Framing both the body and social identity as malleable material, this and other works reject the notion of a single, unchanging self.

As he had done in videos such as *Bouncing in the Corner*, Nauman set up the camera in *Walk with Contrapposto* so that his head was not visible to emphasize his role as anonymous performer. It was after making this work that Nauman realized that the viewer could

die Tänzerin Meredith Monk, die er 1968 getroffen und als Choreografin schätzen gelernt hatte, ließen sich in die Ecken des Ausstellungsraums fallen. Mit steter Wiederholung verlor sich der gemeinsame Rhythmus und damit der Zusammenhang zwischen Aktion und Reaktion (Bewegung und Ton). Zusätzliche Konfusion stiftete der Umstand, dass Judy Nauman unsichtbar, und der dritte dumpfe Aufschlag unerklärbar blieb. Nauman nutzt derartige Verdopplungs- und Verwirrungsstrategien in vielen seiner Arbeiten, um Verfremdungseffekte zu erzielen und Reflexreaktionen der Zuschauer zu blockieren.

Die Routinehandlungen, die der Künstler sich selbst und schließlich auch seinem Publikum verschrieb, sollen primär das Ich und dessen Verhältnis zur Wirklichkeit hinterfragen. «Selbsterfahrung ist das Resultat eines gewissen Aktivitätspensums», attestiert Nauman.[11] Angesichts seiner Vorliebe für Wortspiele fällt es schwer, der Versuchung zu widerstehen, die Vorzugsstellung der bewussten Aktion in Naumans Œuvre auf die sprachliche Ebene zu übertragen. Gemeint ist hier besonders der Ursprung des Worts ‹Aktion› aus dem Stammwort ‹Akt›, dessen Doppelbedeutung Nauman gerne zur Deckung bringt. Wer einen bewussten ‹Akt› ausführt, wird zum ‹Akteur›. Diese Folgerung führt direkt zur vierteiligen Filminstallation *Art Make-Up, Nos. 1–4* (1967–68, [Kat.Nr. 3–6]), in der sich der Künstler wie ein Schauspieler schminkt. Er be-malt sich, um sich als Kunstmedium zu markieren und seine Identität zurechtzumachen – und zu maskieren.

Die Maske spielt eine Schlüsselrolle in Naumans Schaffen. Der Bogen spannt sich von der *First Hologram Series: Making Faces* (1968, [Kat.Nr. 8]) über die Verwendung von Clowns und Pantomimen bis zu den ab 1989 entstandenen Wachsköpfen, die an Totenmasken erinnern. In den Hologrammen drückt, zieht und quetscht der Künstler sein Gesicht zu bizarren Grimassen, die er als ‹Sozialgehabe› charakterisiert.[12] Die gespenstischen, dreidimensionalen Bilder untergraben wie die Zerrbilder des Spiegelkabinetts unser Vertrauen in eine feste, unverrückbare Wirklichkeit. Die Körperverrenkungen der *Second Hologram Series: Full Figure Poses* (1969, [Kat.Nr. 9]) werden konzeptuell verdoppelt, wenn der Betrachter vor ihnen verschiedene Blickwinkel ausprobiert. Angesichts der verzweifelten Anstrengungen, die der Künstler unternimmt, um sich in den Bildrahmen zu zwängen, könnte man meinen, dass er in seiner *Performance Box* gefangen sitzt. Im Video *Walk with Contrapposto* (1968, [Kat.Nr. 10]) schreitet Nauman einen langen, engen Gang entlang. Hände am Kopf, den Torso schräg auf den Hüften, ahmt er den Kontrapost nach, mit dem die klassische Bildhauerkunst die statische Figur mit einem Schein der Bewegung behaften wollte. Möglicherweise will Nauman sagen, dass in einer Kunst, die Platz für tatsächliche Handlungen hat, derartige Posen überflüssig werden. Diese Konvention der ‹Repräsentation› kann überdies als Verweis auf jene Konventionen interpretiert werden, die das ‹Sein› determinieren. Der Korridor verkörpert die äußeren Kräfte, die Verhalten und Sozialisierung prägen. Sie behandeln sowohl den Körper als auch die gesellschaftliche Identität als formbaren Stoff und negieren dadurch die Vorstellung von einem einheitlichen, konstanten Ich.

Wie bereits in *Bouncing in the Corner* wird der Bildausschnitt in *Walk with Contrapposto* so gewählt, dass der Kopf unsichtbar und der darstellende Künstler anonym bleibt. Nach Fertigstellung des Videos erkannte Nauman, dass es möglich sein muss, den Betrachter einer ähnlichen Erfahrung zu unterziehen. *Performance Corridor*

re-create a similar experience. *Performance Corridor* (1969, ^{plate 11}; initially just a prop for the contrapposto video but exhibited as a discrete work for the first time in the *Anti-Illusions* exhibition) signals the transition between his works that feature the artist as performer and those that would subsequently foreground his role as director of the viewer's experience. Constructed from simple plywood and measuring twenty feet long and only twenty inches wide, the narrow passageway of *Performance Corridor* (designed to the width of the artist's hips) forces the viewer to move with the same deliberation and self-consciousness as the artist. "The first corridor pieces were about having someone else do the performance. But the problem for me was to find a way to restrict the situation so that the performance turned out to be the one I had in mind. In a way, it was about control."[13] Not long after creating the corridor, Nauman virtually disappeared from his work and became the director or choreographer behind the scenes.[14] His subsequent corridor works would become the stage set upon which the artist would manipulate the viewer's actions and experience. "I try to make these works as limiting as possible,"[15] he has stated. So while Nauman expanded the spectator's role as performer, he allows him or her to perform only what is "scripted." The earlier *Device to Stand In* (1966, ^{plate 2}) hinted at Nauman's restrictive concepts of choreography. The small steel contraption was conceived as a device for dancing, but only called for one foot to be inside the box, limiting the participant's moves. The artist compared standing in the box to dancing with one shoe nailed to the floor.[16]

Nauman's installations trap the viewer in a confused position between action and nonaction, agency and compliance, doing and watching. *Video Corridor for San Francisco (Come Piece)* (1969, ^{plate 12}) operates in a similar way. Two monitors positioned at opposite ends of a room depict the viewer as two security cameras capture his or her image. The monitor facing the

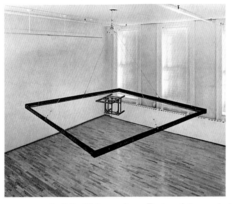

viewer, however, shows the image recorded by the camera behind him or her. According to Nauman, "It's really like the corridor pieces only without the corridors." I tried to do something similar but using television cameras and monitors and masking part of the lenses on the cameras."[17] With the lens partially covered, the viewer is only able to see part of his image, and thus moves this way or that trying (futilely) to find a complete view. The camera may also be turned on its side or upside down, so the disorientation is heightened, the over-compensating movements of the viewer exaggerated. This work magnifies the degree of control that Nauman exerts over his viewer in his corridor works. Although positioned as the performer, the viewer/participant is given little agency; the sight lines of the cameras are like the strings controlling a marionette.

In *Corridor Installation with Mirror—San Jose Installation (Double Wedge Corridor with Mirror)* (1970, ^{plate 14}), the mirror plays the role of the camera and allows the viewer to watch his own actions, positioning him or her as both performer and spectator. Walking down either side of the V-shaped corridor, one sees the first of what appears to be two long passageways that seem to be open at the opposite end. As one approaches the apex of the V, however, it becomes apparent that the corridors end at a mirror; the open passage or passages are an illusion. Nauman leaves a gap above the mirror, however, so that the viewer can see the structure of the space behind and thus understand the "trick." In this sense, the piece, and other Nauman corridors,

(1969, ^{Kat.Nr. 11}; anfänglich nur ein Requisit für *Walk with Contrapposto*, jedoch als eigenständige Arbeit erstmals in der Ausstellung *Anti-Illusions*) eröffnet eine neue Phase seiner künstlerischen Entwicklung. Anstelle des Künstlers als Performer tritt nun der Künstler als Regisseur oder Choreograf der Erfahrung des Betrachters auf den Plan. Die Hüftbreite des Künstlers diente als Maß für den engen Sperrholz-Korridor: nur gute 45 cm breit und 6 m lang. Wer passieren will, muss ebenso bedacht und behutsam vorgehen wie der Künstler. «In den ersten Korridorwerken ging es darum, jemand anderen die Performance ausführen zu lassen. Das Problem war, die Situation so einzugrenzen, dass die Performance auch wirklich meinen Vorstellungen entsprach. Es war also primär eine Frage der Kontrolle.»[13] Innerhalb eines Jahrs nach *Performance Corridor* verschwand Nauman fast völlig aus seinem Werk und beschränkte sich nun darauf, hinter den Kulissen die Fäden zu ziehen.[14] Er benutzte die folgenden Korridorstücke als Bühne, um die Handlungen und Erfahrungen des Betrachters zu manipulieren. «Ich versuche, diese Arbeiten so streng wie möglich zu reglementieren.»[15] Er sprach dem Zuschauer eine aktivere Rolle zu und ließ ihn dennoch nach seiner Pfeife tanzen. Bereits *Device to Stand In* (1966, ^{Kat.Nr. 2}) hatte eine Vorschau auf Naumans restriktive Choreografie geliefert. Der enge Stahlbehälter, in den bloß ein Fuß hineinpasst, fungiert als reduzierter Tanzboden mit entsprechend reduzierten Bewegungsmöglichkeiten. Der Proband muss laut Nauman wie «mit einem am Boden festgenagelten Schuh» tanzen.[16]

Naumans Installationen sind wie Fallen, die den Betrachter im Niemandsland zwischen Aktivität und Passivität, Initiative und Subordination, Tatenlust und Schaulust festhalten. *Video Corridor for San Francisco (Come Piece)* (1969, ^{Kat.Nr. 12}) funktioniert ganz ähnlich. Zwei Bildschirme an gegenüberliegenden Wänden zeichnen wie ein Überwachungssystem das Raumgeschehen auf. Der Bildschirm vis-a-vis dem Betrachter zeigt jedoch immer die Bildspur der Kamera hinter dessen Rücken. Nauman kommentiert: «Es ist wie bei den Korridorwerken, nur ohne Korridor. Ich wollte ein ähnliches Resultat erzielen, aber mithilfe von TV-Bildschirmen und teilweise abgedeckten Kameraobjektiven.»[17] Da er aufgrund der verengten Kameraöffnung immer nur ein Bildfragment wahrnehmen kann, versucht der Betrachter (vergeblich), sich durch Positionswechsel komplett ins Bild zu bringen. Durch Drehung der Kamera auf die Seite oder auf den Kopf kann der Betrachter trotz der kuriosesten Ausgleichsbestrebungen gänzlich aus der Fassung gebracht werden. Nauman nimmt in dieser Installation das Publikum stärker an die Zügel. Der Betrachter darf in das Kostüm des Performers schlüpfen, wird aber ohne Spielraum für Extempore an den optischen Achsen der Kameras gegängelt wie an Marionettenfäden.

In *Corridor Installation with Mirror – San Jose Installation (Double Wedge Corridor with Mirror)* (1970, ^{Kat.Nr. 14}) übernimmt ein Spiegel die Funktion der Kamera und präsentiert so dem Teilnehmer ein Bild seiner Handlungen und seiner Doppelrolle als Schauspieler/Zuschauer. Wenn man einen der zwei Gänge der Installation entlanggeht, die wie ein ‹V› zusammenlaufen, meint man zuerst einen, dann zwei Gänge wahrzunehmen, die den Weg am anderen Ende fortsetzen. Kommt man näher, erkennt man allerdings, dass man einer optischen Täuschung aufgesessen ist: Der Durchgang wird von einem Spiegel versperrt. Eine Lücke über dem Spiegel, die den Blick in den Raum

South American Square, 1981

are reminiscent of the minimal, anti-illusionist stage sets of Bertolt Brecht, who eliminated "the fourth wall" separating audience from actors and left the lighting and other workings of the theater visible. As Brecht did not pretend the stage was anything but a stage, likewise Nauman lays bare the nature of his constructions: they are not sculptural, nor are they part of the architecture of the exhibition space, but function as temporary stage sets inviting the viewer to perform. As the space narrows and the viewer-cum-performer nears the apex of the V, an unexpected figure appears—one's own reflection in the mirror. At five and a half feet high, the mirror cuts off the head of the viewer (if he or she is as tall as the artist is) as the camera had often done in the artist's earlier videos. Rendered as a headless body and hovering between reality and illusion, the viewer is confronted with a simultaneous recognition and misrecognition. Nauman's strategy could be compared to the "alienation effect" of Brechtian theater that transforms the familiar into "something peculiar, striking, and unexpected." "Before familiarity can turn into awareness the familiar must be stripped of its inconspicuousness. ..." Brecht wrote.[18] In both Brecht's work and Nauman's this strategy allows for a new critical perspective and reevaluation of the "subject."

Nauman's videos and environments with their unexpected sights and sounds, also have an affinity to Antonin Artaud's Theater of Cruelty,[19] the description of which could be mistaken for one of Nauman's works: "a mode in which one is shocked bodily into an awareness of ... the uncanny ... suddenly in the midst of reassuringly familiar forms, a space opens up, lit by a strange light."[20] Artaud believed that to reach an inner sensibility "intensities of colors, lights, or sounds, which utilize vibration, tremors, repetition, whether of a musical rhythm or a spoken phrase, special tones or a general diffusion of light can obtain their full effect only by the use of *dissonances*" and an overlapping of the senses with "neither respite nor vacancy in the spectator's mind."[21] Likewise the disturbing, chaotic, even aggressive nature of many of Nauman's environments (which have been variously bathed in discomfiting white, yellow, and green fluorescent lights) provokes in the viewer a consciousness of psychological and physiological responses—a certain awareness amidst uncertainty. These environments also suggest an unidentified, exterior force working on the self or selves. These private and public confrontations played out in Nauman's corridors would soon be translated into a more literal investigation of the power relations and violence enacted on the world stage.

In the 1980s Nauman's work took on a political tone, inspired in part by the writings of V. S. Naipaul, in particular *The Return of Eva Peron* (1980), as well as Jacobo Timerman's accounts of his imprisonment and torture in Argentina in *Prisoner Without a Name, Cell Without a Number* (1981).[22] *South American Square* (1981, facing page) and related works addressed the subject of torture and brutality. "My work comes out of being frustrated with the human condition." Nauman has stated. "And about how people refuse to understand other people. And about how people can be cruel to each other."[23] The spaces of *Diamond Africa with Chair Tuned D E A D*[24] and the *South American* series (1981) are defined by steel beams hung horizontally from the ceiling at eye level and symbolize the rooms that Nauman imagined as the scenes for the acts of torture described by Timerman.

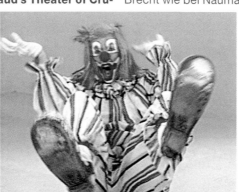

dahinter freigibt, verrät den ‹Trick›. *Corridor Installation with Mirror* und andere Korridorwerke knüpfen an die karge, anti-illusionistische Bühne Bertolt Brechts an, die ohne ‹vierte Wand› (die gedachte Scheidewand zwischen Publikum und Schauspielern) auskommt und die Bühnentechnik und Beleuchtung unverhüllt zur Schau stellt. Wie Brecht nie von der Bühne verlangt hat, mehr als nur Bühne zu sein, lässt auch Nauman die Apparatur seiner Installationen offen zutage treten: Sie sind weder skulpturaler Natur, noch ein Element der Architektur des Ausstellungsraums, sondern laden als temporäre Bühne den Betrachter ein, ins Rampenlicht zu treten. Der Gang verengt sich. Nahe am Schnittpunkt des ‹V› geschieht etwas Unerwartetes. Eine Figur erscheint – ein Spiegelbild! Der Spiegel ist 1,68 m hoch und schneidet, wie die Kamera in früheren Videos, den Kopf des Betrachters ab (wenn seine Körpergröße der des Künstlers entspricht). Als kopfloser Torso in der Schwebe zwischen Wirklichkeit und Illusion sehen wir uns mit einer Erkenntnis/Unkenntnis konfrontiert. Naumans Strategie macht sich den Verfremdungseffekt des brechtschen Theaters zu Eigen, der das Selbstverständliche «zu einem besonderen, auffälligen, unerwarteten Ding» werden lässt. «Damit aus dem Bekannten etwas Erkanntes werden kann, muss es aus seiner Unauffälligkeit herauskommen … » schreibt der deutsche Dramatiker.[18] Bei Brecht wie bei Nauman fördert diese Strategie eine kritische Haltung und eine Neubewertung des «Subjekts».

Eine weitere Zeitspur führt zu Antonin Artauds *Theater der Grausamkeit*,[19] dessen Beschreibung ebensogut auf Naumans Environments gemünzt sein könnte: «eine Art, die den Körper aufschrecken lässt und uns zum Bewusstsein des … Un-heimlichen bringt … plötzlich inmitten beruhigender, bekannter Formen öffnet sich ein seltsam beleuchteter Raum».[20] Artaud glaubte: «Mit Hilfe von Vibration, Erschütterung und Wiederholung erzeugte Farbintensität, Licht oder Klang musikalischer Rhythmen oder gesprochener Phrasen, spezifischer Töne oder allgemeiner Lichtdiffusion entfaltet nur dann eine volle Wirkung, wenn Dissonanzen angewandt werden und wenn sich die Sinne nicht durch Unterbruch oder Leere im Geist des Zuschauers/Zuhörers überschneiden. Nur so kann eine innere Sensibilität erreicht werden.»[21] Die beunruhigende, aggressive Wirkung, die zahlreiche Werke Naumans ausstrahlen (verstärkt durch das kalte weiße, gelbe oder grüne Neonlicht), suggeriert einen Bewusstseinsstrom inmitten der Ungewissheit und weckt instinktive psychische und physische Reaktionen. Die privaten und öffentlichen Konflikte, die in den Korridorstücken ausgetragen werden, mündeten schon bald in einer noch literarischer gefassten Analyse der auf der Weltbühne inszenierten Gewalt- und Machtspiele.

Für Naumans stärkere politische Ausrichtung in den 80er Jahren waren zum Teil die Schriften V.S. Naipauls verantwortlich, insbesondere *The Return of Eva Peron* (1980), sowie Jacobo Timermans Protokoll von Haft und Folter in Argentinien, *Prisoner Without a Name, Cell Without a Number* (1981).[22] *South American Square* (1981, gegenüberliegende Seite) und andere Werke widmen sich dem Themenkomplex Folter und Brutalität. Nauman bekennt: «Meine Arbeit entspringt der Frustration über die menschliche Existenz. Mit unserer Weigerung, andere Menschen zu verstehen. Und mit den Grausamkeiten, die wir einander antun.»[23] In *Diamond Africa with Chair Tuned D E A D*[24] und in der *South American*-Serie (1981) wird der Raum durch waagerechte

A chair suspended upside down or sideways from wires between the beams acts a surrogate for the body and recalls the disorientation of many of Nauman's video works. These designated territories may be seen also as references back to the square Nauman first outlined in tape on his studio floor to strictly demarcate his own actions as well as the more overtly uncomfortable spaces of his corridors and environments. In the *South American* series, the stage has become part of a different type of theater of cruelty, more akin to a theater of war. Situated outside this sculptural and symbolic arena, Nauman's viewers are returned to a more traditional spectatorial role. Once the subject of Nauman's control as well as the subject of surveillance, the viewer is now put into a metaphorical position of observer of other's torment. The "complicity" of the viewer that Fried had once described here takes on an unexpected significance. Nauman's subsequent work has both insinuated and questioned the violence and voyeurism latent in other types of looking.[25] A series of neons, which he began in 1981, does this through form as well as subject matter, which is often both sexual and sadistic. Evoking the signage of sex theaters and peep shows the neon works make explicit the often implicit associations between pleasure and entertainment with violence.

The connection between humor and violence in Nauman's work is an expression of an essential but perplexing aspect of human consciousness that is at the very foundation of his work. Nauman's first clown piece, a neon work entitled *Mean Clown Welcome* (1985, plate 15), perfectly articulates this connection between humor, cruelty, and anonymity. The simplified, outlined figures seen in previous neon works are here transformed into a different kind of abstraction or stereotype. (It is worth noting that Nauman's own body was the template for the clown's figure.) Traditionally, the clown has been the "everyman" of the theater. As Nauman has explained, "I got interested in the idea of the clown first of all because there is a mask, and it becomes an abstracted idea of a person. It's not anyone in particular, see, it's just an idea of a person. And for this reason, because clowns are abstract in some sense, they become very disconcerting."[26] At the same time, clowns' anonymity makes their role as both perpetrators and victims of meanness and violence more palatable.

The action performed in *Mean Clown Welcome* suggests the masquerade that characterizes the social theater. As the clowns greet one another and attempt to shake hands, they move stiffly, clearly controlled by an unseen mechanism. They resemble puppets whose movements are limited and decided by others. The repeated ritual resembles one of Nauman's studio routines, which similarly revealed the mundane as absurd. Coosje van Bruggen related this work specifically to the performance of *Bouncing in the Corner* at the Whitney, explaining that the movements of the clowns—set to repeat at different speeds—were not synchronized, "the figures on the left flash at a rate 'about that of a brisk handshake' while the figure's at the right flash faster and thus go out of phase, so that the limbs no longer align with each other, creating confusion and complexity."[27] As the clowns greet each other, their penises move from flaccid to erect, implying the power struggle that lies behind social interactions. The clowns' failure to connect suggests a basic social alienation and lack of true communication. Similarly the mechanical, isolated, and disjointed limbs recalls the separation between the self and the body or

Stahlträger definiert, die bis auf Augenhöhe von der Decke hängen – Naumans Umsetzung der von Timerman beschriebenen Folterkammern. Zwischen den Trägern schwebt seitlich oder kopfüber ein an Drähten montierter Stuhl, der den Körper symbolisiert und der an die Verwirrung vieler Videos erinnert. Die umschlossenen Zellen können als Nachfolger des Klebeband-Quadrats auf dem Atelierboden, mit dem Nauman seine Aktionen umrissen hat, und als Hinweis auf das bedrückende Raumgefühl der Korridore und Environments interpretiert werden. In der *South American*-Serie hebt sich der Vorhang für das Drama des Kriegs. Das Publikum wird wieder auf seinen traditionellen Platz außerhalb der skulpturalen, symbolischen Arena verwiesen. Nicht länger der Kontrolle Naumans ausgesetzt, weidet es sich am Leiden anderer. Die von Fried erwähnte ‹complicity› des Betrachters erfährt hier eine neue, überraschende Bedeutung. Nauman hat in seiner folgenden Recherche die Gewalt und den Voyeurismus, die anderen Arten des Sehens inhärent sind, angesprochen und hinterfragt.[25] Eine Reihe von Neonarbeiten ab 1981 setzen zu diesem Zweck ein sowohl formales als auch inhaltliches Instrumentarium ein. Ihre oft sexuelle, sadistische Thematik kleidet sich in das Dekor der Sexkinos und Peepshows und entblößt dadurch den latenten Zusammenhang zwischen Lust, Unterhaltung und Gewalt.

Die schwer erklärbare Veranlagung des Menschen zu Humor und Brutalität ist ein wichtiger Impuls in Naumans Schaffen. In der Neonskulptur *Mean Clown Welcome* (1985, Kat.Nr. 15), in der zum ersten Mal das Clownmotiv auftritt, wird der Nexus von Spaß, Grausamkeit und Anonymität schlagend visualisiert. Die stilisierten Silhouetten früherer Leucht-Bilder arrangieren sich hier zu einer völlig anderen Schablone. (ein vielleicht nicht unwichtiges Detail: Der Künstler selbst diente als Vorlage für die Clowns.) Der Clown galt traditionell als ‹Jedermann› des Theaters. Nauman erklärt: «Die Idee des Clowns hat mich vor allem interessiert, weil da eine Maske ist, die zur abstrahierten Idee einer Person wird. Nicht jemand bestimmter, sondern nur die Idee einer Person. Aus diesem Grund, weil Clowns Abstraktionen sind, haben sie was Unheimliches.»[26] Die Anonymität des Clowns macht es auch leichter, seine Doppelrolle als Täter und Opfer übler Bosheiten zu verdauen.

Die Handlung, die sich in *Mean Clown Welcome* entspinnt, gleicht einer Maskerade des sozialen Theaters. Die Clowns begrüßen sich und schütteln sich die Hände, ungelenk wie Marionetten, die von einem unsichtbaren Puppenspieler dirigiert werden. Ihr Wiederholungsritual ähnelt den Atelierroutinen, mit denen Nauman schon einmal die Banalität des Alltags entlarvt hat. Coosje van Bruggen hat nachdrücklich auf die Parallelen zwischen *Mean Clown Welcome* und der Whitney-Performance von *Bouncing in the Corner* hingewiesen. Sie berichtet, dass die mit verschiedenem Tempo ablaufenden Clown-Bewegungen nicht synchronisiert waren: «Die Figuren links blinken im Takt ‹eines heftigen Händeschüttelns›. Die Figuren rechts blinken schneller und bringen das Wechselspiel der Arme außer Tritt. Das erzeugt Verwirrung und Komplexität.»[27] Die Clowns bekommen während der Begrüßung eine Erektion, ein Anzeichen der unterschwelligen Hierarchiekonflikte im sozialen Miteinander. Die misslungene Kontaktaufnahme der Clowns ist ein Symptom ihrer fundamentalen Entfremdung und ihrer Unfähigkeit zu echter Kommunikation. Im Tanz der mechanischen, amputierten Glieder schwingt auch die Trennung von Ich und Körper mit sowie die Trennung von Ich und Spiegelbild in Naumans Korridor-Environments.

Indoor/Outdoor Seating Arrangement, 1999

the self and one's reflection that the viewer experiences in Nauman's corridor environments.

In many works from this period, Nauman's viewer is witness and voyeur. In the unsettling *Clown Torture* (1987, page 17) a veritable encyclopedia of clown "types" suffer through various humiliations (filmed sitting on the toilet in a public bathroom), impossible and ridiculous tasks (balancing a goldfish bowl on a pole), and frustrations at the hands of an unseen individual (we hear only a voice). Just as the clowns in Nauman's work are both instigators and victims, so too are the works' viewers. We see in the clowns' pathetic state our own malleability—perhaps Nauman has just made us look into another mirror.

In other similar works, Nauman seems to offer a potential agency, a conscience. "Art ought to have a moral value, a moral stance, a position," Nauman has declared.[28] *Double No* (1988, plate 16), for example, features two jesters jumping up and down, repeatedly yelling "No." While the repetitive refrain is reminiscent of a child's tantrum, the jester is traditionally a type of clown afforded certain respect. He is an entertainer and counselor to kings; protected by his mask of foolishness, the jester is allowed to speak his mind when others are not. Presenting the image of two jesters on two stacked monitors, one jester seen upside down, *Double No* suggests the double role of the jester as well as presenting multiple voices—a chorus—of dissent. And like the fool and the Greek chorus in theatrical tradition they may be the voice of reason cloaked in folly or word play. Nauman himself might be seen as a jester as artists are traditionally afforded the same freedom while also being situated outside society looking in—another incarnation of the spectator who becomes performer.

When *Double No* is installed in museums, it is often situated in a window, facing the street, where the soundtrack is played for passersby. Like minstrels and mimes, or the performances and Happenings of the 1960s, *Double No* brings theater to the streets and spaces of the everyday. Simultaneously the museum becomes a stage of sorts and frames the viewers/spectators inside as performers for those outside. Thus each "arena" both mirrors and is defined by the other. Nauman's more recent works, such as *Stadium* (1997–99, above) and *Indoor/Outdoor Seating Arrangement* (1999, facing page) further examine the interchangeable roles of performer and spectator and the implications of this inversion.[29] The multiple sets of bleacher-like seats of *Indoor/Outdoor Seating Arrangement* have been installed facing each other, and even facing a wall, reiterating that the focus of a given work might be the audience themselves, or the very act of looking itself. *Stadium*, a monumental outdoor sculpture constructed as a series of concrete steps, further emphasizes the significance of the spectator. Intended as a gathering place—a site for communication and social interaction—the work as Nauman conceived it is also a place for "spectators [watching] activities occurring around it."[30] The artwork, usually an object to be looked at, is instead a platform for looking.

While Nauman has continuously addressed the role of the viewer, he has sustained an interest in his own role as artist, performer, and choreographer, as he did in his studio during the 1960s. After two decades, *Raw Material—BRRR* (1990, plate 17) marked the artist's return as the primary subject of his work for the first time since the early 1970s. Part of a series of six related video installations, *Raw Material* harks

Viele Arbeiten dieser Periode drängen den Betrachter in die Rolle des Zeugen und Voyeurs. In der bitterbösen Videoinstallation *Clown Torture* (1987, Seite 17) jagt ein Unbekannter (wir hören nur die Stimme) eine ganze Kollektion von ‹Clowntypen› durch einen Spießrutenlauf von Erniedrigungen (während er auf der öffentlichen Toilette sitzt), Belastungs- und Geschicklichkeitsproben (er muss z.B. mit einer Goldfischkugel jonglieren) und Enttäuschungen. Unter Naumans Regie ereilt das Schicksal der Clowns als Täter/Opfer auch den Betrachter. Wer genau hinsieht, erkennt im Jammerzustand der Clowns nichts als die eigene Charakterschwäche. Offenbar sind wir dem Künstler einmal mehr in die Spiegelfalle gegangen.

Andere Werke dieser Gruppe scheinen eine moralische Instanz anzubieten. «Kunst sollte einen moralischen Wert haben, eine moralische Haltung, einen Standpunkt», fordert Nauman.[28] In *Double No* (1988, Kat.Nr. 16) rufen zwei auf und ab springende Hofnarren unablässig «No!». Man denkt an tobsüchtige Kinder, obwohl der Hofnarr als Unterhalter und Berater von Königen eine eher respektierliche Schelmfigur ist. Unter dem Schutz seiner Narrenkappe kann er es wagen die Wahrheit zu sagen. Das Treiben der Possenreißer wird auf zwei aufeinander gestapelten Monitoren gezeigt, wobei eines der Bilder auf dem Kopf steht. *Double No* dramatisiert die Doppelrolle des Hofnarren und lässt einen Kanon des Widerstands ertönen, der wie die Narrenfigur oder der griechische Chor der Bühnentradition mit der Stimme der Vernunft spricht, verschlüsselt in Witzen und Wortspielen. Gut möglich, dass Nauman sich selbst als Hofnarr versteht, genießt doch der Künstler seit jeher das Privileg des Außenseiters, der die Gesellschaft aus der Distanz mustert – wieder ein Zuschauer, der aktiv in die Handlung eingreift.

Museen installieren *Double No* häufig in einem Schaufenster, wo der Ton die Passanten erreicht. Wie die fahrenden Musikanten und Spielleute oder die Performances und Happenings der 60er Jahre erobert Naumans Clowntheater die Straße und den öffentlichen Raum. Gleichzeitig wird das Museum zur Bühne und verwandelt seine Besucher zu Schaustellern für das draußen vorüberziehende Publikum. Jeder Schauplatz wird vom anderen reflektiert und definiert. Arbeiten jüngeren Datums wie *Stadium* (1997–99, oben) und *Indoor/Outdoor Seating Arrangement* (1999, gegenüberliegende Seite) setzen die Untersuchung des Rollentauschs zwischen Schauspieler und Zuschauer und dessen Konsequenzen fort.[29] In *Indoor/Outdoor Seating Arrangement* starren sich zwei Tribünen mit Sitzbankreihen gegenseitig an. Ihr Gegenüber bezeugt, dass im Zentrum der Kunstproduktion das Publikum selbst steht, oder direkt der Akt des Sehens. Dieser Sachverhalt wird in der monumentalen Außenskulptur *Stadium* noch schärfer herausgearbeitet. Eine Reihe von Betonstufen bildet einen Ort der Verständigung und Zusammenkunft, an dem, nach Naumans Vorstellung, «Zuschauer ‹beobachten›, was um sie herum geschieht».[30] Das Kunstwerk, das sonst als Schauobjekt dient, wird zu einer Warte des Schauens.

Trotz des Schlaglichts auf den Betrachter hat Nauman nie das Interesse an seiner Rolle als Künstler, Performer und Choreograf verloren, das die Atelierarbeiten der 60er Jahre geprägt hat. In *Raw Material – BRRR* (1990, Kat.Nr. 17) übernimmt der Künstler zum ersten Mal seit Anfang der 70er Jahre wieder die Hauptpartie. Die Videoinstallation, die einem sechsteiligen Zyklus angehört, greift auf die

back to earlier explorations of the self through bodily exercises. However, while the earlier film and videos that featured Nauman often cut off a view of his head, here, the artist is completely disembodied. As a "talking head," Nauman spouts incessantly a meaningless sound but which can also be read as the first letters of his name—"BRRR."

Nauman may be reintroducing himself to us in this piece, yet the frustrating exchange offered the viewer is reminiscent of the strange interlude in *Mean Clown Welcome*. As the viewer moves between the artist's image projected on the wall and those depicted on two smaller monitors, he or she is caught in a similar act of repetition and confusion. Standing in a room that takes on the feeling of a theater-in-the-round, the clearly visible video equipment functioning like stage props, the viewer is again both performer and spectator. His face distorted, and multiplied Nauman recalls here his earlier series of holograms, his appearance masklike. His image, seen horizontally and through changing overlays of color, evokes the "makeup" of his earlier film. Nauman's visage in this work has been described as "a mask of aggression" and refers back to his clowns who "personify fear, exposure, aggression, and suffering … the 'raw material' of Nauman's installations."[31] The artist's use of a jarring cacophony of color and sound again also evoke Artaud's strategies, which sought to reveal and provoke the viewer's most primitive, brutal instincts in an effort to overcome them. Nauman's reference to "raw material" suggests this primitive state, one ruled by the instinctual drives that he explores in his work through themes of sex, death, and aggression.

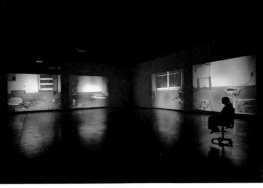

But this condition and the title *Raw Material* itself, also suggest a certain *potential*, which so often characterizes Nauman's enterprise and is a force in one of his most recent installations. *Mapping the Studio I (Fat Chance John Cage)* (2001, right), a video that focuses on the artist's studio brings us back to the beginning of his career, in a loop reminiscent of the structure of so many of his works. Filmed at night, the space is quiet, save for the occasional stirrings of cats and mice and the eerie ambient sounds of coyotes, horses, wind. The predator-prey relationship of the cat and mouse subtly recalls the human struggles scrutinized in other of Nauman's works and makes a pointed comparison about human behavior as he literally spelled out in the neon piece from 1983 entitled *Human Nature*. Flashing various combinations of the words HUMAN, ANIMAL, and NATURE, this work drew attention to the basic instincts shared by both. Nauman's viewers have the capacity to investigate and question their own drives and behavior, as Nauman himself has for so many years by recording his own activities. While the animals' movements in *Mapping the Studio* provide chance moments of action, these bursts of amusement punctuate long expanses of relative nothingness that in previous works are only implied. The almost six-hour-long recording is presented in a large rectangular space defined by seven video screens. Surrounded by these walls of images, the viewer can almost imagine him- or herself in the artist's studio, sitting in the artist's chair. With this work, it is as if Nauman has finally found a way to integrate the spectator into his studio activities with him. As the roles of performer and spectator collapse, so too have those of artist and viewer, who now both face the anxiety and possibility expressed in the space before them as well as their roles in shaping its meaning.

Susan Cross

physischen Selbsterfahrungstechniken früherer Werke zurück. Anstatt des kopflosen Torsos erscheint jetzt jedoch ein körperloser ‹Schwatzkopf›, der Unverständliches von sich gibt und die ersten Buchstaben seines Namens ausspricht – «BRRR».

Das Wiedersehen mit dem Künstler hat seine Tücken. Es verläuft wie das merkwürdige Zwischenspiel in *Mean Clown Welcome*. Wenn der Blick des Betrachters zwischen dem großen, an die Wand projizierten Kopf und den zwei kleineren Monitorporträts hin und her wandert, verliert er sich im Verwirrspiel der Wiederholungen. Der umgebende Raum wird zur Schauspielarena, die offen installierte Videoausrüstung zur Kulisse, und der Betrachter findet sich abermals zum Subjekt/Objekt der Performance transformiert. Die verzerrten Hydraköpfe scheinen der Hologramm-Serie entsprungen zu sein. Das waagerecht gelegte Gesicht wird von wechselnden Farbschichten überdeckt wie vom ‹Make-up› früherer Videos. Man hat Naumans Grimasse als «Maske der Aggression» bezeichnet, als Rückgriff auf die Clowns, die «Angst, Ausgesetztsein, Aggression und Leid verkörpern … das ‹Rohmaterial› von Naumans Installationen».[30] Die Farb- und Tondissonanzen folgen dem artaudschen Prinzip, die primitiven, brutalen Instinkte des Betrachters zu wecken, um sie zu transzendieren. Das ‹Rohmaterial› des Titels bezieht sich auf den von Urtrieben beherrschten ‹Rohzustand›, dem Nauman anhand der Aspekte Sex, Tod und Gewalt auf den Grund geht.

Dieser Zustand impliziert wie der Titel *Raw Material* ein unerschöpfliches *Potenzial*, das in vielen Arbeiten Naumans und auch in einer seiner neuesten Installationen präsent ist. Die Videoschleife *Mapping the Studio I (Fat Chance John Cage)* (2001, links) ist nach erprobtem Muster strukturiert. Wir werfen einen Blick in das Atelier des Künstlers, in das nächtliche Ruhe eingekehrt ist. Nur ab und zu huscht eine Katze oder Maus vorbei und in der Ferne sind Kojoten, Pferde oder ein vorüberfahrender Zug zu hören. Das Katz-und-Maus-Spiel evoziert die animalische Tendenz im Menschen, die Nauman bereits in anderen Werken verarbeitet hat, besonders pointiert in *Human Nature* (1983). In dieser Neonskulptur leuchten wechselnde Kombinationen der Wörter ‹HUMAN›, ‹ANIMAL› und ‹NATURE› auf, um auf die Triebe aufmerksam zu machen, die Mensch und Tier gemeinsam sind. Der Betrachter ist imstande, seine Triebe und sein Verhalten infrage zu stellen – wie es Nauman durch das Aufnehmen seiner eigenen Aktivitäten bereits seit Jahren vormacht. Das Pirschen und Trippeln der Tiere in *Mapping the Studio* liefert kurze Unterhaltungsmomente zwischen langen Sequenzen der Stille. Das fast sechs Stunden dauernde Band läuft in einem großen, rechteckigen Raum auf sieben Videobildschirmen ab, die den Betrachter ins Atelier des Künstlers versetzen. Wie es scheint, hat Nauman zu guter Letzt einen Weg gefunden, das Publikum in seine Atelieraktivitäten einzubinden. Nicht nur die Rollentrennung zwischen Schauspieler und Zuschauer wird aufgehoben, sondern auch die zwischen Künstler und Betrachter. Beide sehen jetzt den erschreckenden Möglichkeiten ins Auge, die der Raum vor ihnen ausbreitet und werden sich ihrer eigenen Rolle bewusst, in der sie ihm Bedeutung schenken.

Susan Cross

Mapping the Studio I (Fat Chance John Cage), 2001

1 While performance and theater are often considered separate disciplines and their differences are the subject of many nuanced and complex discussions, their shared concepts, particularly duration and its relationship to an audience (whether live or implied by the camera), are what seem most relevant for Nauman. He has relied on aspects of both performance and theater. The artists who interested Nauman in his early career made work that was "un-theatrical" and consciously devoid of mannerisms and overt dramatics; however, Nauman would utilize these more traditional theatrical tropes in his later work, which capitalized on the exaggerated, self-conscious theatrics of clowns, jesters, mimes, and similar characters. Nauman has also occasionally employed professional actors.

2 Bruce Nauman, quoted in Robert C. Morgan "Interview with Bruce Nauman," in Morgan ed., *Bruce Nauman* (Baltimore: John Hopkins University Press, 2002), p. 266.

3 At this time Nauman was making works which gave physical form to language. For example, in 1966 and 1967 he produced a series of photographs depicting visual puns. Perhaps the most fitting example is *Eating My Words* (1967), which shows the artist spreading jam on the letters "w o r d" on his plate.

4 Michael Fried, "Art and Objecthood," in Fried, *Art and Objecthood: Essays and Reviews* (Chicago: University of Chicago Press, 1998), pp. 153; 155. Originally published in *Artforum* (New York) 10, no. 5 (June 1967), pp. 12–23.

5 Ibid., pp. 166–67.

6 Ibid., p. 155.

7 Nauman, in Michele de Angelus, "Interview with Bruce Nauman," in *Bruce Nauman*, exh. cat. (London: Hayward Gallery, 1998), p. 127.

8 Bruce Nauman quoted in Jane Livingston, *Bruce Nauman: Work from 1965 to 1972*, exh. cat. (New York: Praeger Publishers; Los Angeles: Los Angeles County Museum of Art, 1972), p. 26.

9 Nauman, quoted in Morgan, "Interview with Bruce Nauman," p. 265.

10 Nauman, quoted in de Angelus, "Interview with Bruce Nauman," p. 126.

11 Nauman, quoted in an interview with Willoughby Sharp, "Bruce Nauman," *Avalanche* (Berkeley, Calif.) no. 2 (winter 1971), p. 27

12 Nauman, quoted in de Angelus, "Interview with Bruce Nauman," p. 125.

13 Nauman, quoted in Joan Simon, "Breaking the Silence: An Interview with Bruce Nauman," *Art in America* (New York) 76, no. 9 (September 1988), p. 147.

14 In 1970 Nauman participated in his last live performance, a work conceived by Meredith Monk and performed at The Santa Barbara Arts Festival in Santa Barbara, California. Nauman did not reappear in his own work again until 1988 when he appeared in a video installation, *Green Horses*, in which he is shown exercising his horse, and in a related film projected as a backdrop for a dance performance, *Roll Back* (1988). In both pieces, Nauman's maneuvers with the horse, which he rides around in circles, might recall the artist's repeated activities which he documented in his studio in the 1960s. In 1990, upon moving into his new studio in Galisteo, New Mexico, Nauman again focused his camera on himself in the *Raw Material* series.

15 Nauman, quoted in Willoughby Sharp, "Nauman Interview," *Arts Magazine* (New York) 44, no. 5 (March 1970), p. 23.

16 See description of this work in Joan Simon, ed., *Bruce Nauman*, exh. cat. and catalogue raisonné (Minneapolis: Walker Art Center; Washington, D.C.: Hirshhorn Museum, Smithsonian Institution, 1994), p. 200.

17 Nauman, quoted in Sharp, "Bruce Nauman," p. 24.

18 Bertolt Brecht, "Short Description of a New Technique of Acting which Produces an Alienation Effect," in *Brecht on Theatre: The Development of an Aesthetic*, trans. and ed. J. Willett (New York: Hill and Wang), pp. 136–47.

19 See Antonin Artaud, *The Theater and Its Double*, trans. Mary Caroline Richards (New York: Grove Press, 1958).

20 Susie J. Tharu, *The Sense of Performance: Post-Artaud Theatre* (New Delhi: Arnold-Heinemann, 1984), p. 57.

21 Artaud, *The Theater and Its Double*, pp. 125–26.

22 See V. S. Naipaul, *The Return of Eva Peron, with The Killings in Trinidad* (New York: Knopf, 1980); and Jacobo Timerman, *Prisoner Without a Name, Cell Without a Number*, trans. Toby Talbot (New York: Knopf, 1981).

23 Nauman, quoted in Simon, "Breaking the Silence," p. 148.

24 This work is directly related to two of the studio "performances": a film *Playing a Note on the Violin While I Walk Around the Studio* (1967–68) and a video entitled *Violin Tuned D E A D* (1969). In the sculpture, the chair legs were tuned so that if struck, they played the notes D, E, A, and D.

25 In previous works Nauman had assigned a certain responsibility to his viewers, drawing attention to their participation as a conscious, deliberate act. For the installation of *Kassel Corridor: Elliptical Space* (1972), Nauman instructed that a person wishing to enter the corridor had to obtain a key from a designated office.

26 Nauman, quoted in Simon, "Breaking the Silence," p. 203.

27 Coosje van Bruggen, *Bruce Nauman* (New York: Rizzoli, 1988), p. 236.

28 Nauman, quoted in Simon, "Breaking the Silence," p. 143.

29 These works might also be seen in the context of Nauman's investigation of the connection between spectatorship, entertainment, and violence which is embodied in the historic uses of amphitheaters and arenas, such as the Circus Maximus in Rome or the Ball Court at Chichén Itzá, as well as in the more contemporary soccer stadiums of Taliban-ruled Afghanistan.

30 Nauman, quoted by Ariane Fehrenkamp in "Bruce Nauman: *Stadium Piece*, Bellingham, WA," *Sculpture* (Washington, D.C.) 18, no. 9 (November 1999), p. 14.

31 Ursula Frohne, "Bruce Nauman: *Raw Material—BRRR*," in *Mediascape*, exh. cat. (New York: Guggenheim Museum, 1996), p. 29.

1 Performance und Theater werden gewöhnlich als getrennte Disziplinen behandelt und ihre Unterschiede waren Gegenstand eingehender Untersuchungen. Dessen ungeachtet konzentriert sich Nauman auf ihre Gemeinsamkeiten, speziell auf die Zeitdimension und die Präsentation vor dem Publikum (entweder direkt oder vermittelt über eine Kamera), und macht sich Aspekte beider Disziplinen zunutze. Die Werke der Künstler, die Nauman in seiner Frühphase interessiert haben, waren dezidiert ‹un-theatralisch› und frei von Künstelei und offener Dramatik. Erst später ließ Nauman auch traditionelle Theaterelemente in sein Werk einfließen, die auf der übertriebenen Mimik von Clowns, Narren, Pantomimen und ähnlichen Figuren beruhten. Fallweise wurden auch professionelle Schauspieler eingesetzt.

2 Nauman, zitiert nach Robert C. Morgan «Interview with Bruce Nauman», in: Morgan, Hrsg., *Bruce Nauman,* Baltimore: John Hopkins University Press, 2002, S. 266.

3 Naumans Werke dieser Phase verliehen der Sprache eine physische Form. So entstand 1966 und 1967 eine Fotoserie mit visuellen Wortspielen. Ein besonders typisches Beispiel ist die Fotografie *Eating My Words* (1967), die zeigt, wie der Künstler die Buchstaben ‹w o r d› auf seinem Teller mit Marmelade beschmiert.

4 Michael Fried, «Kunst und Objekthaftigkeit», in: Gregor Stemmrich, Hrsg., *Minimal Art:. Eine kritische Retrospektive*, Dresden/Basel 1995, S. 334-374.

5 Ebenda, S. 166-67.

6 Ebenda, S. 155. Begriff in Kursivdruck: Susan Cross.

7 Nauman, zitiert nach Michele de Angelus, «Interview with Bruce Nauman», in: *Bruce Nauman*. Ausst.Kat. London: Hayward Gallery, 1998, S. 127.

8 Nauman, zitiert nach Jane Livingston, *Bruce Nauman: Work from 1965 to 1972*, Ausst.Kat. New York: Praeger Publishers; Los Angeles: Los Angeles County Museum of Art, 1972, S. 26.

9 Nauman, zitiert nach Morgan, a.a.O., S. 265.

10 Nauman, zitiert nach de Angelus, a.a.O., S. 126.

11 Nauman, zitiert nach einem Interview mit Willoughby Sharp in: «Bruce Nauman», *Avalanche* (Berkeley, Kalifornien), Nr. 2 (Winter 1971), S. 27.

12 Nauman, zitiert nach de Angelus, a.a.O., S. 125.

13 Nauman, zitiert nach Joan Simon, «Breaking the Silence: An Interview with Bruce Nauman», *Art in America* (New York) 76, Nr. 9 (September 1988), S. 147.

14 Nauman nahm 1970 an seiner letzten Live-Performance teil, einer Choreografie von Meredith Monk, die im Rahmen des kalifornischen Santa Barbara Arts Festival aufgeführt wurde. In einem selbstproduzierten Film trat Nauman erst 1988 wieder persönlich auf, und zwar in der Videoinstallation *Green Horses* und in einem Film derselben Serie, der der Tanzaufführung *Roll Back* (1988) als Hintergrund diente. Beide Werke zeigen Nauman bei der Pferdedressur, eine Fortsetzung seiner Atelierroutinen der 60er Jahre. 1990, nach dem Umzug ins neue Atelier in Galisteo, New Mexico, stellte er sich in der *Raw Material*-Serie erneut vor die Kamera.

15 Nauman, zitiert nach Willoughby Sharp, «Nauman Interview», *Arts Magazine* (New York) 44, Nr. 5 (März 1970), S. 23.

16 Joan Simon, Hrsg., *Bruce Nauman,* Ausst.Kat. und Werkverzeichnis, Minneapolis: Walker Art Center; Washington, D.C.: Hirshhorn Museum, Smithsonian Institution, 1994, S. 200.

17 Nauman, zitiert nach Sharp, a.a.O., S. 24.

18 Bertolt Brecht, «Kurze Beschreibung einer neuen Technik der Schauspielkunst, die einen Verfremdungseffekt hervorbringt», in: Werner Hecht, Hrsg., *Schriften zum Theater 3,* Frankfurt a.M.: Suhrkamp, 1963, S. 174.

19 Antonin Artaud, *The Theater and Its Double*, Übersetzung: Mary Caroline Richards, New York: Grove Press, 1958.

20 Susie J Tharu, *The Sense of Performance: Post-Artaud Theatre,* Neu-Delhi: Arnold-Heinemann, 1984, S. 57.

21 Artaud, *The Theater and Its Double*, S. 125–26.

22 V.S. Naipaul, *The Return of Eva Peron, with The Killings in Trinidad.* New York: Knopf, 1980. Jacobo Timerman, *Prisoner Without a Name, Cell Without a Number.* Übersetzung: Toby Talbot. New York: Knopf, 1981.

23 Nauman, zitiert nach Simon, a.a.O., S. 148.

24 Dieses Werk ist eng mit zwei Atelier-Performances verwandt, dem Film *Playing a Note on the Violin While I Walk Around the Studio* (1967–68) und dem Video *Violin Tuned D E A D* (1969). In der Skulptur sind die Beine des Stuhls auf die Töne D, E, A und D gestimmt.

25 Nauman hatte dem Betrachter in vorhergehenden Arbeiten eine gewisse Verantwortung zugewiesen und dessen bewusste Beteiligung unterstrichen. Wer die Installation *Kassel Corridor: Elliptical Space* (1972) betreten wollte, musste sich erst im zuständigen Büro den Schlüssel holen.

26 Nauman, zitiert nach Simon, a.a.O., S. 203.

27 Coosje van Bruggen, *Bruce Nauman,* New York: Rizzoli, 1988, S. 236.

28 Nauman, zitiert nach Simon, a.a.O., S. 143.

29 Diese Werke können zu jener Gruppe gezählt werden, die den Zusammenhang zwischen Schaulust, Unterhaltung und Gewalt erforscht. Beispiele für dieses Phänomen aus der fernen und jüngeren Geschichte sind die Amphitheater und Zirkusarenen der Antike, der Zirkus Maximus in Rom, der Ballspielplatz von Chichén Itzá oder die Fußballstadien der Taliban in Afghanistan.

30 Nauman, zitiert nach Ariane Fehrenkamp «Bruce Nauman: *Stadium Piece, Bellingham, WA», Sculpture* (Washington, D.C.) 18, Nr. 9 (November 1999), S. 14.

31 Ursula Frohne, «Bruce Nauman: Raw Material: BRRR», in: *Mediascape*, Ausst.Kat. New York: Guggenheim Museum, 1996, S. 29.

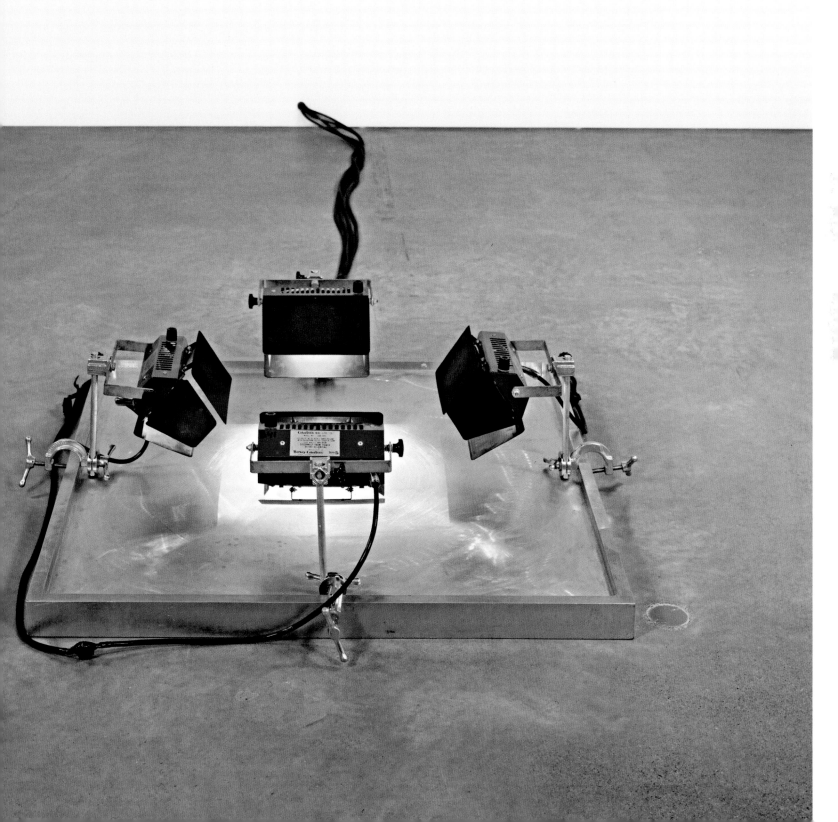

Plate 2 *Device to Stand In*, 1966

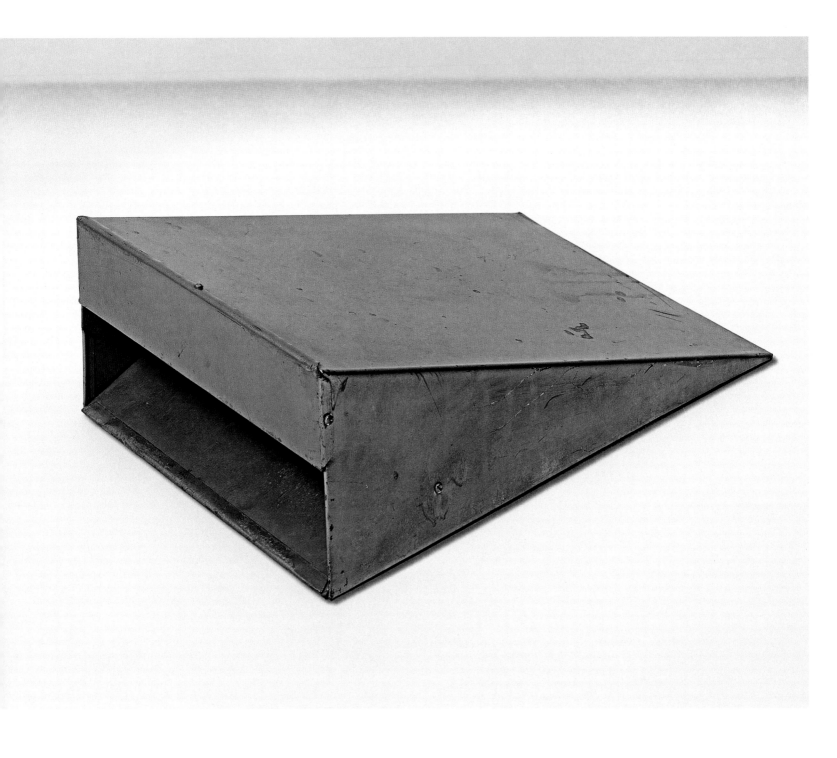

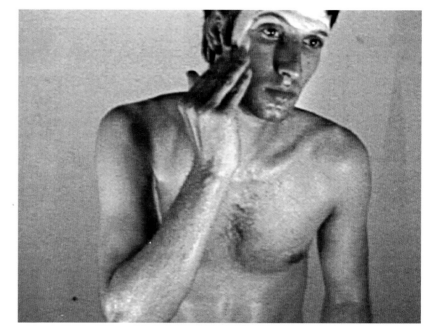

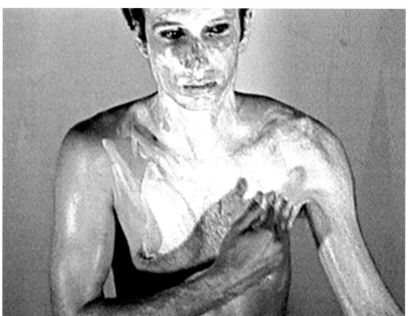

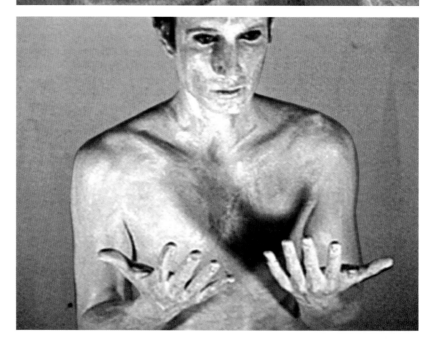

Plate 3 Film stills from / Einzelbilder aus dem Film *Art Make-Up, No.1: White*, 1967

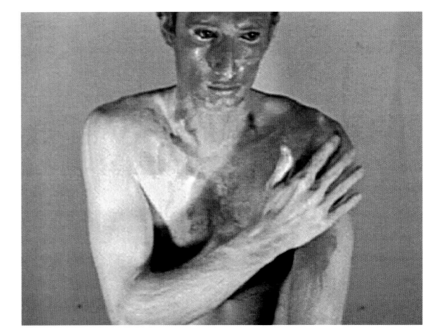

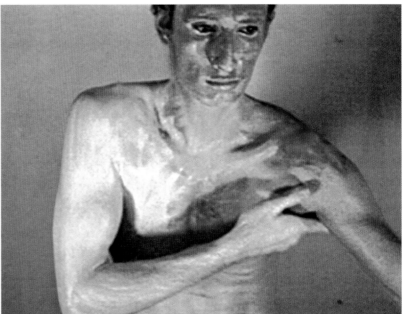

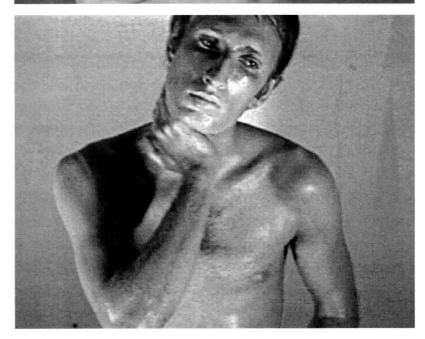

Plate 4 Film stills from / Einzelbilder aus dem Film *Art Make-Up, No. 1: White, No. 2: Pink*, 1967-68

Plate 5 Film stills from / Einzelbilder aus dem Film *Art Make-Up, No. 3: Green*, 1967–68

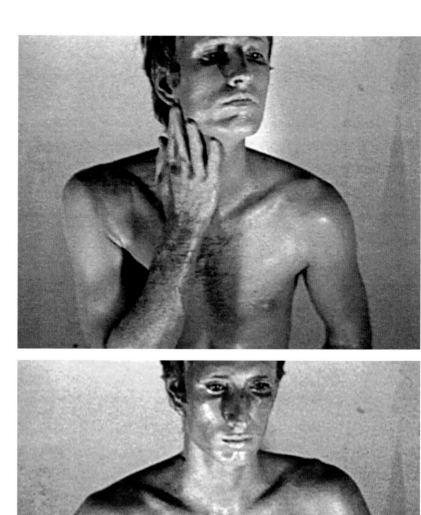

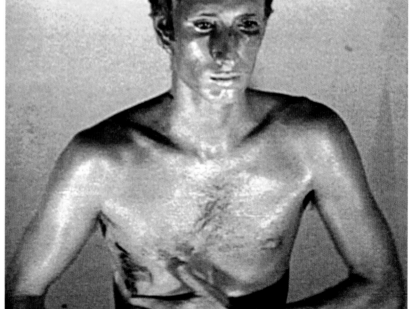

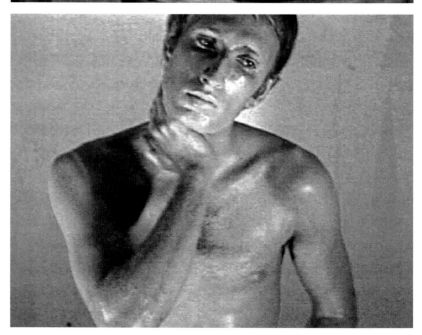

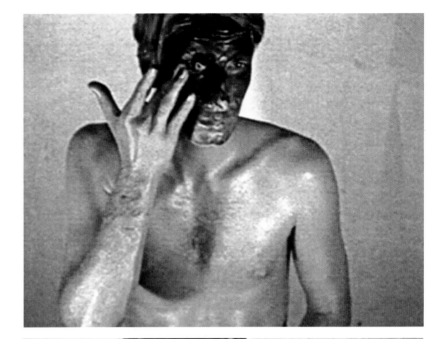

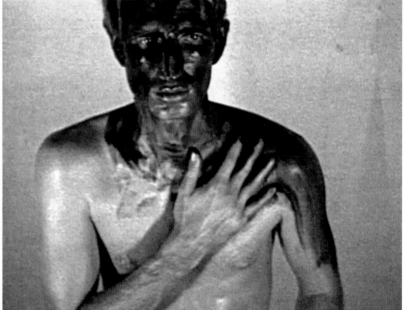

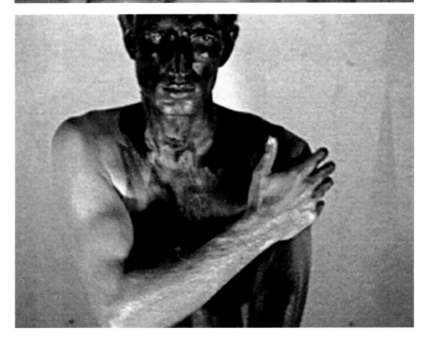

Plate 6 Film stills from / Einzelbilder aus dem Film *Art Make-Up, No. 4: Black*, 1967–68

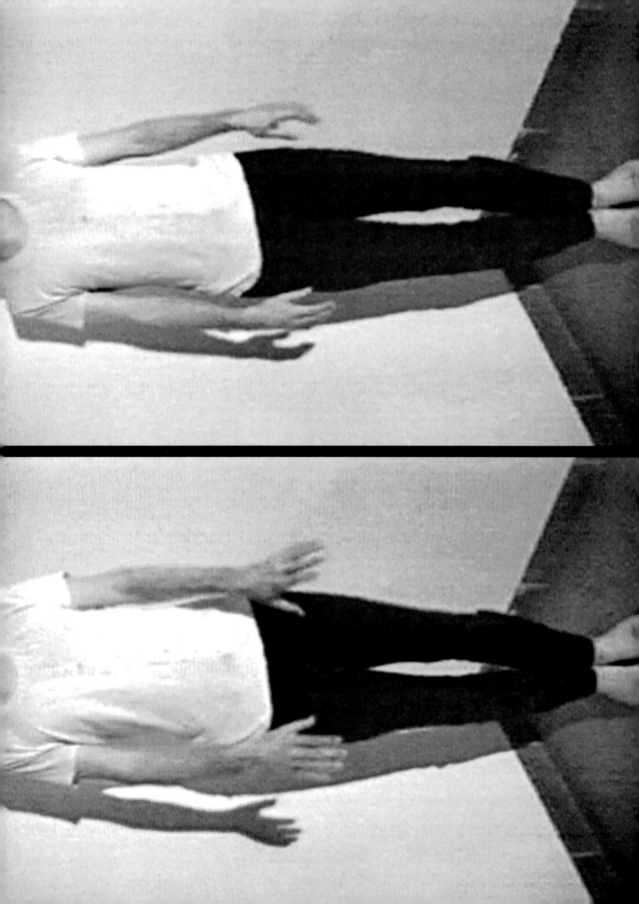

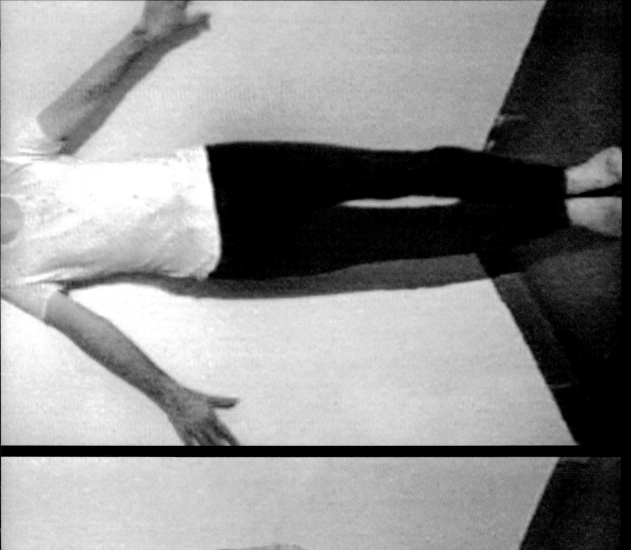
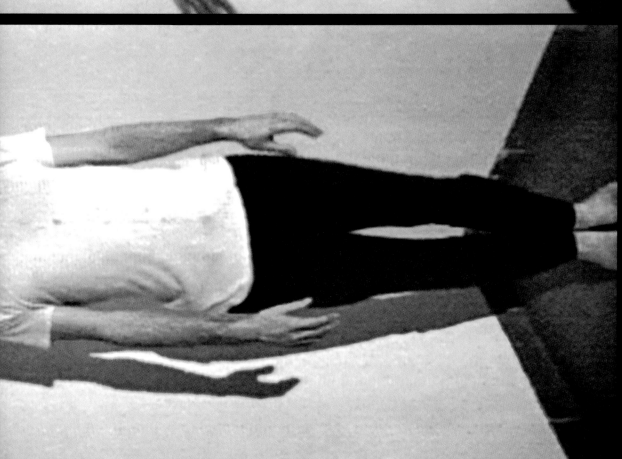

Plate 7 Video stills from / Einzelbilder aus dem Video *Bouncing in the Corner, No. 1*, 1968

Plate 8 *First Hologram Series: Making Faces (K), 1968*

Plate 9 *Second Hologram Series: Full Figure Poses (A)*, 1969

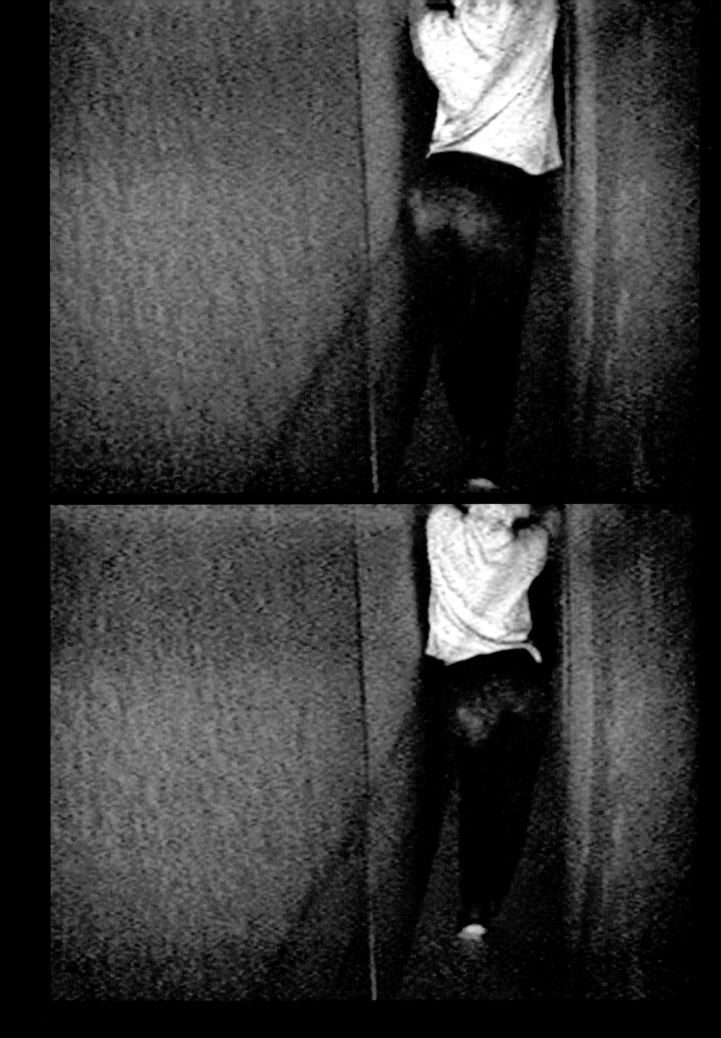

Plate 11 *Performance Corridor*, 1969

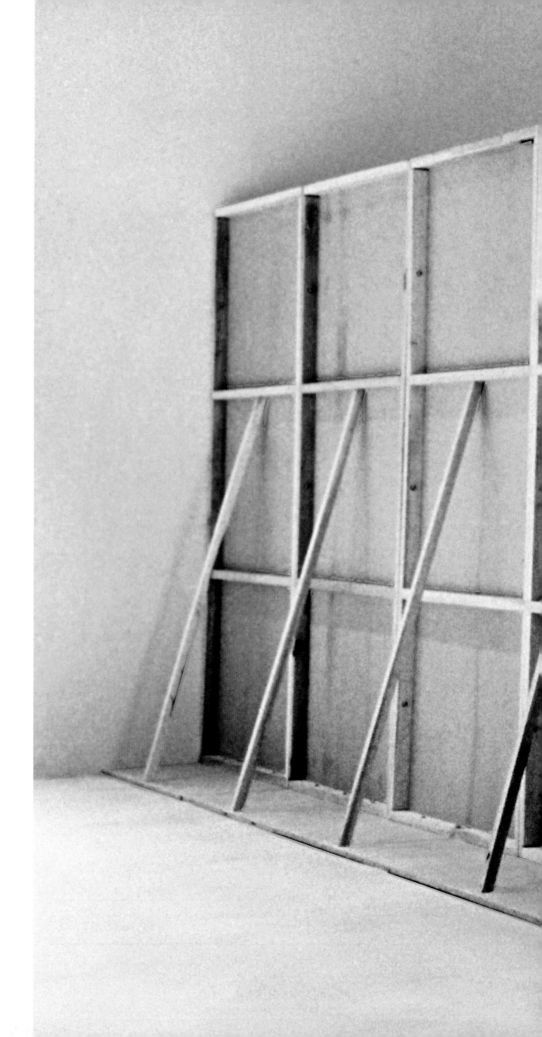

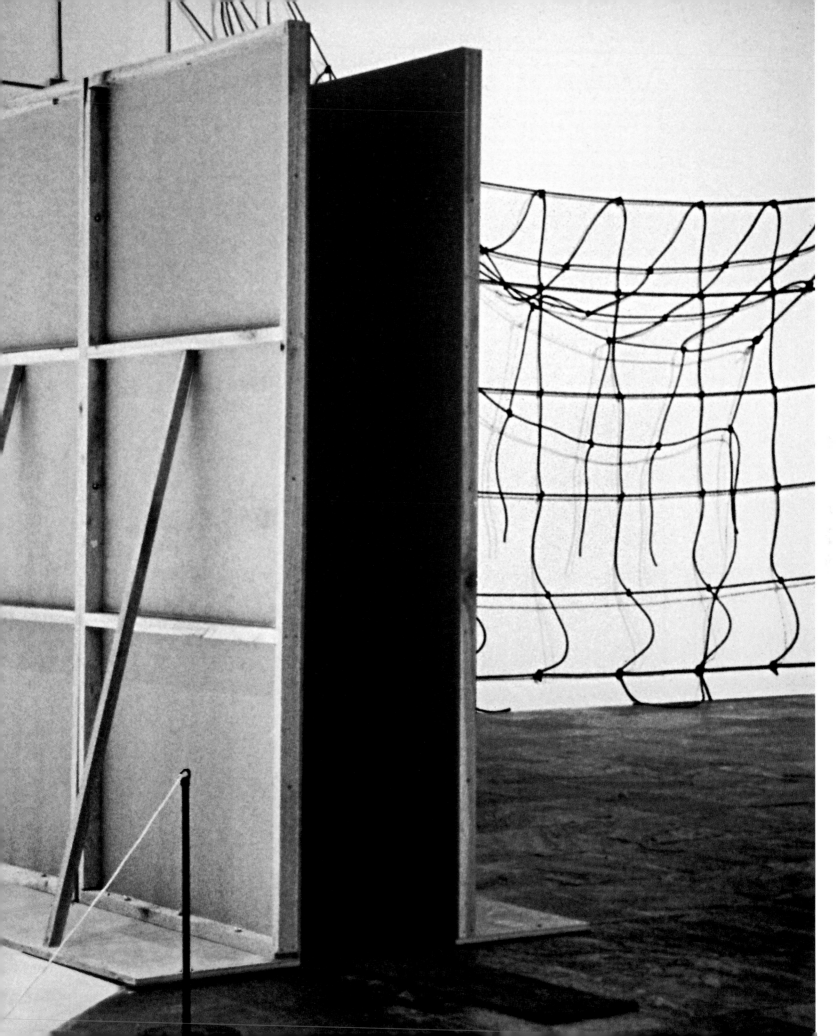

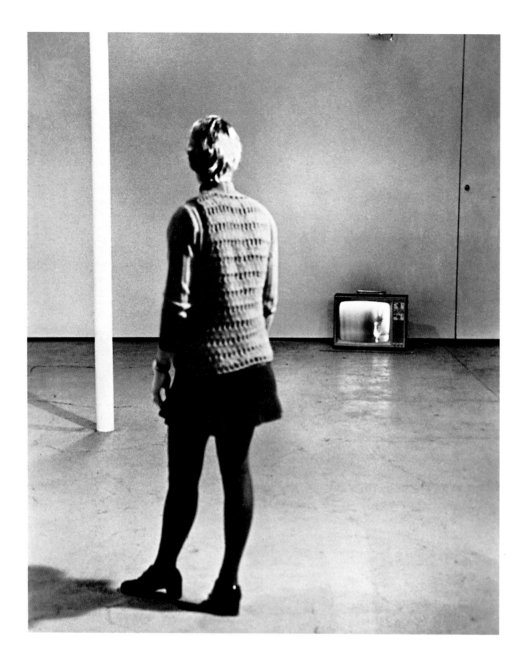

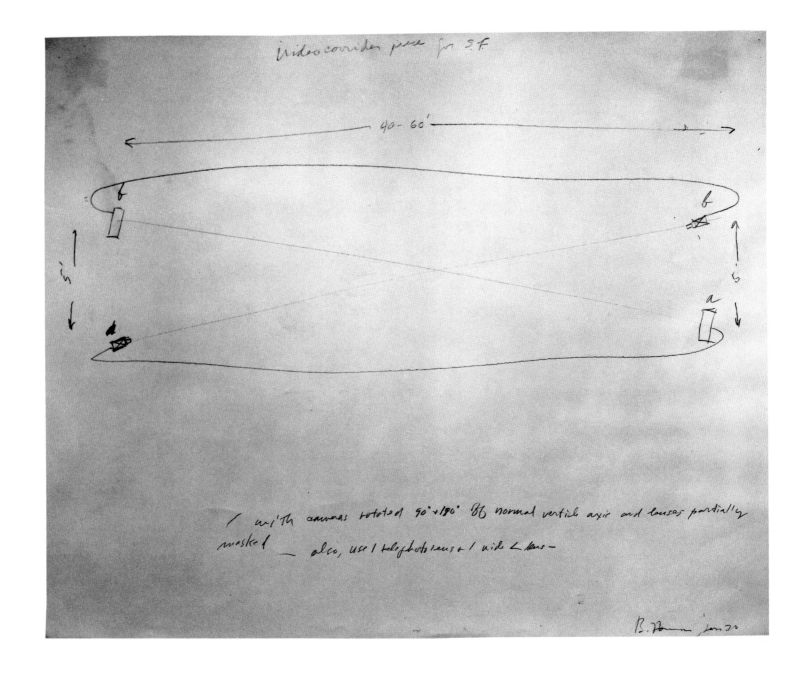

Plate 13 Drawing for / Zeichnung für *Video Corridor for San Francisco (Come Piece)*, 1969

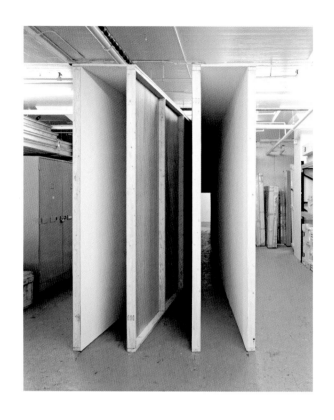

Plate 14 *Corridor Installation with Mirror—San Jose Installation (Double Wedge Corridor with Mirror)*, 1970

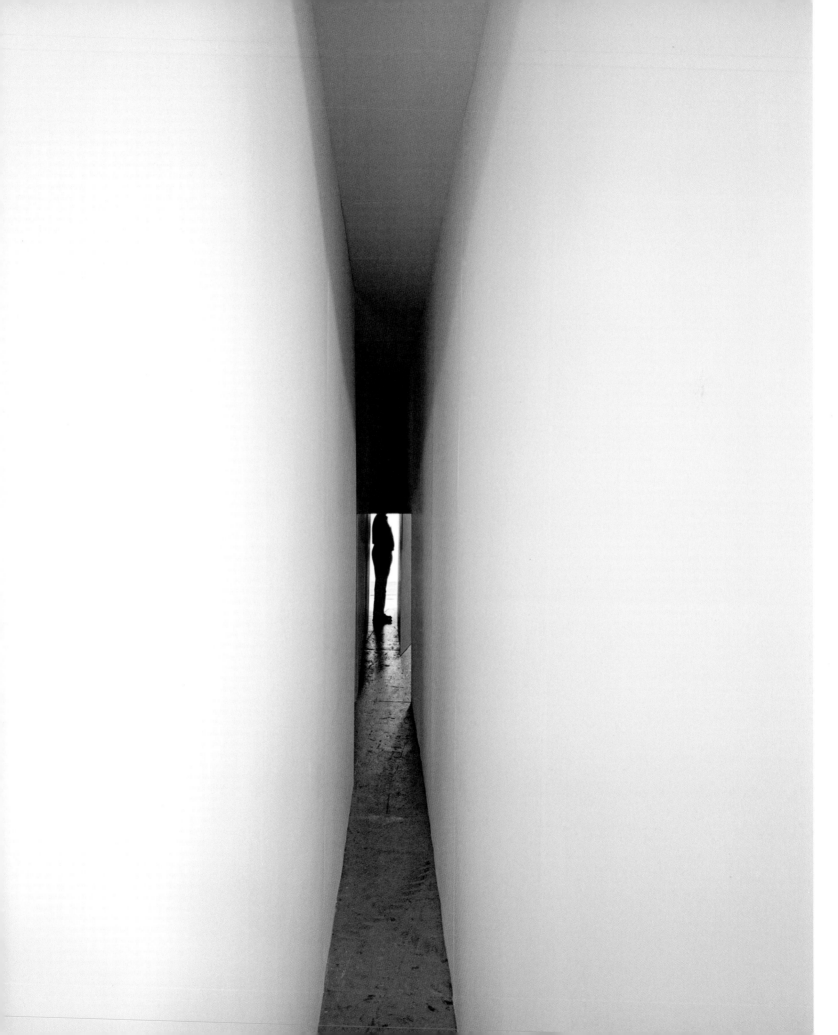

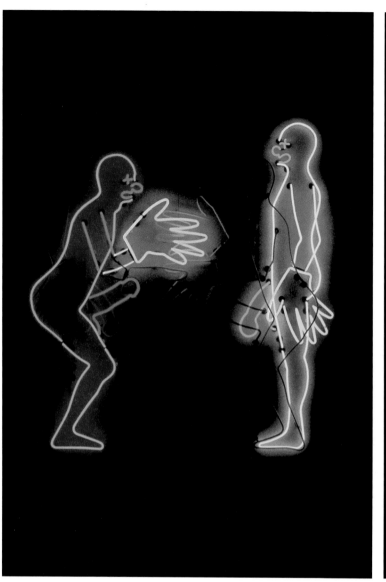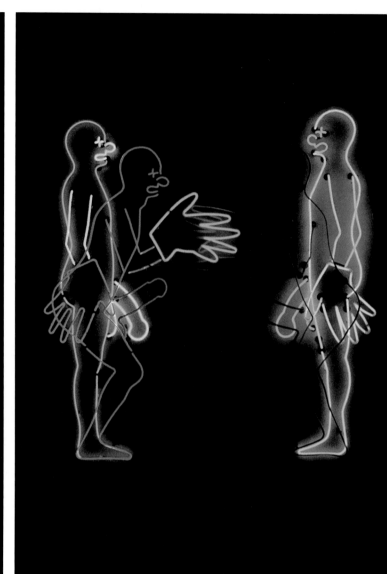

Plate 15 *Mean Clown Welcome*, 1985

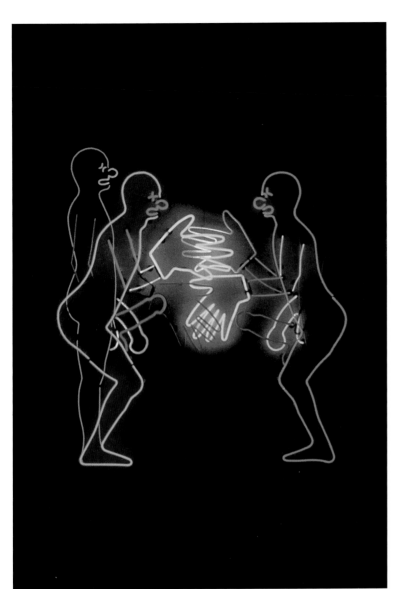
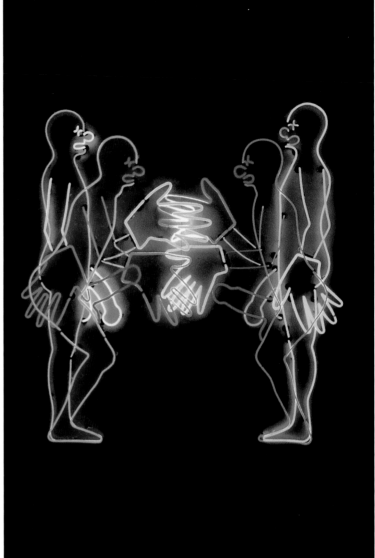

Plate 16 *Double No*, 1988

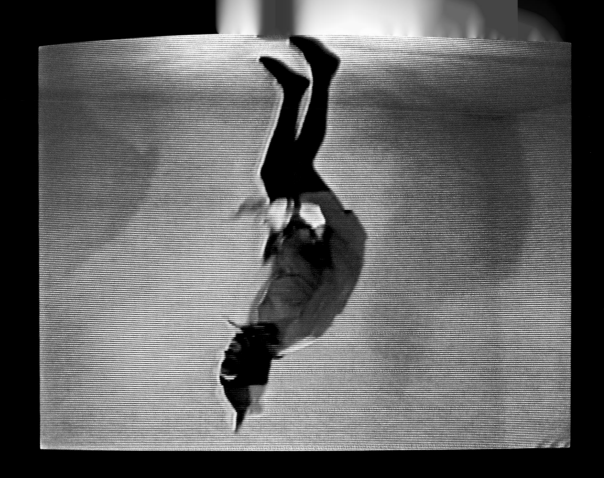

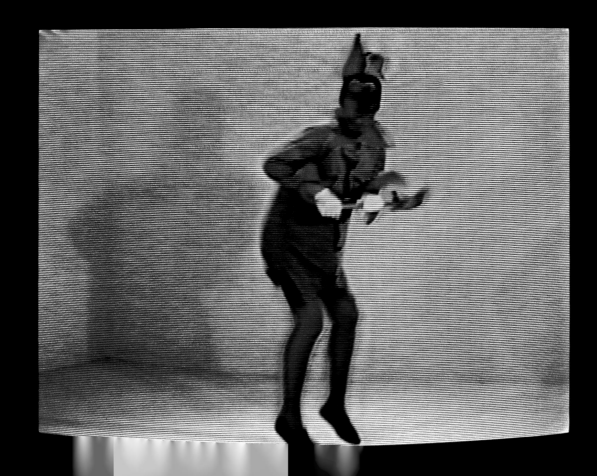

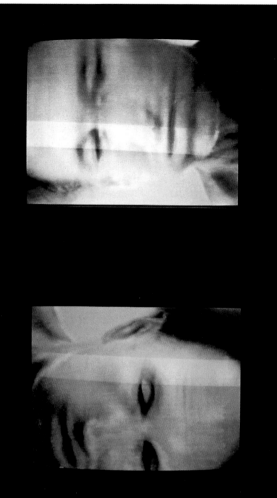

Think-Thank

Denk-Dank

Wellheads

In the emblematic *Self-Portrait as a Fountain* (1966, facing page), Bruce Nauman ironically styles himself as a fountain. The artist and his work meld one into the other in this self-portrait. Nauman represents the wellhead of creativity.

He takes as his subject his own role as an artist in this work as well as related pieces, among them photographs and drawings.[1] In assuming the form of a fountain, Nauman reminds us how refreshing and nourishing his contribution really is. The meaning of the stream that spews from his mouth in this solitary performance remains ambiguous. In a sense he is brazenly spitting in the viewer's face, spraying us with unholy water. With a title suggestive of Marcel Duchamp's *Fountain* (1917), the image has overtones of that other stream emanating from farther down the body. On the other hand, dousing a person with a fluid can be a fully acceptable act when it is part of a spiritual or shamanistic ritual, one meant to provide healing or betterment to the seeker. Some Christian priests sprinkle the faithful with holy water. Does art cleanse us with pure water?

> Then down a little way
> Through the trash
> Towards where
> All dark no begging
> No giving no words
> No sense no need
> Through the scum
> Down a little way
> To whence one glimpse
> Of that wellhead.[2]

These words from Samuel Beckett suggest that the path to the wellhead of creativity leads through trash. The filth of everything mortal is a given throughout his oeuvre. Beckett's protagonists often lie or creep on the floor, sit in urns and holes in the ground, and sleep or dig in trash cans. They struggle awkwardly through resistant environments, or find themselves trapped and directionless. Beckett offers his audiences a pure mental experience, in which the intensity of his writing conveys the vital chaos of an irritating and endlessly circulating odyssey in pursuit of meaning. "The form and the chaos remain separate. The latter is not reduced to the former," as Beckett put it in 1956 in an interview.[3]

There is a strong strain of following such a premise in the investigations of Nauman's early years, when he began to use his body as a medium. In exploring the space of his studio through bewildering activities and exercises, he defined a new artistic enterprise.

Recording Mediums

In *La Peinture des van Velde, ou le monde et le pantalon* (1945), an eloquent homage to his painter friends the van Velde brothers, Beckett makes (after forty pages) a laconic capitulation on the possibility of describing what painting (or art) is, referring to Miguel

Denk-Dank

Quellpunkte

Im emblematischen *Self-Portrait as a Fountain* (1966, gegenüberliegende Seite) stilisiert sich der junge Bruce Nauman ironischerweise als Brunnen. In diesem Selbstportait verschmelzen Künstler und Werk. Er repräsentiert den Quellpunkt des Schöpferischen.

Nauman macht hier, wie in verwandten Arbeiten, darunter Fotografien und Zeichnungen, seine eigne Rolle als Künstler zum Thema.[1] Diese ‹Brunnengestalt› gemahnt an den erfrischenden und bereichernden Beitrag des Künstlers. Aber der Wasserstrahl, den er in seiner einsamen Performance ausspeit, bleibt hinsichtlich der Bedeutung in der Schwebe: in gewisser Weise spuckt er frech und verwegen den Betrachter auf Augenhöhe an. Auch schwingt der andere Strahl von tieferer Stelle, in Wechselbeziehung zu Duchamps *Fountain*, dabei mit. Andererseits ist das Besprühen mit Flüssigkeiten in spirituellen oder schamanistischen Ritualen ein durchaus würdiger Akt, der dem Probanden Besserung oder Heilung verspricht. Auch der christliche Priester besprengt mit geweihtem Wasser. Reinigt die Kunst mit klarem Wasser?

> Dann hinab ein kleines Stück
> Durch den Dreck
> Dorthin, wo
> Alles schwarz, kein Betteln
> Kein Geben, kein Wort,
> kein Sinn, keine Not,
> durch den Feim
> hinab, ein kleines Stück,
> dahin, woher ein Schimmer
> von jenem Quellpunkt.[2]

Becketts Worten nach führt der Weg zum «Quellpunkt» des Schöpferischen durch den Unrat. Der Schmutz alles Irdischen findet sich durchgängig in Becketts Werk. Seinen Protagonisten ist er vertraute Umgebung. Sie finden sich häufig am Boden liegend oder kriechend, sie sitzen in Urnen oder Bodenlöchern und übernachten oder wühlen in Mülltonnen. Sie kämpfen sich umständlich durch feindliche Umgebungen oder finden sich, eingeschlossen oder richtungslos, in der Falle. Beckett bietet seinen Lesern und Zuschauern eine pur mentale Erfahrung, bei der die Intensität seiner Texte das vitale Chaos der irritierenden und endlos kreisenden Odyssee der Suche nach Sinn in Gang hält. «Form und Chaos bleiben getrennt voneinander. Letzteres wird nicht zu Ersterem reduziert», sagt Beckett 1956 in einem Interview.[3]

Der ausgeprägte Hang einer solchen Prämisse zu folgen, findet sich in den Untersuchungen Naumans in seinen frühen Jahren, als er begann, den Körper als Medium zu gebrauchen. Er definierte ein neues künstlerisches Unternehmen, als er anfing, mit verblüffenden und wunderlichen Aktivitäten und Übungen den Raum des Ateliers zu erforschen.

Medien der Aufzeichnung

Beckett, der sich in *Die Welt und die Hose* eloquent eine Hommage an die von ihm geschätzten Malerfreunde, die Brüder van Velde, abringt, inszeniert nach vierzig Seiten eine lakonische Kapitulation angesichts der Möglichkeit zu beschreiben, was die Malerei sei, mit

de Cervantes's painter in *Don Quijote de la Mancha* who, when asked, "What are you painting?" responds, "Whatever comes out of my brush."[4] Beckett weaves this, the only quotation he uses, into his text in order to suggest a commonsense, but also potentially experimental, approach to creativity.[5]

In the late 1960s Nauman came to the conclusion that "Art is what an artist does in his studio."[6] To some extent this statement sums up his entire approach to art making. Recently, a derogatory piece of criticism about Nauman's *Mapping the Studio I (Fat Chance John Cage)* (2001, page 20) maintained: "Studios don't make art any more than pens make poetry."[7] Another critic complained in 1995: "Indiscriminately, he makes use of whatever means are available to him," and also stated that Nauman's art is "a floundering that is strategically entrenched as the artist's project."[8]

Interestingly, this preoccupation with the basic state of floundering—being stranded on the threshold and wondering how to proceed—is indeed characteristic of Nauman's work, and is a recurrent theme in Beckett's work as well. The writer succeeds in molding that dangerous, transitional phase of confusion into his clear and clean-cut observations of the moment at hand. In *Malone Dies* (1951) he notes his sense of the physical process of writing and its potential dangers, given that a yawning abyss lies beyond the edge of the paper: "My little finger glides before my pencil across the page and gives warning, falling over the edge, that the end of the line is near."[9]

By contrast, the fingers that might grasp the writing implement included in Nauman's sculpture *Brown Crayon Box* (1966),[10] is in no danger of "falling off the page." Nauman limited the range of the pen by attaching it with string to the box. Was his purpose to secure the pen by attaching a box to it? After all, pens often disappear from service counters unless they are tied down. Was Nauman's related drawing (1966, page 54) made with such a pen attached to a box? No, the sculpture had been destroyed, and Nauman made the sketch later to preserve his idea. This drawing can be related to Nauman's sculpture *Space under My Hand When I Write My Name* (1966), which refers to the process of writing or recording by spatializing the activity. This wax cast was either inadvertently or intentionally destroyed too, although it survives as a photograph shown in section D (for "destroyed") of the Nauman catalogue raisonné.[11] Yet the space defined by Nauman's hand and wrist when writing remains as a concrete abstraction in the mind of the viewer.

At about the same time, in a spiral-shaped piece of 1967, he introduced the dictum, "The true artist helps the world by revealing mystic truths," spelled out in script.[12] This slogan in neon, which he announced almost as a proposition to be tested, reverberated at the time and still does today.[13] It continues to puzzle viewers as well as its author, but then artists have always been fond of such conundrums.

In Beckett's novel *Watt* (1953), his protagonist, a servant, wants to enter the locked room of another servant by any means. He can neither get a hold of the keys, nor can he use a picklock or a simple key to break into the room. The reader finds him musing

dem Verweis auf die Antwort des Malers in Miguel de Cervantes' *Don Quijote*, der auf die Frage, was er male, antwortet: «Was aus meinem Pinsel herauskommt».[4] Mit diesem einzigen, in den Text eingewobenen Zitat offeriert Beckett ein scheinbar allgemein verständliches, zugleich potentiell experimentelles Konzept des Schöpferischen.[5]

In den späten 60er Jahren kam Nauman zum Schluss: «Kunst ist, was ein Künstler tut, wenn er im Atelier ist».[6] Hiermit fasst er seine Herangehensweise an die künstlerische Arbeit zusammen. Kürzlich war in einer harschen Kritik an Naumans *Mapping the Studio I (Fat Chance John Cage)* (2001, S. 20) zu lesen: «Ateliers machen ebenso wenig Kunst wie Schreibstifte dichten».[7] Ein anderer Kritiker beschwerte sich 1995: «Er verwendet unterschiedslos alles, was ihm gerade zur Verfügung steht», und zudem sei Naumans Kunst «ein Herumzappeln, das sich strategisch als künstlerisches Projekt verschanzt».[8]

Interessanterweise ist diese Beschäftigung mit dem elementaren Zustand des Herumzappelns charakteristisch für Naumans Kunst. Gestrandet an der Schwelle wie ein Fisch auf dem Trockenen und sich dann zu fragen, wie es weitergeht – das ist auch ein wiederkehrendes Motiv in Becketts Werk. Dem Schriftsteller gelingt es, diesen gefährlichen, verwirrenden Zwischenzustand in präzise und klare Beobachtungen des Nächstliegenden umzuformen. In *Malone stirbt* (1951) hält er zum Vorgang des Schreibens und dessen potentiellen Gefahren fest:

«Mein kleiner Finger gleitet vor meinem Bleistift über die Seite und warnt, wenn er am Rand herunterfällt, dass das Zeilenende naht.»[9]

Im Gegensatz dazu sind die Finger, die den Stift von Naumans Skulptur *Brown Crayon Box* (1966, S. 54)[10] halten, nicht gefährdet vom Blatt zu fallen, denn ihr Radius ist limitiert. Ging es hier darum, den Stift durch Anbinden zu sichern? Schließlich verschwinden ja Stifte häufig und werden deshalb, zum Beispiel an Schaltern, gerne festgemacht. Ist die hier zu sehende Zeichnung mit einem solchen an der Box angebundenen Stift gemacht worden? Nein, die Skulptur war da bereits zerstört, Nauman machte die Zeichnung nachträglich um die Idee zu bewahren. Sie verweist auf den Prozess der Aufzeichnung, ähnlich wie die Skulptur *Space under My Hand When I Write My Name* (1966), die den Raum einer Aktivität plastisch darstellte. Dieser Wachsabguss wurde gleichfalls absichtlich oder versehentlich zerstört, überlebte aber als Fotografie, die in der Abteilung D (für «destroyed» [zerstört])[11] in Naumans Catalogue Raisonné zu sehen ist. Der durch die Hand und das Handgelenk beim Schreiben definierte Raum bleibt als konkrete Abstraktion im Kopf des Betrachters hängen.

Mit einem spiraligen Neonzeichen führte Nauman um dieselbe Zeit das Diktum ein: «The true artist helps the world by revealing mystic truths» (Der wahre Künstler hilft der Welt durch die Enthüllung mystischer Wahrheiten).[12] Dieser quasi als Test-Projektion entworfene Slogan fand und findet ein breites Echo.[13] Wie einst sein Autor rätseln noch heute die Betrachter darüber. Künstler hatten schon immer eine Vorliebe für solche Verschlüsselungen.

In Becketts Roman *Watt* (1953) hat der gleichnamige Protagonist, ein Diener, den dringenden Wunsch, ins zugeschlossene Zimmer eines anderen Dieners einzutreten. Aber er kommt nicht an die Schlüssel heran, und mit einem Dietrich oder einem einfachen Schlüssel gelingt es ihm nicht das Schloss zu öffnen. Zu lesen ist, wie er hin und her sinniert über die «einfachen» oder «okkulten» Eigenschaften des Schlüssels, den er braucht um das Schloss

over the "simple" or "obscure" qualities of the key he needs to gain access to the room. Watt interrupts his own endless train of thought to observe: "Obscure keys may open simple locks, but simple keys obscure locks never."[14] Here Beckett's two partial truths do not by a long shot add up to a whole truth. Both statements—Nauman's spiraling neon with its tautological closure and Beckett's chiastic construction—direct one's thinking into a trap.

After making the observation above, Watt endlessly vacillates between regretting and being pleased with his words. For Beckett's character, this hemming and hawing over utterances is typical: "Thinking now this, now that, he did not in the end know what to think, of the words that had sounded, even when they were plain and modest like the above, of a meaning so evident, and a form so inoffensive, that made no matter, he did not know what to think of them, from one year's end to the next, whether to think poorly of them, or highly of them, or with indifference."[15] Nauman's reflections on his statement about the "true artist" sound much the same. In one of his first interviews, in 1967, for example, he was asked whether he believed in his statement. Nauman responded: "I don't know, I think we should leave that open."[16]

The act of making an assertion, even if it is anything but specific in its content, can fill a writer with childlike pleasure. Franz Kafka recorded such an experience in his diary on February 19, 1911, after noting, "He looked out of the window." Suddenly he felt that he could do anything. "Because the author of this sentence exists—or, more precisely, he is an author because of this sentence; he owes his very existence to it, he has made it, and it has made him. ... Whatever else he may write, 'this sentence is already perfect.' Such is the profound and disturbing certainty art strives for."[17]

In his programmatic focus on uncertainty, Nauman in his early years began a kind of spatial thinking as he sat around or paced in his studio. Forcing himself to pursue an extreme straightforwardness, he started to structure and record simple activities. He set up experimental arrangements in order to disentangle the complex mass of artistic possibilities that sat like a knot in his neck or back. This became the threshold he would seek again and again. In retrospect, when one reviews Nauman's oeuvre it is possible to see it as a rhizome-like system. Individual works seem like fusions or ramifications of ongoing concerns and topics. One can also observe filtering and connecting processes across mediums and ideas, interlocking chains of opposing, seemingly incoherent questions and answers that time and again come to a momentary standstill when they are caught within an artwork. Moreover, Nauman's ability "to speak in tongues" in several different mediums makes it difficult to fit the artist into any single category and establishes his polymorphous public image.[18] In essence, his works balance vertiginously on the edge of dissolution, like the roller-coaster rides at the edge of meaninglessness that unfold in Beckett's *Watt*.

Hugh Kenner once characterized Beckett's writing as "a raid of syntax upon chaos."[19] Or, in Beckett's words: "The form and the chaos remain separate." The form strives for ultimate clarity, while consistently redirecting the artistic process to "incapacity combined with obligation."[20]

aufzukriegen und in den Raum hineinzugelangen. Schließlich sagt Watt: «Okkulte Schlüssel können einfache Schlösser aufschließen, aber einfache Schlüssel nie okkulte Schlösser.»[14] Diese Teilwahrheiten lassen sich beim besten Willen nicht zu einer ganzen Wahrheit zusammenfügen. Beide Aussagen – Naumans spiralige Neon-Arbeit mit ihrem tautologischen Kreisschluss als auch Becketts chiastische Konstruktion – lenken das Denken in die Falle.

Im Anschluss an die getroffene Feststellung ergeht sich Watt in einem nicht enden wollenden Wechselspiel von Bedauern und Nichtbedauern der getroffenen und für seine Rolle bezeichnenden Aussage: « … bald dies denkend und bald das, wusste er letztlich nicht, was er halten sollte von den Worten, die laut geworden waren, selbst wenn sie so klar und bescheiden waren wie die oben erwähnten, mit ihrer so einleuchtenden Bedeutung und ihrer so harmlosen Form, das spielte keine Rolle, er wusste nicht, was er von ihnen halten sollte, von einem Ende des Jahres zum anderen, ob er sie für schlecht, für gut oder für gleichgültig halten sollte.»[15] Nicht unähnlich hören sich die Überlegungen Naumans zu seinem Statement über den ‹wahren Künstler› an. In einem seiner ersten Interviews im Jahre 1967 wurde er gefragt, ob er an die von ihm getroffene Feststellung glaube. «Ich weiß nicht, ich denke, wir sollten das offen lassen», war seine Antwort.[16]

Eine Aussage als Feststellung zu machen, selbst wenn sie hinsichtlich ihres Ausdrucksgehalts völlig unspezifisch ist, kann bei dem, der sie macht, eine fast kindliche Freude auslösen, zum Beispiel bei Franz Kafka, wenn er einen Satz wie «Er schaute aus dem Fenster.» am 19. Februar 1911 in sein Tagebuch schreibt. Diesen Satz geschrieben zu haben erfüllt mit der Inspiration alles zu können, «weil er der Autor dieses Satzes ist – oder genauer, dank dieses Satzes ist er Autor; ihm verdankt er sein Dasein, ihn hat er gemacht und er hat ihn gemacht. … Was immer er schreiben mag, ‹der Satz ist schon vollkommen›. Solcher Art ist die tiefe und befremdliche Gewissheit, die die Kunst sich als Zweck setzt.»[17]

Beim Herumsitzen und –laufen im Atelier mit programmatischem Fokus aufs Ungewisse ging Nauman in seinen frühen Jahren das Denken im Raum an. Dabei zwang er sich zu größtmöglicher Direktheit, strukturierte einfache Tätigkeiten und nahm sie auf. Er erstellte Versuchsanordnungen, um die komplexe Masse künstlerischer Möglichkeiten, die wie ein Knoten im Nacken oder im Rücken saß, zu entwirren. Diese Schwelle suchte er auch später immer wieder auf. Im Rückblick hat Naumans Werk eine rhizomartige Struktur. Die einzelnen ‹Stücke› wirken jeweils wie Aufspaltungen und Zusammenführungen durchgängiger Fragen und Themen. Deutlich bleiben im Überblick die Filterungs- und Leitungsprozesse zwischen Medien und Ideen, ineinander verzahnte Prozesse von gegeneinanderlaufenden, inkohärent anmutenden Fragen und Antworten, die immer wieder als ‹Arbeit› zum Stillstand kommen. Seine Fähigkeit, medial in «vielen Zungen zu reden», erschwert die einfache Kategorisierung in ein leicht handhabbares Profil.[18] Im Grunde balancieren Naumans ‹Stücke› auf der eignen Auflösungsgrenze, schwindelerregend wie die Achterbahnfahrten am Rande des Unsinns, die sich in Becketts *Watt* entfalten.

Hugh Kenner kennzeichnete die Texte Becketts einmal als «Luftangriffe der Syntax aufs Chaos»[19]. «Die Form und das Chaos bleiben voneinander getrennt», sagt Beckett. Die Form strebt nach äußerster Klarheit – wohingegen der Künstler seinen Prozess immer wieder

Drawing of the Brown Crayon Box, 1966

In a dialogue published in 1949 Beckett spoke of the profound challenges his art, an art of the impossible, faced: "The expression that there is nothing to express, nothing with which to express, nothing from which to express, no power to express, no desire to express, together with the obligation to express."[21] Dubbed "Gestapo convention" by Kenner, this forced expression—being forced to speak without knowing what one is expected to say, how it should be said, and what it is that is to be said—propels language across the gaps and lapses of conscious awareness.[22] The self-imposed obligation to express can also be thought of as the "exploitation of impotence," a quality that Beckett considered to be elementary to his artistic project.[23] Thus the reader, the writer, and the protagonist in crossing such gaps and crevasses by means of Beckett's precisely placed syntax, rhythms, repetitions, inversions, and mirror images find themselves, as it were, all in the same boat. Confronted with Nauman's art, we find ourselves in a similar situation.

Two Messes on the Studio Floor
In ancient Greece, the Cynic philosopher and tramp Diogenes lived in a barrel, digging through trash to live. He wanted no possessions; nothing was to intervene between himself and the sun. When he saw a young boy use his hands to scoop up water from a well and drink, he promptly destroyed one of his last possessions, a cup.[24] As the weakest link in the chain of power, and this by choice, Diogenes challenged power by attesting to his own impotence. He is said to have asked the mighty Alexander the Great to step aside, so as not to block the sun. Michel Serres explains the paradoxical message of Diogenes: "Power is what it is because it interposes itself always and everywhere. ... Diogenes wants to do away with all mediation. He bridges the interstitial space, discharges intermediaries, attempts to rid his hand and voice of parasites. He is truly disinterested. Culture and knowledge both tell us the same thing: Whatever is of interest is in reality without interest."[25]

In his work of the mid-1960s Nauman investigated what he had at hand: Images of spilling coffee cups, for example, began to recur in his work. They would appear throughout his oeuvre from the earliest of such works, the sculpture *Cup and Saucer Falling Over* (1965); to photographs of discarded cups like *Coffee Thrown Away Because It Was Too Cold* (1967); to the video sculpture *Coffee Spilled and Balloon Dog* (1993), in which the cups take on a life of their own, falling over and over again.[26] Once come to rest, their spent forms joined the detritus of other sculptures on the studio floor. From such objects Nauman the sculptor composes new work.

In *Composite Photo of Two Messes on the Studio Floor* (1967, page 56), the artist's fascination with intervening spaces joins his thrifty habit of using scraps and pieces of former wholes that had either disintegrated or broken. The rephotographed montage resembles the format of early satellite images. The relatively empty expanse of the floor in the middle is used to divide the two trash heaps. That stretch of interstitial space sets up a triangular relationship among the two piles of garbage and the viewer, who could almost be standing on the empty floor between them.

Addressing a similar concept in a different medium, Nauman had previously lured the viewer into three dimensions rather than the two of the composite photograph. To make the sculpture *Platform Made Up of the Space between Two Rectilinear Boxes on*

umlenkt auf «Unfähigkeit, kombiniert mit Zwang».[20]

In einem Dialog, der 1949 veröffentlicht wurde, sprach Beckett über die enorme Herausforderung, der er sich in seiner Arbeit an einer ‹Kunst des Unmöglichen› stellte: «Der Ausdruck, dass da nichts ist auszudrücken, nichts womit auszudrücken, keine Kraft auszudrücken, kein Verlangen auszudrücken, zusammen mit dem Zwang auszudrücken.»[21] Diesen Zwang kennzeichnet Kenner auch als «gestapo convention»: eine Zwangsbefragung, bei der der Befragte nicht weiß, was von ihm erwartet wird, wie es gesagt werden soll, und was überhaupt zu sagen ist. Ein solches Vorgehen hält die Sprache über die Löcher und Lücken des Bewusstseins hinaus in Gang.[22] Die selbstgesetzte ‹obligation to express› lässt sich als «Ausbeutung der Ohnmacht» verstehen, die Beckett als elementar für sein künstlerisches Projekt begreift.[23] Bei der Überquerung solcher Abgründe durch präzis gesetzte Syntax, Rhythmen und Muster aus Wiederholungen, Umkehrungen und Spiegelungen sitzen Leser, Schriftsteller und der Protagonist, der all dies erleidet, quasi im selben Boot. In einer ähnlichen Situation befinden wir uns, wenn wir mit der Kunst von Nauman konfrontiert werden.

Bodenschätze
Im alten Griechenland lebte der Landstreicher und Philosoph Diogenes in seiner Tonne und stöberte im Müll. Nichts wollte er besitzen; nichts sollte zwischen ihn und die Sonne treten. Als Diogenes einen Jungen am Brunnen Wasser aus der Hand schöpfen und trinken sieht, zerstört er umgehend eines seiner letzten Besitztümer, seinen Becher.[24] Als schwächstes Glied des Machtgefüges, als bewusster Bewohner der Ohnmacht, legt er sich mit der Macht an, indem er ihr seine Ignoranz bezeugt. Den Herrscher Alexander verweist er aus dem Zwischenraum zwischen sich und der Sonne. Michel Serres zeichnet die paradoxen Botschaften des Philosophen nach: «Die Macht ist deshalb so groß, weil sie stets und überall dazwischentritt. ... Diogenes will alle Vermittlung streichen. Er überbrückt das Zwischen, löscht die Medien, versucht aus Hand und Stimme die Parasiten auszutreiben. Er ist, im eigentlichen Sinne, uninteressiert. Kultur und Erkenntnis sagen beide dasselbe: dasjenige, was von Interesse ist, ist in Wahrheit ohne Interesse.»[25]

In seinen Arbeiten Mitte der 60er Jahre untersucht Nauman das Nächstliegende: Seit dieser Zeit tauchen zum Beispiel immer wieder die Bilder von stürzenden Kaffeetassen auf. Eine der frühesten Arbeiten ist die Skulptur *Cup and Saucer Falling Over* von 1965, in Fotografien von *Coffee Thrown Away Because It Was Too Cold* sind sie unter anderem 1967 zu sehen, und in *Coffee Spilled and Balloon Dog,* einer späteren Videoskulptur, führen sie 1993 ein Eigenleben in unablässigem Fallen.[26] Zur Ruhe kommen sie erst auf dem Atelierfußboden, wo sich ihre Bruchstücke zu den Überresten anderer Skulpturen gesellen. Daraus ‹komponiert› der Bildhauer Nauman eine neue Arbeit.

In *Composite Photo of Two Messes on the Studio Floor* (1967, S. 56) verbindet sich die Vorliebe für Zwischenräume mit der Ökonomie der Verwertung dessen, was übrigbleibt, was einmal ein Ganzes war, bevor es zerfiel oder zertrümmert wurde. Die fotografierte Montage erinnert an frühe Satellitenaufnahmen. Eine fast leere, große Bodenfläche teilt die Müllhaufen voneinander. Durch die Strecke des Zwischenraums geraten die zwei Müllhaufen und der Betrachter in eine Dreiecksbeziehung. Er steht selbst wie im leeren Raum zwischen den Haufen.

Zuvor hatte Nauman eine ähnliche Idee in einem anderen Medium verfolgt und den Betrachter dabei in den dreidimensionalen Raum hineingezogen. Für die Skulptur *Platform Made Up of the Space between*

the Floor (1966), he made a cast of the space between two cartons standing on the studio floor.[27] The resulting work, the embodiment of a negative space, offers a physical sense of absence—of the objects one can imagine at both sides of the piece and of the viewer's own presence. There is an absence of meaning as well: The object-like sculpture cannot be identified without the attached title. Rosalind Krauss comments: "What Nauman's casts force us to realize is that the ultimate character of entropy is that it congeal the possibilities of meaning as well. ... Entropy, as a force that sucks out all the intervals between points of space ... , imagines the eradication of those distances that regulate the grid of oppositions, or differences, necessary to the production of meaning."[28]

Deck of Fools

"From the depths of history, Alexander and Diogenes approach us as a pair, figures on one and the same playing card, inseparable twins, like tongue and groove. Which accounts for the fame of the other, which for the other's power?"[29] writes Serres.

At royal courts in the Middle Ages only the fool could joke with the king. The fool was marginalized, yet he simultaneously had a metaphysical authority. He was an "extra" in two senses, as an outsider and as a performer without a major role. His paradoxical power is reflected in the figure of the joker in decks of cards. From their beginnings, playing cards have served as a metaphor for the real world.

Together with his clowns of varied provenance, most of Nauman's performers in films, videos, and photographs act strangely and look equally peculiar. Perhaps comprising an atlas of inanity, all these figures could be regarded as fools. Nau-

man shows them sometimes in colorful disguise, sometimes in black and white (these include the young Nauman doing bizarre activities in his films and videos from 1968–69), in full figure or in close-ups of heads, hands, and mouths.

The juxtaposition of image and reversed or upside-down image—of the clowns in particular—in many of Nauman's video pieces is reminiscent of the design of playing cards. He combines images that are nearly mirrored doubles in works with two video monitors, such as *Double No* (1988, plate 16). In many of his language-related pieces, reversed statements abut one another, and opposing words and values collide and then disengage. Nauman may use such devices in video works—as in *Good Boy, Bad Boy* (1985), in which the monologues of a man and a woman play off one another—or in neons such as *Eat/Death* (1972), in which the word *eat* is embedded within *death*.[30] In these visual and semantic spaces a precisely choreographed network unfolds.

If we were to imagine an artist's ship of fools, it might include Naumanesque clowns, grimacing figures, and Beckett's nightmarish characters—a motley crowd whiling away the time by performing staggering gymnastic exercises. Diogenes rolls his barrel across the deck. Among them we might find those crossover artists who explored the interrelationships between sanity and delusion, clarity and bewilderment. In so doing they left behind works that redefine artistic boundaries.

A particularly notable example would be Antonin Artaud, who

Narren-Kartenspiel

«Aus der Tiefe der Geschichte kommen Alexander und Diogenes paarweise auf uns zu, auf ein und derselben Spielkarte, als untrennbare Zwillinge, wie Hut und Feder. Wer steht für den Ruhm des anderen, wer für dessen Macht?»,[29] schreibt Serres.

An mittelalterlichen Höfen durfte nur der Narr mit dem König spielen. Der ‹fool› war ausgestoßen, zugleich besaß er eine metaphysische Autorität. Ein ‹Extra› war er im doppelten Sinne, als einer, der außerhalb stand, besonders war, und als einer ohne tragende Rolle, als ‹Statist›. Seine paradoxe Macht spiegelt sich in der Figur des Jokers im Kartenspiel wieder. Das Kartenspiel war seit seiner Entstehung Metapher für die Welt.

Wie die Clowns verschiedenster Herkunft führen die Darsteller in Naumans Filmen, Videos und Fotografien seltsame Dinge auf und sehen entsprechend merkwürdig aus. In einem Atlas des Abstrusen und Irren ließen sie sich unter dem Oberbegriff des ‹Narren› zusammenfassen. Mal treten sie bunt verkleidet auf, mal in schwarzweiß (dazu gehört vor allem der junge Nauman selbst mit seinen bizarren Aktivitäten in den Filmen und Videos von 1968-69), mal als Ganzkörperaufnahme und mal als Nahaufnahme von Kopf, Hand und Mund.

Die Gegenüberstellung von Bild und auf dem Kopf stehenden Bild in vielen Videoarbeiten Bruce Naumans – insbesondere bei den Clowns – erinnert ans Bildprinzip der Spielkarte. Er kombiniert Bilder in fast spiegelartiger Doppelung in Arbeiten wie *Double No* (1988, Kat.Nr. 16). In vielen seiner sprachbezogenen Arbeiten grenzen gegenläufige Aussagen aneinander, opponierende Wörter und Werte kollidieren oder gehen auseinander hervor. Nauman verwendet diese formalen Prinzipien in Videoarbeiten – wie *Good Boy, Bad Boy* (1985), wo die Monologe eines Mannes und einer Frau aufeinandertreffen – oder in Neonarbeiten wie *Eat/Death* (1972), wo das Wort ‹eat› (essen) in das Wort ‹death› (Tod) eingebettet ist.[30] In diesen visuellen und semantischen Räumen entfaltet sich ein präzise choreographiertes Netzwerk von Bezügen.

Stellen wir uns das Narrenschiff der Kunst vor: darauf fänden sich naumaneske Clowns und Grimassenschneider, und auch die alptraumartigen Gestalten Becketts. Ein torkelnd-turnender Haufen vertreibt sich die ausgerastete Zeit. Diogenes lässt seine Tonne quer übers Deck rollen. Vertreten sind auch solche, die die Verschlingungen von Hellsicht und Verdunklung, Klarheit und Verwirrung grenzgängerisch verorteten. Dabei hinterließen sie Werke, die selbst Grenzen umdefinierten.

Einer der bemerkenswertesten unter ihnen ist Antonin Artaud, der

Composite Photo of Two Messes on the Studio Floor, 1967

Failing to Levitate in the Studio, 1966

represents an "extreme instance of aesthetic crossover."[31] He is at once perpetrator and victim, equipped with a disdain for everything that eludes the clash of mind and matter. Seen from the coolness of distance, and read against the stream of infectious despair embedded in them, his "nerve scales," a book of prose poems, remain balanced yet quivering.[32]

Artaud's vehement poetic exaltations still echo in contemporary art. Like a diary of the mind, they give glimpses into impossible realizations, those unreachable or yet to come. They derive from the fundamental paradox experienced by Artaud. Gilles Deleuze has commented upon the revealing correspondence between Artaud and Jacques Rivière: "Artaud said that the problem (for him) was not to orientate his thought, or to perfect the expression of what he thought, or to acquire application and method or to perfect his poems, but simply to manage to think something."[33]

Rising and Falling

Like the eye's blind spot, what we think with is a multidimensional black hole that can best be described by what it is not. Thinking is the only activity that requires nothing but itself to proceed. In its impulses and velocities, however, it is tied to the body. If one tries to journey into the rarified realm of the spirit, one may imagine the body as levitating. Yet any attempt at actual levitation generally ends with one's body on the ground.

As a boy, Beckett would climb trees in his family's garden with the express intention to fall out of them. In early performances Nauman let himself fall off the edge of a stage. He also practiced something close to levitation in his studio, trying to lie flat in the air with only his head and feet supported on two chairs. This feigned attempt to be a bridge between the chairs was a physical failure, one that Nauman documented in the photographic double exposure *Failing to Levitate in the Studio* (1966, above). But in other ways it was a success, because the artist metaphorically bridged the abyss between an inner, invisible experience and visible appearances.

A few years later Nauman experimented with the opposite effect, instructing two performers, Tony and Elke, to try through mental activity to sink into the floor or let it close over them. These efforts, which he caught on videotape, failed.[34] Both performers found their bodies strongly resistant to the exercise, and experienced difficulty in breathing. Still there were positive results here as well, because the experiment provided Nauman and his actors an intense experience.[35] Under Nauman's predetermined conditions, the will to depict the impossible fed on the futility of the very goal. If the mental activity had succeeded, however, and if it could be expressed in words, we might compare the activity to a description by Artaud of his thought processes: "When I think of myself, my thought seeks itself in the ether of a new dimension. I am on the moon as others are sitting at their balcony. I am part of the gravitation of the planets in the fissures of my mind."[36]

Make Me Think / Me

Nauman's drawing *Make Me Think Me* (1993, page 58) is a command directed to the artist—as long as the work is simply titled

«Ernstfall moderner ästhetischer Grenzüberschreitung».[31] Er, der Täter und Opfer zugleich war, ist ausgestattet mit einer Verachtung für alles, was sich dem Zusammenprall zwischen Geist und Materie entzieht. Mit der Abkühlung des Abstands und gegen den Strom der ansteckenden Verzweiflung, die darin nistet, gelesen, schwanken seine ‹Nervenwaagen› noch immer leise, aber nachhaltig.[32]

Artauds vehementen poetischen Exaltationen finden bis in die Kunst der Gegenwart ihr Echo. Wie in einem mentalen Tagebuch finden sich darin unmögliche Werkideen; solche, die nicht zu verwirklichen waren oder erst noch zu verwirklichen sind. Diese Unmöglichkeit geht einher mit dem grundlegenden Paradox seiner Erfahrung, das im aufschlussreichen Briefwechsel zwischen Artaud und Jacques Rivière aufscheint. Gilles Deleuze resümiert: «Artaud sagt, dass das Problem (für ihn) weder darin liege, sein Denken zu orientieren, noch darin, den Ausdruck dessen, was er denkt zu vervollkommnen, noch darin, Applikation und Methode zu erwerben … sondern darin, einfach dahin zu gelangen, etwas zu denken.»[33]

Steigen und Fallen

Im Vergleich zum blinden Fleck des Auges ist das, womit und wodurch gedacht wird, ein vieldimensionales schwarzes Loch, das sich am besten durch das beschreiben lässt, was es nicht ist. Denken ist die einzige Tätigkeit, die zu ihrer Ausübung nur ihrer selbst bedarf. Mit seinen Impulsen und Geschwindigkeiten bleibt es jedoch an den Körper gebunden. Unternimmt der Körper die Reise in das Zwischenland des Geistes, so wird er als schwebend imaginiert. Der Versuch zu schweben endet zumeist am Boden.

Beckett kletterte als Junge im heimischen Garten gezielt auf Bäume um sich herunterfallen zu lassen. In frühen Performances ließ Nauman sich von einer Bühnenrampe fallen. Im Atelier unternahm er Levitationsversuche. Der Versuch, Brücke zwischen zwei Stühlen zu sein, war, körperlich gesehen, ein Scheitern. Nauman dokumentierte es als Doppelbelichtung in der Fotoarbeit *Failing to Levitate in The Studio* (1966, oben). Andererseits ist dieses Scheitern aber ein Erfolg: Nauman gelingt es, metaphorisch den Abgrund zwischen einer inneren, unsichtbaren Erfahrung und der sichtbaren Erscheinung zu überbrücken.

Einige Jahre später experimentierte Nauman quasi in umgekehrter Richtung. Er instruierte seine zwei Performer, Tony und Elke, den Versuch zu unternehmen, durch mentale Konzentration im Boden zu versinken oder den Boden über sich zusammenwachsen zu lassen. Auch diese Versuche, die als Videoarbeiten festgehalten sind, scheiterten.[34] Beide Performer erlebten bei den Übungen starke körperliche Widerstände, die sich in beängstigenden Atembeschwerden äußerten. Dennoch ergab sich auch Positives: Das Experiment bescherte Nauman und seinen Akteuren eine intensive Erfahrung.[35] Unter der Laborbedingung der Zweckfreiheit, beziehungsweise innerhalb des selbstgesetzten Ziels, findet der Wille, das Unmögliche darzustellen, in der Ohnmacht seine Nährlösung.

Wäre die mentale Aktivität des Im-Boden-Versinkens erfolgreich gewesen, und hätte sie sich in Worten ausdrücken lassen, sie wäre mit dem vergleichbar, was Artaud über seinen Denkprozess sagt: «Wenn ich mich denke, sucht sich mein Denken im Äther eines neuen Raums. Ich bin auf dem Mond wie andere auf ihrem Balkon. In den Gesteinsspalten meines Geistes nehme ich teil an der planetarischen Gravitation.»[36]

Make Me Think. The statement, however, is extended with the word *me*, which appears to be a taped-on addition to an earlier drawing. With that extra *me*, the command is transformed into a circular statement. Does thinking require an outside stimulus, or can thinking come into being by itself? Does the drawing represent the thinking itself? Nauman's phrase also reflects the urgency that thinking imposes, its imperative either latent or threatening, depending on how one reads it. Nauman took up the demand "Think" again in 1993 in the video sculpture *Think*, whose structure he would reuse in *Work* of 1994. Both consist of an upright image and another upside down.[37]

On the interdependencies between thinking and commands, Deleuze observes, "The imperatives and questions with which we are infused ... do indeed form the ... differentials of thought, at once that which cannot be thought and that which must be thought. ... Imperatives are addressed to the fractured I as though to the unconscious of thought. ... The Ideas which derive from imperatives enter and leave only by that fracture in the I, which means that another always thinks in me, another who must also be thought."[38]

In other works Nauman's commands may easily drift into that gray area between demand, request, and plea, as in the collage *Please Pay Attention Please* (1973).[39] Emotion-laden linguistic traps are the province of the audio heard in the installation *Get Out of My Mind, Get Out of This Room* (1968), which vigorously directs the mind of the viewer, and thus the body, to leave.[40] Commands that mutate into requests, or vice versa, can mean danger. Obedience and a mix of fear and empathy merge so completely that one can no longer be distinguished from another. The perpetrator disguises himself as victim, a wolf in sheep's clothing.

Theater of the Absurd

In Beckett's *Waiting for Godot* (1952) pathetic characters stand about in the no-man's-land of a seemingly endless, temporal loop. They play and joke with each other, hitting and screaming, in a circus act balanced between comedy and tragedy. Following his master Pozzo's command to "Think, pig!" Lucky rattles off a monologue as if his life depended on it. He appears to have sprung a leak, though the drip is controlled. In Lucky's soliloquy, Beckett employed fragments and deliberately garbled references to produce elaborate linguistic nonsense. Pozzo, the master, leaves the thinking to his "horse"—Lucky wears the sadomasochistic restraint of a bridle. And the thinking horse gallops on command, just as previously he had been made to dance. Where does this wild ride of spewed verbiage end? The protagonist lands on the floor. "There's an end to his thinking!" says the master as he stomps on Lucky's hat.[41]

Beckett's *Waiting for Godot* allows us to lean back in our seats and follow the nearly nonsensical slapstick, while we undergo the experience of waiting together with the characters. In Nauman's *Clown Torture* (1987), the space of waiting has turned into a torture chamber of sense and sensibility.[42] The torture is never-ending, and Nauman's mental spaces lie beyond the experience of waiting. The structures they offer us ask for immediate participation.

MAKE ME THINK ME

Make Me Think Me, 1993

Make Me Think / Me

Die Zeichnung *Make Me Think Me* (1993, unten) ist eine an sich selbst gerichtete Aufforderung – solange es nur ‹Make Me Think› heißt. Es scheint, als sei hier eine bestehende Zeichnung um ein Stück, das mit Klebeband angeheftet ist, verlängert worden. Das ist das ‹Me›, womit sich die befehlsartige zu einer zirkulären Aussage wandelt. Braucht das Denken einen äußeren Stimulus oder entsteht es aus sich heraus? Steht das Zeichnen für den Denkprozess? Aus Naumans Satz lässt sich der Zwang, den das Denken auf sich selbst ausübt, heraushören. Es lauert oder droht darin ein Befehl, je nach Lesart. Nochmals aufgenommen wird die Aufforderung des ‹Think› in der gleichnamigen Videoskulptur von 1993, deren Gestus wiederum in der Videoskulptur *Work* (1994) variiert wird. Beide Werke enthalten ein aufrechtes und ein um 180 Grad gekipptes Monitorbild.[37]

Wie eng Denken und Befehlen miteinander verflochten sind, stellt Deleuze heraus: «Die Imperative, die uns durchdringen ... bilden die Differentiale des Denkens, zugleich das, was nicht gedacht werden kann, was aber gedacht werden muss. ... Die Imperative ... wenden sich ans gespaltene Ego wie ans Unbewusste des Denkens. ... Die Ideen, die sich aus den Imperativen ergeben, betreten und verlassen das Ego durch diesen Spalt ... ,was dazu führt, dass stets ein anderer in mir denkt, der selbst gedacht werden muss.»[38]

In anderen Arbeiten Naumans driften Befehle in die Grauzone zwischen Aufforderung, Verlangen und Bitte ab, wie in *Please Pay Attention Please* (1973).[39] In diesen emotionalen Sprechgebieten siedelt auch das *Get Out of My Mind, Get Out of This Room*,[40] das als Androhung eines Rausschmisses den Geist physisch in Bewegung setzt. Befehle, die zu Bitten mutieren, und vice versa, bedeuten Gefahr. Empathie, Furcht und Gehorsam vermischen sich bis zur Ununterscheidbarkeit. Der Täter verkleidet sich als Opfer, der Wolf hat Kreide gefressen.

Absurdes Theater

In Becketts *Warten auf Godot* (1952) stehen armselige Gestalten auf niemandslandartiger Fläche in der Zeitschlaufe, spielen und kaspern miteinander herum, schlagen und schreien sich an – eine Zirkusaufführung, die zwischen Komik und Tragik balanciert. Auf den Befehl seines Meisters Pozzo hin: «Denke, Schwein!» rattert Lucky seinen Monolog herunter, als ginge es um sein Leben. Lucky scheint auszufließen – allerdings in kontrolliertem Dripping. Beckett arrangiert in Luckys Monolog ein Cut-up aus Bruchstücken und gezielt verstümmelten Bezügen: hochpräzisen Sprachmüll. Der Herr überlässt hier wortwörtlich das Denken dem Pferd – dem im Zaumzeug sadomasochistisch eingespannten Lucky. Und das Denkpferd galoppiert wild aber folgsam, wie es zuvor tanzte. Wo endet der fliegende Ritt ausgespuckter Wörter? Der Protagonist landet am Boden. «So, jetzt denkt er nicht mehr», sagt der Herr, als er Luckys Hut zertritt.[41]

In Becketts *Warten auf Godot* können wir uns in die Sitze zurücklehnen, dem Slapstick am Rande des Unsinns folgen, während wir zusammen mit seinen Figuren das Warten erleben. In Naumans *Clown Torture* (1987)[42] hat sich der Raum des Wartens in eine Folterkammer des Sinns und der Sinne verwandelt. Bei dieser Tortur ist kein Ende abzusehen – Naumans mentalen Räume liegen jenseits des Wartens. Denn die Strukturen, die sie anbieten, verlangen unmittelbare Teilnahme. Unseren aufgerissenen Augen und offenen

With eyes and mind wide open, we are empowered and involved, sometimes unwillingly. Sometimes the work makes us angry. The fourth wall, the invisible plane that cuts through the space of traditional theater—which both separates and connects so-called real life from the representational space of the stage—has been transformed into a three-dimensional space, the viewer's domain.

In 1976 Nauman produced a sketch titled *Theater, private theater, absurdly private theater* for an outdoor sculpture.[43] The project, never executed, was intended to be a simple, square-walled enclosure eighteen meters on a side and open to the sky. Each side was to have a low opening through which a visitor would have to crawl to get inside. There one would find nothing but the interiors of the walls and an otherwise empty floor—the viewer would be the sole performer. The identically placed openings were bound to be confusing; after turning around a few times—perhaps with eyes closed—the viewer would no longer be able to tell through which entrance he or she had come.

In *Anthro/Socio (Rinde Spinning)* (1992, below), the video images block every visual exit, denying us a calm moment to orient ourselves. Viewers are deluged and overwhelmed both visually and aurally, as the images of the talking heads rotate and utter contradictory statements. Viewers entering the exhibition space either stand rooted to the spot or flee from the physical attack on their thinking processes: "Help me, hurt me, sociology, feed me, eat me, anthropology," the voices shout. "Feed me, help me, eat me, hurt me. ..."

A dense dilemma of conceptualizations is to be found in these words. Can hurt feed, and does being eaten help? Doesn't help hurt sometimes, if we want to be fed? Do we have to be hurt to be helped? Or be helped instead of fed, or vice versa? What an astonishing but frightening cosmos of anthro-sociology.

Nauman's pieces impel us to an awareness of our human condition and the societal systems that constrict it. Against the backdrop of the works' disorienting qualities, we come to recognize the power structures, processes, and undercurrents we have long internalized and been assimilated into. In our normal lives, we operate seamlessly within the prescriptions of these systems, among them everyday language, roles, habits, and practices. By contrast, in Nauman's art the observer is the central actor, but one without a role prescribed by society's structures. This opens up the possibility for a genuine experience in those spaces in between—the interstitial spaces—through our physical and spiritual presence. What is to be expected when it is the viewer who makes the art?

Becoming the unknown part of the equation, we are forced, and have the opportunity, to sense, feel, and think at the same time. Our role is an active one. It is like swimming upstream against the resistance of the unknown and against our tendency to gravitate toward preconceived, comfortable conceptions. Is the effort rewarded? Perhaps either dumbstruck or awash with clues and loquacious floundering, we might catch "one glimpse of that well-head." How astonishing!

From that jolting sense of wonder the beginning of thinking is inspired, which in its linguistic and philosophical origins is closely entwined with thanking. Thinking itself gratefully, if

Sinnen stehen sie zur Verfügung, und wir werden, manchmal unfreiwillig, hineingezogen. Manchmal lösen die Arbeiten Wut aus. Die unsichtbare vierte Wand, die den Raum des traditionellen Theaters abtrennte, die Grenze, die das sogenannte Reale vom Bühnenraum der Repräsentation abteilte, hat sich in einen Raum aufgelöst, der die Domäne des Betrachters ist.

Theater, private theater, absurdly private theater heißt eine Zeichnung, in der Nauman 1976 eine Skulptur für den Außenraum entwarf.[43] Die deckenlose, quadratische Ummauerung mit jeweils 18 Metern Seitenlänge, die bisher nicht ausgeführt wurde, würde vier niedrige Eingänge haben, durch die der Besucher kriechen müsste um ins Innere zu gelangen. Darin wäre nichts als die leere Fläche, die der, der eingetreten ist, bespielt. Die gleich gesetzten Ein- und Ausgänge lüden zur Verwechslung ein: ein paar Mal, mit geschlossenen Augen, im Kreis gedreht, und es gäbe keinen Anhaltspunkt mehr, durch welchen Eingang man hineingekommen ist.

In *Anthro/Socio (Rinde Spinning)* (1992, unten) blockieren die Videobilder jeglichen visuellen ‹Ausgang› und verwehren uns jeglichen Ruhemoment zur Orientierung. Hören und Sehen werden von den Drehbewegungen der projizierten Köpfe und antagonistischen Ausrufen eingekreist und überwältigt. Wer in den Raum hineinkommt, bleibt wie angewurzelt stehen oder flüchtet weg vom physischen Angriff auf seine Denkprozesse. «Help me, hurt me, sociology, feed me, eat me, anthropology», rufen die Stimmen, «Feed me, help me, eat me, hurt me ... »

Was für ein Dilemma von Wörtern und Begriffen braut sich hier zusammen! Kann Schmerz nähren, und hilft es, gegessen zu werden? Tut Hilfe nicht auch weh, wenn wir eigentlich nur Nahrung wollen? Muss man uns wehtun, um uns zu helfen? Oder sollte lieber geholfen werden anstatt Nahrung zu geben, oder umgekehrt? Was für ein erstaunlicher und erschreckender Kosmos der Anthro-Soziologie.

Naumans Arbeiten zwingen zu wachem Bewusstsein gegenüber der ‹condition humaine› und den Gesellschaftssystemen, die sie einschnüren. Vor dem Hintergrund ihrer desorientierenden Kraft werden Machtstrukturen, Machtprozesse und die Unterströme, an die wir uns längst angeglichen und die wir verinnerlicht haben, deutlich. Dazu gehören auch unsere Alltagssprachen, Rollen, Gewohnheiten und Formen des Umgangs miteinander. All die Systeme, die wir als Einengung empfinden, ergänzen wir, perfiderweise, auch perfekt. In einer Kunst wie der von Nauman ist der Betrachter Hauptakteur, allerdings ohne vorgeschriebene Rolle. Das eröffnet die Möglichkeit einer Erfahrung im ‹Zwischenraum›, wo sich durch physische und geistige Präsenz genuine Erfahrung bildet. Was ist zu erwarten, wenn der Betrachter die Kunst macht?

Als unbekannter Teil der Gleichung ist er gezwungen – und hat die Gelegenheit – zu gleichzeitigem Wahrnehmen, Fühlen und Denken. Die Rolle ist aktiv. Es ist wie beim Schwimmen gegen den Strom: zu überwinden sind die Widerstände gegen das Unbekannte und die Neigung, sich vorgefertigten und bequemen Auffassungen hinzugeben. Wird die Mühe belohnt? Vielleicht erwischen wir – mal mit Sprachlosigkeit geschlagen, mal wortreich herumzappelnd – einen Blick auf jenen ‹Quellpunkt›. Welch ein Erstaunen!

Darin gründet der Anfang des Denkens, das in seinem Ursprung mit dem Danken eng verschlungen war. Das Denken nimmt, mit

belatedly, accepts the fountain, stream, or river into which it is thrown by art; likewise, it thankfully accepts whatever comes out of the pen, brush, or studio of artists like Nauman, Beckett, and their kin. The echoes of thinking/thanking come from a faraway age. They can scarcely be heard in times that seem "out of tune."[44] However, the attentive listener will still be able to discern them in the most precious works of art.

Christine Hoffmann

1 See, for example, *The Artist as a Fountain* (1966–67), in Joan Simon, ed., *Bruce Nauman: Exhibition Catalogue and Catalogue Raisonné* (Minneapolis: Walker Art Center, 1994), catalogue raisonné no. 71, p. 209, and *Myself as a Marble Fountain* (1967), in *Bruce Nauman: Drawings 1965–1986* (Basel: Museum für Gegenwartskunst, 1986), catalogue raisonné no. 49.

2 Samuel Beckett, *Words and Music*, in Beckett, *Collected Shorter Plays* (London: Faber, 1984), pp. 133–34.

3 Dougald McMillan and Martha Fehsenfeld, *Beckett in the Theatre: The Author as Practical Playwright and Director*, vol. 1 (London: John Calder; New York: Riverrun Press, 1988), p. 14.

4 See Beckett's reading of the passage in Beckett, *La Peinture des van Velde, ou le monde et le pantalon* (1945), published in German as *Die Welt und die Hose*, trans. Erika Tophoven-Schöningh (Frankfurt am Main: Suhrkamp, 1990), p. 41.

5 John Pilling, "From a (W)horoscope to *Murphy*," in Pilling and Mary Bryden, eds., *The Ideal Core of the Onion: Reading Beckett Archives* (Reading, U.K.: The Beckett International Foundation, 1992), p. 8.

6 Nauman said about his time in San Francisco: "And a lot of things I was doing didn't make sense so I quit doing them. That left me alone in the studio; this in turn left the fundamental question of what an artist does when left alone in the studio. My conclusion was that I was an artist and I was in the studio, then whatever I was doing in the studio must be art." In Ian Wallace and Russel Kezière, "Bruce Nauman Interviewed," *Vanguard* (Vancouver) 8, no. 1 (Feb. 1979), p. 18.

7 Mark Swartz, "Nauman's Endless Games," *ArtKrush: The Art Magazine Online* (http://www.artkrush.com/thearticles/016_endlessgames/index.asp).

8 Pamela M. Lee, "Pater Nauman," *October* (Cambridge, Mass.), no. 74 (fall 1995), p. 131.

9 Samuel Beckett, *Malone Dies*, in *The Beckett Trilogy* (London: Pan Books, 1979), p. 190.

10 Simon, ed., catalogue raisonné no. D-6 (destroyed), p. 336.

11 Ibid., catalogue raisonné no. D-10 (destroyed), p. 336.

12 *The True Artist Helps the World by Revealing Mystic Truths (Window or Wall Sign)*, 1967. Simon, ed., catalogue raisonné no. 92, p. 216.

13 Criticism on Nauman is full of attempts to interpret the sentence. The ultimate interpretation of the role of the artist overall in contemporary society, following his or her postmodern death, appears to rest largely on just how one reads it. See Beatrice von Bismarck, *Bruce Nauman: Der wahre Künstler/Bruce Nauman: The True Artist* (Ostfildern-Ruit, Germany: Cantz, 1998), p. 14.

14 Beckett, *Watt* (New York: Grove Press, 1959), p. 124.

15 Ibid., p. 125.

16 Joe Raffaele and Elizabeth Baker, "The Way-Out West: Interviews with San Francisco Artists," *ArtNews* (New York) 66, no. 4 (summer 1967), pp. 38–41 and 75–76. Nauman also commented: "The most difficult thing about the whole piece for me was the statement. It was a kind of test—like when you say something out loud to see if you believe it. Once written down, I could see that the statement, 'The true artist helps the world by revealing mystic truths,' was on the one hand a totally silly idea and yet, on the other hand, I believed it. It's true and it's not true at the same time. It depends on how you interpret it and how seriously you take yourself. For me it's still a very strong thought." Quoted in Brenda Richardson, *Bruce Nauman: Neons*, exh. cat. (Baltimore: The Baltimore Museum of Art, 1982), p. 20.

17 Maurice Blanchot, *Die Literatur und das Recht auf den Tod* (Berlin: Merve Verlag, 1982), p. 21.

18 See Robert Storr, "Beyond Words," in Simon, ed., p. 59.

19 Hugh Kenner, *A Reader's Guide to Samuel Beckett* (Syracuse: Syracuse University Press, 1996), p. 77.

20 Ibid., p. 186.

21 Ibid.

22 Ibid., pp. 185ff. For his aesthetic program, see Beckett, *Das Gleiche nochmal anders: Texte zur bildenden Kunst* (Frankfurt am Main: Suhrkamp, 2000), pp. 50ff.

23 Israel Shenker and Beckett, "Moody Man of Letters," *New York Times*, May 6, 1956.

24 References to Diogenes are from Michel Serres, *Ablösung: Eine Lehrfabel* (Munich: Klaus Boer Verlag, 1988), pp. 87–94. When Beckett received an honorary degree from his university in 1959, he was eulogized—in Latin—as "a modern Diogenes." According to James Knowlson, *Damned to Fame: The Life of Samuel Beckett* (New York: Simon & Schuster, 1996), p. 420, he was amused.

25 Serres, p. 94.

Verspätung, dankbar Fluss, Strahl und Springbrunnen, in die es durch die Kunst geworfen wird, an, gleichfalls was aus Feder, Pinsel oder Atelier von Künstlern wie Nauman, Beckett und ihresgleichen kommt. Die Echos von Denken/Danken kommen aus alter Zeit. Kaum sind sie noch zu hören in Zeiten, die so «falsch gestimmt» zu sein scheinen.[44] Der Aufmerksame wird sie in den kostbaren Werken der Kunst wiederfinden.

Christine Hoffmann

1 Siehe auch «The Artist as a Fountain», in: Joan Simon, Hrsg., *Bruce Nauman: Exhibition Catalogue and Catalogue Raisonné*, Minneapolis 1994, Catalogue Raisonné Nr. 71, S. 209 und *Myself as a Marble Fountain* (1967), in: *Bruce Nauman: Zeichnungen 1965 – 1986*, Museum für Gegenwartskunst, Hrsg., Basel, 1986, Katalog-Nr. 49.

2 Samuel Beckett, «Worte und Musik», in: *Beckett, Werke, I,2*, Frankfurt a.M. 1976, S. 317.

3 Dougald McMillan und Martha Fehsenfeld, *Beckett in the Theatre: The Author As Practical Playwright and Director*, Vol.1, London 1988, S. 14.

4 Becketts Lesart der Stelle siehe in: Samuel Beckett, *Die Welt und die Hose*, übers. von Erika Tophoven-Schöningh, Frankfurt a.M. 1990, S. 41.

5 John Pilling, «From a (W)horoscope to Murphy», in: Pilling und Mary Bryden, Hrsg., *The Ideal Core of the Onion*, Reading 1992, S. 8.

6 Nauman über seine Zeit in San Francisco: «Und vieles, was ich tat, machte keinen Sinn, also hörte ich damit auf. Im Atelier war ich auf mich selbst gestellt. Das warf dann die grundlegende Frage auf, was ein Künstler tut, wenn er im Atelier ganz auf sich selbst gestellt ist. Ich folgerte also, dass ich ein Künstler im Atelier war und dass demnach alles, was ich dort tat, Kunst sein müsste.», in: Christine Hoffmann, Hrsg., *Bruce Nauman, Interviews 1967 – 1988*, Amsterdam 1996, S. 113.

7 Mark Swartz, «Nauman's Endless Games», *Art Krush: The Art Magazine Online* (www.artkrush.com/thearticles/016-endlessgames/index.asp).

8 Pamela M. Lee, Pater Nauman, *October*, Nr. 74, Herbst 1995, Cambridge/Mass., S. 131.

9 Samuel Beckett, «Malone Dies», in: *The Beckett Trilogy*, London 1979, S. 190. Der Satz lehnt sich stärker an den englischen Text an als die deutsche Übersetzung, Beckett, «Malone stirbt», in: *Werke III,2*, Frankfurt a.M. 1976, S. 284.

10 Simon, Hrsg., a.a.O. Catalogue Raisonné Nr. D-6, S. 336.

11 Ebenda, Catalogue Raisonné Nr. D-10, S. 336.

12 *The True Artist Helps the World Revealing Mystic Truths (Window or Wall Sign)*, 1967, Ebenda, Catalogue Raisonné Nr. 92, S. 216.

13 Die Nauman-Kritik versucht diesen Satz immer wieder zu deuten. Die ultimative Interpretation der Rolle des Künstlers in der gegenwärtigen Gesellschaft, nach seinem oder ihrem postmodernen Tod, scheint sich aus der Lesart dieses Statements zu ergeben. Siehe auch: Beatrice von Bismarck, Bruce Nauman: *Der wahre Künstler/ Bruce Nauman: The True Artist*, Ostfildern-Ruit, 1998.

14 Samuel Beckett, «Watt», in: *Werke II,2*, Frankfurt a.M. 1976, S. 334.

15 Samuel Beckett, «Watt», Ebenda, S. 335.

16 Nauman antwortet in einem seiner ersten Interviews 1967 (mit Joe Raffaele) auf die Frage, ob er an diesen Satz glaubt: «Ich weiß nicht, ich denke wir sollten das offen lassen.» In : *Bruce Nauman Interviews, 1967 – 1988*, a.a.O., S.11. Später heißt es: «Das schwierigste an der ganzen Arbeit war für mich die Aussage. Es war gewissermaßen wie ein Test: wie man etwas laut ausspricht, um zu sehen, ob man's auch glaubt. Einmal niedergeschrieben, wurde mir klar, dass der Satz...einerseits einen völlig blödsinnigen Gedanken darstellt, und dennoch, andererseits glaubte ich daran. Er ist gleichzeitig wahr und unwahr. Es kommt darauf an, wie ernst man sich selbst nimmt. Für mich ist es ein überaus zwingender Gedanke.», Nauman zitiert bei Brenda Richardson. *Bruce Nauman: Neons*, Katalog Baltimore 1982, S. 20.

17 Maurice Blanchot, *Die Literatur und das Recht auf den Tod*, Berlin 1982, S. 21.

18 Robert Storr, *Beyond Words*, in: Simon, Hrsg., a.a.O. S. 59.

19 Hugh Kenner, *A Reader's Guide to Samuel Beckett*, Syracuse 1996, S. 77.

20 Ebenda, S. 186.

21 Ebenda, S. 186.

22 Ebenda, S. 186. Becketts ästhetisches Programm siehe auch: *Das Gleiche nochmal anders*, M. Glasmeier und G. Hartel, Hrsg., Frankfurt a.M. 2000, S. 50 ff.

23 Becketts Äußerungen dazu in: «Moody Man of Letters», *New York Times*, Sonntag, 6. Mai 1956.

24 Die Diogenes-Bezüge sind aus: Michel Serres, *Ablösung*, München 1988, S. 87-94. Als Beckett 1959 von seiner Universität die Ehrendoktorwürde erhielt, wurde er in der lateinischen Ansprache als ‹moderner Diogenes› gewürdigt. Wie James Knowlson schreibt, hat er sich darüber amüsiert. In: James Knowlson, *Damned to Fame: The Life of Samuel Beckett*, New York 1996, S. 420.

25 Serres, a.a.O., S. 94.

26 Siehe Simon, a.a.O., Catalogue Raisonné Nr. 1, S. 191 ; 74, S. 210 ; und 480, S. 332. Zu den Fotografien zählen Catalogue Raisonné Nr. 90, S. 175, 362-64, und 372. Andere Kaffee(Tassen)-bezogene Arbeiten sind die Zeichnung Nr. 42, Werkverzeichnis der Zeichnungen in: *Bruce Nauman, Drawings/Zeichnungen 1965 – 1986*, Museum

26 See, respectively, catalogue raisonné nos. 1, p. 191; 74, p. 210; and 480, p. 332, in Simon, ed. Photographs include catalogue raisonné nos. 90, p. 215; 175, pp. 242–44; 362–64, pp. 302–03; and 372, p. 305, in Simon, ed. Other coffee cup–themed works include catalogue no. 42 in *Bruce Nauman, Drawings/Zeichnungen 1965–1986*; and p. 130, in Christopher Cordes and Debbie Taylor, eds., *Bruce Nauman, Prints 1970–89: A Catalogue Raisonné* (New York: Castelli Graphics and Lorence-Monk Gallery; Chicago: Donald Young Gallery, 1989).

27 Simon, ed., catalogue raisonné no. 50, p. 204.

28 Rosalind Krauss, "X Marks the Spot," in Yve-Alain Bois and Krauss, *Formless: A User's Guide* (New York: Zone Books, 2000), p. 216.

29 Serres, p. 112.

30 Simon, ed., catalogue raisonné nos. 337, p. 295; and 211, p. 255, respectively.

31 Peter Gorsen, "Es spricht der gemarterte Körper," *Frankfurter Allgemeine Zeitung*, Oct. 18, 2002.

32 Originally published in French as *Le Pèse-nerfs* (1925). Portions have been translated into English as *The Nerve Meter* in Antonin Artaud, *Antonin Artaud: Selected Writings*, ed. Susan Sontag, trans. Helen Weaver (New York: Farrar, Straus and Giroux, 1976), pp. 79–85.

33 Gilles Deleuze, *Differenz und Wiederholung* (Munich: Fink, 1997), p. 191. The English quote is from Deleuze, *Difference and Repetition*, trans. Paul Patton (New York: Columbia University Press, 1994), p. 147.

34 *Elke Allowing the Floor to Rise Up over Her, Face Up*, 1973; *Tony Sinking into the Floor, Face Up and Face Down*, 1973. See Simon, ed., catalogue raisonné nos. 225, p. 259; and 228, p. 261.

35 Nauman speaks enthusiastically about this work in Ian Butterfield, "The Center of Yourself," *Arts Magazine* (New York) 49, no. 6 (Feb. 1975), pp. 53–55.

36 Antonin Artaud, *Die Nervenwaage*, trans. Gerd Henniger (Berlin: Henssel, 1961), p. 56. The English quote is from Artaud, *Anthology: Antonin Artaud*, ed. Jack Hirschman (San Francisco: City Lights Books, 1965), p. 47.

37 *Think*, The Museum of Modern Art, New York; *Work*, Froehlich Collection, Stuttgart.

38 Deleuze, *Differenz und Wiederholung*, p. 253. The English quote is from Deleuze, *Difference and Repetition*, pp. 199–200.

39 See also catalogue no. 16, the lithograph *Pay Attention* (1973), in *Bruce Nauman, Prints 1970–89*. (Its text reads "Pay Attention Motherfuckers.")

40 Simon, ed., catalogue raisonné no. 113, p. 223.

41 Beckett, *Warten auf Godot*, in Beckett, *Werke*, ed. Elmar Tophoven, vol. I, 1 (Frankfurt am Main: Suhrkamp, 1976), pp. 46ff. The English quote is from Beckett, *Waiting for Godot: A Tragicomedy in Two Acts* (New York: Grove Press, 1954), p. 30.

42 Simon, ed., catalogue raisonné no. 365, p. 303.

43 *Bruce Nauman, Drawings/Zeichnungen 1965–1986*, catalogue no. 354.

44 Etymologically, the word *absurd* means out of tune. Cicero called a powerless voice a *vox absurda*. The notion of the absurd was popularized through Jean-Paul Sartre's existentialist philosophy, here defined as a revolt of the individual against a meaningless world. In the existentialist fashion, Beckett's work has often been characterized as Theater of the Absurd. However, for him the absurd represents an acute, highly precise relationship to the inscrutable.

für Gegenwartskunst, Hrsg., Basel 1986, und das Poster *Caffeine Dreams*, S. 130 im Werkverzeichnis der Drucke und Multiples, in: Christopher Cordes und Debbie Taylor, Hrsg., *Bruce Nauman, Prints 1970-89: A Catalogue Raisonné*, New York 1989.

27 Simon, Hrsg, a.a.O., Catalogue Raisonné Nr. 50, S. 204.

28 Rosalind Krauss, «X Marks the Spot», in: Yve-Alain Bois und Krauss, *Formless: A User's Guide*, New York 2000 S. 216.

29 Serres, a.a.O., S. 112.

30 Simon, Hrsg., a.a.O., Catalogue Raisonné Nr. 337, S. 295 und Nr. 211, S. 255.

31 Peter Gorsen, «Es spricht der gemarterte Körper», *Frankfurter Allgemeine Zeitung*, 18. Okt. 2002.

32 Antonin Artaud, *Die Nervenwaage*, übers. von Gerd Henniger, Berlin 1961.

33 Gilles Deleuze, *Differenz und Wiederholung*, München 1997, S. 191.

34 *Elke Allowing the Floor to Rise Up over Her, Face Up*, 1973; *Tony Sinking into the Floor, Face Up and Down*, 1973, in: Simon, Hrsg., Catalogue Raisonné Nr. 225 und 228.

35 Nauman spricht mit (bei ihm ungewöhnlichem) Enthusiasmus über diese Arbeit. In: Ian Butterfield, «The Center of Yourself», *Arts Magazine* (New York) 49, Nr. 6, Februar 1975, übers. in: *Bruce Nauman, Interviews 1967 - 1988*, a.a.O., S. 92-95.

36 Antonin Artaud, a.a.O., S. 56.

37 *Think*, 1993, Museum of Modern Art, New York, Schenkung von Elaine und Werner Dannheisser und *Work*, 1994, Sammlung Froehlich, Stuttgart.

38 Gilles Deleuze, a.a.O., S. 253.

39 Siehe auch *Pay Attention*, Lithografie, 1973 (mit dem Text: Pay Attention Motherfuckers) und *Please Pay Attention Please* 1973, Collage auf Papier, Nr. 16, in: Cordes und Taylor, Hrsg., S. 118.

40 Siehe Simon, Hrsg., a.a.O., Catalogue Raisonné Nr. 113, S. 223, *Get Out of My Mind, Get Out of this Room*, 1968 Audiotape, in einem Raum abgespielt, 6-Minuten-Segment, Loop.

41 Samuel Beckett, «Warten auf Godot», in: *Werke, Bd.I,1* Frankfurt a.M. 1976, S. 46 ff.

42 Simon, Hrsg., a.a.O., Catalogue Raisonné Nr. 365, S. 303.

43 *Bruce Nauman*, Museum für Gegenwartskunst, Hrsg., Basel 1986, Katalog-Nr. 354

44 Gegen das Gehör verstoßen ist Wortbedeutung des lateinischen ‹absurdus›. Cicero bezeichnet eine kraftlose Stimme als eine ‹vox absurda›. Sartres Existenzialismus machte das Absurde populär als Revolte des Individuums gegen eine sinnlose Welt. Becketts Theaterstücke wurden fälschlicherweise dem existenzialistisch geprägten ‹Absurden Theater› zugerechnet. Das wesentliche Erbe des Absurden in Becketts Texten ist eine intensive und hochpräzise Beziehung zum Unbegreiflichen.

Biography

Biografie

Bruce Nauman was born on December 6, 1941, in Fort Wayne, Indiana. He graduated in 1964 with a B.S. from the University of Wisconsin, Madison, where he studied math, physics, and art, while independently studying music and philosophy, in particular, the writings of Ludwig Wittgenstein. In 1966 Nauman earned a master's degree in art from the University of California at Davis, where he studied under William T. Wiley and Robert Arneson. Originally trained as a painter, Nauman abandoned the more traditional medium and began making process-oriented sculpture and performance-based work, including photographs, films, and videos, which featured the artist himself. That same year Nauman began reading the work of author and playwright Samuel Beckett and had his first solo exhibition at the Nicholas Wilder Gallery, Los Angeles, and was included in the influential group exhibition *Eccentric Abstraction* at the Fischbach Gallery, New York. In 1968, Nauman met dancer-choreographer Meredith Monk and composer Steve Reich, and he became aware of the work of John Cage, Merce Cunningham, and Karlheinz Stockhausen—all of whom influenced his experiments in time-based, performative work. Nauman had his first solo exhibition that year in New York at the Leo Castelli Gallery and in Europe at the Konrad Fischer Gallery in Düsseldorf, and his work was included in *Documenta 4* in Kassel. His work would also be included in *Documenta 5* (1972), *6* (1977), *7* (1982), and *9* (1992). In 1969 Nauman exhibited a corridor piece for the first time in *Anti-Illusion: Procedures/Materials* at the Whitney Museum of American Art, New York, where he staged a performance work for a live audience. The following year, at the invitation of Jasper Johns, Nauman designed the stage set for the Merce Cunningham Dance Company's performance *Tread.* The artist had his first one-person museum exhibition in 1972 with *Bruce Nauman: Work from 1965 to 1972*, a touring show co-organized by the Los Angeles County Museum of Art and the Whitney Museum of American Art, New York. Throughout the 1970s Nauman focused on his corridor and spatial works, including his models for tunnels, influenced by his earlier readings of Gestalt theory as well as Elias Canetti's *Crowds and Power* (1962). He continued to make work based on language and word play. In 1977 the artist was represented in the Whitney *Biennial* (which also featured his work in 1985, 1987, 1991, 1997) and in 1978, was included in the *Venice Biennale* (and again in 1980 and 1999). In 1979 the artist moved from Pasadena, California, to Pecos, New Mexico, where he developed an interest in horseback riding. In the 1980s the artist began working more heavily in neon, a medium he had used as early as 1966. In the mid-1980s, the artist introduced clowns into his aesthetic vocabulary, an extension of the artist's own role as performer and his use of professional actors, which he initiated in 1973. He also began working again with video. Around this time the artist started including animal imagery in his sculpture and video work. In 1988 Nauman collaborated on a dance piece with choreographer Margaret Jenkins and composer Terry Allen, which featured film of Nauman on his horse. This marked the reappearance of the artist as a subject in his work. Nauman moved his home and studio to Galisteo, New Mexico, in 1989. His first work

Bruce Nauman wurde am 6. Dezember 1941 in Fort Wayne, Indiana, USA, geboren und schloss 1964 sein Studium an der University of Wisconsin, Madison, mit einem Bachelor of Science ab. Er hatte Mathematik, Physik und Kunst studiert, sowie privat auch Musik und Philosophie, insbesondere die Schriften von Ludwig Wittgenstein. 1966 erhielt er einen Master of Arts von der University of California, Davis. Zu seinen Professoren zählten William T. Wiley und Robert Arneson. Obwohl zum Maler ausgebildet, wendete er sich weniger traditionellen Ausdrucksformen zu (u.a. prozessorientierte Skulptur und eigene Performances für Foto, Film und Video). Im Jahr 1966 beginnt die Beschäftigung mit dem Werk von Samuel Beckett. Zwar lebte Nauman in San Francisco, doch hatte er seine erste Einzelausstellung in der Nicholas Wilder Gallery, Los Angeles, und nahm an der wichtigen Gruppenausstellung *Eccentric Abstraction* in der New Yorker Fischbach Gallery teil. 1968 traf er die Tänzerin/Choreografin Meredith Monk und den Komponisten Steve Reich. John Cage, Merce Cunningham und Karlheinz Stockhausen beeinflussten seine Experimente mit performativer Medienkunst. Ins selbe Jahr fällt die erste New Yorker Einzelausstellung in der Leo Castelli Galerie und die erste Einzelausstellung in Europa in der Galerie Konrad Fischer, Düsseldorf, sowie die Beteiligung an der *documenta 4* in Kassel. Nauman war später auch in der *documenta 5* (1972), *6* (1977), *7* (1982) und *9* (1992) vertreten. Im Rahmen der Schau *Anti-Illusion: Procedures/Materials* (1969) im Whitney Museum, New York, präsentierte Nauman seine erste Korridorinstallation und eine Live-Performance. Im folgenden Jahr entwarf er auf Einladung von Jasper Johns das Bühnenbild für das Tanzprogramm *Tread* der Merce Cunningham Dance Company. 1972 organisierten das Los Angeles County Museum of Art und das Whitney Museum of American Art, New York, die Wanderausstellung *Bruce Nauman: Work from 1965 to 1972*, die erste Einzelschau des Künstlers in einem Museum. Werkschwerpunkt der 70er Jahre sind die räumlichen Werke, dazu gehören die Korridorinstallationen und die Modelle für Gänge, die von der Gestalttheorie und von Elias Canettis *Masse und Macht* (1962) inspiriert waren. Weiterhin beschäftigte er sich auch mit Sprache und Wortspiel. Nauman war im Jahr 1977 (später auch 1985, 1987, 1991 und 1997) auf der Whitney *Biennial* bzw. im Jahr 1978 (später auch 1980 und 1999) auf der *Biennale von Venedig* vertreten. 1979 zog er von Pasadena, Kalifornien, nach Pecos, New Mexico, wo er sich für die Pferdedressur zu interessieren begann. In den 80er Jahren entstanden zahlreiche Neonarbeiten, für die es bereits 1966 frühe Werkbeispiele gibt. Mitte des Jahrzehnts erschien die Clownfigur in seinem ästhetischen Vokabular, eine Weiterentwicklung von Naumans aktiver Rolle als Performer und der Verwendung professioneller Schauspieler ab 1973. Er wandte sich zu dieser Zeit wieder dem Medium Video zu und baute Tiermotive in seine Skulpturen und Videos ein. Ein Film für ein Gemeinschaftsprojekt mit der Choreografin Margaret Jenkins und dem Komponisten Terry Allen (1988) zeigt Nauman auf einem seiner Pferde. Der Künstler stellte sich damit wieder selbst in den Vordergrund seiner Praxis. 1989 verlegte er seinen Wohn- und Arbeitsplatz nach Galisteo, New Mexico. Das erste Produkt der neuen Umgebung, *Raw Material – BRRR* (1990), gab den Auftakt zu einer Serie von Videoinstallationen mit Nauman als Darsteller, die an die frühen Atelierfilme

in the new studio was *Raw Material—BRRR* (1990), the first of a series of video installations that featured the artist and which seem closely related to the earliest studio films. Nauman has continued to create large-scale, room-size video installations, including the recent series entitled *Mapping the Studio* begun in 2001. In 1994 the artist was the subject of a major retrospective, organized by the Walker Art Center in Minneapolis, with the Hirshhorn Museum and Sculpture Garden, Smithsonian Institution, Washington, D.C., which traveled to the Museo Nacional Centro de Arte Reina Sofía, Madrid, the Museum of Contemporary Art, Los Angeles, and the Museum of Modern Art, New York. Nauman continues to exhibit internationally. Among the numerous awards the artist has received are the Max Beckmann Prize in 1990 from Frankfurt, the Wolf Prize in Arts (Sculpture) in 1993 from Herzlia, Israel, the Wexner Prize from Ohio State University, Columbus, in 1994, and the 1995 Aldrich Prize from the Aldrich Contemporary Art Museum in Ridgefield, Connecticut. In 1999 Nauman was awarded the prestigious Leone d'or (Golden Lion) at the *48th Venice Biennale*. In 2000 he became a member of the American Academy of Arts and Letters, New York, and was awarded an Honorary Doctorate of Arts from the California Institute of the Arts, Valencia. The artist continues to live and work in Galisteo, New Mexico.

anknüpft. Auch die Großraum-Videoinstallationen wurden fortgesetzt, u.a. mit der im Jahre 2001 beginnenden Serie *Mapping the Studio*. 1994 organisierte das Walker Art Center in Minneapolis gemeinsam mit dem Hirshhorn Museum and Sculpture Garden, Smithsonian Institution, Washington, D.C., eine große Retrospektive, die auch im Museo Nacional Centro de Arte Reina Sofía, Madrid, im Museum of Contemporary Art, Los Angeles, und im Museum of Modern Art, New York, zu sehen war. Naumans Werke werden in Ausstellungen in aller Welt gezeigt. Aus der langen Liste der Auszeichnungen seien hier nur der Max-Beckmann-Preis der Stadt Frankfurt (1990), der Kunstpreis (Skulptur) der Wolf Foundation (1993), Herzliyya, Israel, der Wexner Prize (1994) der Ohio State University, Columbus, und der Aldrich Prize (1995) des Aldrich Contemporary Art Museum, Ridgefield, Connecticut, genannt. Auf der *48. Biennale von Venedig* (1999) erhielt Nauman den begehrten «Goldenen Löwen». Seit 2000 ist er Mitglied der American Academy of Arts and Letters, New York, und Ehrendoktor des California Institute of the Arts, Valencia, Kalifornien. Bruce Nauman lebt und arbeitet in Galisteo, New Mexico.

Selected Bibliography

Bibliografie (Auswahl)

Artist's Writings

- "Bruce Nauman: Notes & Projects." *Artforum* 9, no. 4 (December 1970), p. 44.
- "Instructions for a Mental Exercise." *Interfunktionen* (West Germany), no. 11 (1974), pp. 122–24.
- *Flayed Earth/Flayed Self (Skin/Sink).* Los Angeles: Nicholas Wilder Gallery, 1974. Exh. brochure.
- *Bruce Nauman: Cones/Cojones.* New York: Leo Castelli Gallery, 1975. Exh. brochure.
- "False Silences." *Vision*, no. 1 (Sept. 1975), pp. 44–45.
- *The Consummate Mask of Rock.* Albright-Knox Art Gallery, Buffalo, N.Y., 1975. Exh. brochure.
- "Violent Incident, 1986." *Parkett* 10 (Sept. 1986), pp. 50–53.

Interviews

- Butterfield, Jan. "Bruce Nauman: The Center of Yourself." *Arts Magazine* 49, no. 6, (Feb. 1975), pp. 53–55.
- De Angelus, Michele D. "Bruce Nauman Interviews, May 27–May 30, 1980." Archives of American Art, Smithsonian Institution, Washington, D.C., transcript, 106 pages.
- Dercon, Chris. "Keep Taking It Apart: A Conversation with Bruce Nauman." *Parkett*, no. 10 (Sept. 1986), pp. 54–69.
- Raffaele, Joe, and Elizabeth Baker. "The Way-Out West: Interviews with 4 San Francisco Artists." *ARTnews* 66, no. 4 (Summer 1967), pp. 38–41, 75–76.
- Sharp, Willoughby. "Nauman Interview," *Arts Magazine* 44, no. 5 (Mar. 1970), pp. 22–27.
- Sharp, Willoughby. "Bruce Nauman." *Avalanche*, no. 2 (Winter 1971), pp. 22–31.
- Simon, Joan. "Breaking the Silence: An Interview with Bruce Nauman." *Art in America* 76, no. 9 (Sept. 1988), pp. 140–49, 203.
- Smith, Bob. "Interview with Bruce Nauman." Journal published by the Los Angeles Institute of Contemporary Arts, no. 32 (Spring 1982), pp. 35–36.
- Wallace, Ian, and Russell Keziere. "Bruce Nauman Interviewed." *Vanguard* (Canada) 8, no. 1 (Feb. 1979), pp. 15–18.

Monographs and Solo Exhibition Catalogues

- *Bruce Nauman.* Exh. cat., Leo Castelli Gallery, New York, 1968. Text by David Whitney.
- *Bruce Nauman: Work from 1965 to 1972.* Exh. cat., Los Angeles County Museum of Art, 1972. Texts by Jane Livingston and Marcia Tucker.
- *Bruce Nauman, 1972–1981.* Exh. cat., Rijksmuseum Kröller-Müller, Otterlo, The Netherlands, 1981. Texts by Siegmar Holsten, Ellen Joosten, Rudolf Oxenaar, and Katharina Schmidt. In English, Dutch, and German.
- *Bruce Nauman: Neons.* Exh. cat. and catalogue raisonné, Baltimore Museum of Art, Maryland, 1982. Text by Brenda Richardson.
- *Bruce Nauman: Stadium Piece, Musical Chairs, Dream Passage.* Exh. cat., Museum Haus Esters, Krefeld, West Germany, 1983. Text by Julian Heynen. In German.
- *Bruce Nauman: Drawings 1965–1986.* Exh. cat. and catalogue raisonné. Museum für Gegenwartskunst, Basel, Switzerland, 1986. Texts by Coosje van Bruggen, Dieter Koepplin, and Franz Meyer.
- *Bruce Nauman.* Exh. cat., Whitechapel Art Gallery, London, 1986. Texts by Jean-Christophe Ammann, Nicholas Serota, and Joan Simon.
- *Bruce Nauman: Prints, 1970–89: A Catalogue Raisonné.* Castelli Graphics and Lorence-Monk Gallery, New York; Donald Young Gallery, Chicago, 1989. Edited by Christopher Cordes with the assistance of Debbie Taylor. Texts by Christopher Cordes and John Yau.
- *Bruce Nauman: Skulpturen und Installationen, 1985–1990.* Exh. cat., Museum für Gegenwartskunst, Basel, Switzerland, 1990. Texts by Jörg Zutter and Franz Meyer. Published in association with DuMont Buchverlage, Cologne.
- *Bruce Nauman.* Exh. cat. and catalogue raisonné, Museo Nacional Centro de Arte Reina Sofia, Madrid; Walker Art Center, Minneapolis; Museum of Contemporary Art, Los Angeles; Hirshhorn Museum and Sculpture Garden, Smithsonian Institution, Washington, D.C.; Museum of Modern Art, New York, 1994. Essays by Neal Benezra, Kathy Halbreich, Paul Schimmel, Joan Simon, and Robert Storr.
- *Bruce Nauman: Elliott's Stones.* Exh. cat., Museum of Contemporary Art, Chicago, 1995. Text by Lucinda Barnes.
- Hoffmann, Christine, ed. *Bruce Nauman: Interviews, 1967–1988.* Amsterdam: Verlag der Kunst, 1996. In German.
- *Bruce Nauman: Image/Text, 1966–1996.* Exh. cat., Mnam-Cci, Centre Georges Pompidou, Paris, 1997; Kunstmuseum Wolfsburg, 1997; Hayward Gallery, London, 1998; Nykytaiteen museo/The Museum of Contemporary Art Kiasma, Helsinki, 1998. Texts by Jean-Charles Masséra, Vincent Labaume, François Albera, Gijs van Tuyl, Christine van Assche. Essays: Marcia Tucker, Willoughby Sharp, Chris Dercon, Joan Simon, Tony Oursler and Michele De Angelus.
- *Bruce Nauman: 1985–1996. Drawings, Prints, and Related Works.* Exh. cat., The Aldrich Museum of Contemporary Art, Ridgefield, Connecticut, 1997. Texts by Jill Snyder and Ingrid Schaffner.
- *Bruce Nauman: World Peace (Projected).* Exh. cat., Staatsgalerie moderner Kunst, Munich, 1997. Texts by Carla Schulz-Hoffmann and Peter Prange. In German.
- Bismarck, Beatrice von. *Bruce Nauman: Der Wahre Künstler/The True Artist.* New York: D.A.P./Distributed Art Publishers, 1998. In English and German.

Schriften des Künstlers

- «Bruce Nauman: Notes & Projects.» *Artforum* 9, Nr. 4 (Dezember 1970), S. 44.
- «Instructions for a Mental Exercise.» *Interfunktionen* (BRD), Nr. 11 (1974), S. 122–24.
- *Flayed Earth/Flayed Self (Skin/Sink).* (Ausst.Kat.) Nicholas Wilder Gallery, Los Angeles, 1974.
- *Bruce Nauman: Cones/Cojones.* (Ausst.Kat.) Leo Castelli Gallery, New York, 1975.
- «False Silences.» *Vision*, Nr. 1 (September 1975), S. 44–45.
- *The Consummate Mask of Rock.* (Ausst.Kat.) Albright-Knox Art Gallery, Buffalo, New York, 1975.
- «Violent Incident, 1986.» *Parkett*, Nr. 10 (September 1986), S. 50–53.

Interviews

- Butterfield, Jan: «Bruce Nauman: The Center of Yourself.» *Arts Magazine* 49, Nr. 6, (Februar 1975), S. 53–55.
- De Angelus, Michele D.: «Bruce Nauman Interviews, 1980 May 27 – May 30.» Washington, D.C.: Archives of American Art, Smithsonian Institution. Mitschrift, S. 106.
- Dercon, Chris: «Keep Taking it Apart: A Conversation with Bruce Nauman.» *Parkett*, Nr. 10 (September 1986), S. 54–69.
- Raffaele, Joe und Elizabeth Baker: «The Way-Out West: Interviews with 4 San Francisco Artists.» *ARTnews* 66, Nr. 4 (Sommer 1967). S. 38–41, 75–76.
- Sharp, Willoughby: «Nauman Interview.» *Arts Magazine* 44, Nr. 5 (März 1970), S. 22–27.
- Sharp, Willoughby: «Bruce Nauman.» *Avalanche*, Nr. 2 (Winter 1971), S. 22–31.
- Simon, Joan: «Breaking the Silence: An Interview with Bruce Nauman.» *Art in America* 76, Nr. 9 (September 1988), S. 140–49, 203.
- Smith, Bob: «Interview with Bruce Nauman.» Journal des Los Angeles Institute of Contemporary Arts, Nr. 32 (Frühling 1982), S. 35–36.
- Wallace, Ian und Russell Keziere: «Bruce Nauman Interviewed.» *Vanguard* (Kanada) 8, Nr. 1 (Februar 1979), S. 15–18.

Monografien und Kataloge von Einzelausstellungen

- *Bruce Nauman.* (Ausst.Kat.) Leo Castelli Gallery, New York, 1968. Text von David Whitney.
- *Bruce Nauman: Work from 1965 to 1972.* (Ausst.Kat.) Los Angeles County Museum of Art, 1972. Texte von Jane Livingston und Marcia Tucker.
- *Bruce Nauman, 1972–1981.* (Ausst.Kat.) Rijksmuseum Kröller-Müller, Otterlo, Niederlande, 1981. Texte von Siegmar Holsten, Ellen Joosten, Rudolf Oxenaar und Katharina Schmidt. (In engl., holl. und dt. Sprache)
- *Bruce Nauman: Neons.* (Ausst.Kat. und Werkverzeichnis) Baltimore Museum of Art, Maryland, 1982. Text von Brenda Richardson.
- *Bruce Nauman: Stadium Piece, Musical Chairs, Dream Passage.* (Ausst.Kat.) Museum Haus Esters, Krefeld, 1983. Text von Julian Heynen. (In dt. Sprache)
- *Bruce Nauman: Drawings 1965–1986.* (Ausst.Kat. und Werkverzeichnis) Museum für Gegenwartskunst, Basel, 1986. Texte von Coosje van Bruggen, Dieter Koepplin und Franz Meyer.
- *Bruce Nauman.* (Ausst.Kat.) Whitechapel Art Gallery, London, 1986. Texte von Jean-Christophe Ammann, Nicholas Serota und Joan Simon.
- *Bruce Nauman: Prints, 1970–1989: A Catalogue Raisonné.* Castelli Graphics und Lorence-Monk Gallery, New York; Donald Young Gallery, Chicago, 1989. Christopher Cordes (Hrsg.) und Debbie Taylor (Assistenz). Texte von Christopher Cordes und John Yau.
- *Bruce Nauman: Skulpturen und Installationen, 1985–1990.* (Ausst.Kat.) Museum für Gegenwartskunst, Basel. Mitherausgeber: DuMont Buchverlage, Köln, 1990. Texte von Jörg Zutter und Franz Meyer.
- *Bruce Nauman.* (Ausst.Kat. und Werkverzeichnis) Museo Nacional Centro de Arte Reina Sofia, Madrid; Walker Art Center, Minneapolis; Museum of Contemporary Art, Los Angeles; Hirshhorn Museum and Sculpture Garden, Smithsonian Institution, Washington, D.C.; Museum of Modern Art, New York, 1994. Artikel von Neal Benezra, Kathy Halbreich, Paul Schimmel, Joan Simon und Robert Storr.
- *Bruce Nauman: Elliott's Stones.* (Ausst.Kat.) Museum of Contemporary Art, Chicago, 1995. Text von Lucinda Barnes.
- Hoffmann, Christine (Hrsg.): *Bruce Nauman: Interviews, 1967–1988.* Amsterdam: Verlag der Kunst, 1996. (In dt. Sprache)
- *Bruce Nauman: Image/Text, 1966–1996.* (Ausst.Kat.) Mnam-Cci, Centre Georges Pompidou, Paris, 1997; Kunstmuseum Wolfsburg, 1997; Hayward Gallery, London, 1998; Nykytaiteen museo Kiasma/The Museum of Contemporary Art, Helsinki, 1998. Texte von Jean-Charles Masséra, Vincent Labaume, François Albera, Gijs van Tuyl, Christine van Assche. Artikel von Marcia Tucker, Willoughby Sharp, Chris Dercon, Joan Simon, Tony Oursler und Michele De Angelus.
- *Bruce Nauman: 1985–1986. Drawings, Prints, and Related Works.* (Ausst.Kat.) The Aldrich Museum of Contemporary Art, Ridgefield, Connecticut, 1997. Texte von Jill Snyder und Ingrid Schaffner.
- *Bruce Nauman: World Peace (Projected).* (Ausst.Kat.) Staatsgalerie moderner Kunst, München, 1997. Texte von Carla Schulz-Hoffmann und Peter Prange. (In dt. Sprache)
- Bismarck, Beatrice von: *Bruce Nauman: Der Wahre Künstler/The True Artist.* New York: D.A.P./Distributed Art Publishers, 1998. (In engl. und dt. Sprache)
- Bruggen, Coosje van: *Bruce Nauman.* New York: Rizzoli International Publications, Inc., 1998.

- Bruggen, Coosje van. *Bruce Nauman*. New York: Rizzoli International Publications, Inc., 1998.
- *Bruce Nauman: Versuchsanordnungen Werke 1965–1994*. Hamburger Kunsthalle, Germany, 1998. Texts by Uwe M. Schneede, Joan Simon, Barbara Engelbach, Melitta Kliege, Günter Metken, and Friederike Wappler. In German.
- *Bruce Nauman*. Exh. cat., Museum für Neue Kunst, ZKM, Karlsruhe, Germany, 1999. Texts by Dörte Zbikowski, Reto Krüger, Ellen Heider, and Ralph Melcher. In German.
- *Bruce Nauman*. Exh. cat., Wilhelm Lehmbruck Museum Duisburg, Germany, 2000. Texts by Christoph Brockhaus, Ortrud Westheider, Gottlieb Leinz, Friederike Wappler, and Ursula Frohne. In German.
- Brundage, Susan, ed. *Bruce Nauman: Twenty-Five Years, Leo Castelli*. Exh. cat., Leo Castelli Gallery, New York, 1994.
- *Samuel Beckett/Bruce Nauman*. Exh. cat., Kunsthalle Wien, Vienna, 2000. Texts by Gerald Matt, Sabine Folie, Christine Hoffmann, Michael Glasmeier, Joan Simon, Gaby Hartel, Friederike Wappler, Raymond Federman, Steven Connor, Kathryn Chiong, Hédy Kaddour, Werner Spies, and Nam June Paik. In German with some English.
- *Bruce Nauman: Selected Works*. Exh. cat., Zwirner & Wirth, New York, 2000. Text by John Yau.
- Morgan, Robert C., ed. *Bruce Nauman*. Baltimore: Johns Hopkins University Press, 2002.
- Nauman, Bruce, Janet Kraynak, and Curtis Roads. *Please Pay Attention Please: Bruce Nauman's Words: Writings and Interviews*. Boston: MIT Press, 2003.
- *AC: Bruce Nauman. Mapping the Studio I (Fat Chance John Cage)*. Exh. cat., Museum Ludwig, Cologne, Germany, 2003. Texts by Kaspar König and Christine Litz. Statement by the artist. In German and English.

Selected Books and Catalogues of Group Exhibitions

- *1965–1975: Reconsidering the Object of Art*. Exh. cat., The Museum of Contemporary Art, Los Angeles, 1995. Texts by Ann Goldstein and Anne Rorimer, Lucy R. Lippard, Stephen Melville, Jeff Wall, and Susan L. Jenkins.
- *Affinities and Intuitions: The Gerald S. Elliott Collection of Contemporary Art*. Exh. cat., Art Institute of Chicago, 1990. Texts by Neal Benezra, Michael Auping, Lynne Cooke, I. Michael Danoff, Douglas W. Druick, Judith Russi Kirshner, Mary Murphy, Roald Nasgaard, Mark Rosenthal, Norman Rosenthal, and Charles F. Stuckey.
- *Anti-Illusion: Procedures/Materials*. Exh. cat., Whitney Museum of American Art, New York, 1969. Texts by Marcia Tucker and James Monte.
- *Art 21: Art in the Twenty-First Century*. Companion book to broadcast series for National Public Television. New York: Harry N. Abrams, Inc., 2001. Essays by Susan Sollins, Thelma Golden, Lynn M. Herbert, Robert Storr, and Katy Siegel.
- Battcock, Gregory, and Robert Nickas, eds. *The Art of Performance: A Critical Anthology*. New York: E. P. Dutton, Inc, 1984.
- *Being & Time: The Emergence of Video Projection*. Exh. cat., Albright-Knox Art Gallery, Buffalo, 1996. Text by Marc Mayer.
- Bismarck, Beatrice von, Diethelm Stoller, and Ulf Wuggenig. *Games, Fights, Collaborations: Das Spiel von Grenze und Überschreitung. Kunst und Cultural Studies in den 90er Jahren*. Stuttgart: Cantz Verlag, 1996. In English and German.
- *Bodyworks*. Exh. cat., Museum of Contemporary Art, Chicago, 1975. Text by Ira Licht.
- *Castelli-Sonnabend Videotapes and Films*, vol. 1. Distribution and sales catalogue. New York: Leo Castelli Gallery and Ileana Sonnabend, 1974. Notes on Nauman by Nina Sundell.
- Cooke, Lynne, and Michael Govan, eds. *Dia: Beacon*. New York: Dia Art Foundation, 2003.
- *DISLOCATIONS*. Exh. cat., Museum of Modern Art, New York, 1991. Text by Robert Storr.
- *Food for the Mind: Die Sammlung Udo und Anette Brandhorst*. Exh. cat., Staatsgalerie moderner Kunst, Munich, Germany, 2000. Text by Robert Rosenblum and Carla Schulz-Hoffmann. In German.
- *4e Semaine Internationale de Video*. Exh. cat., Saint-Gervais, Geneva, 1991. Texts by Alain Vaissade, André Iten, Lysianne Léchot, Peggy Gale, David A. Ross, Catherine David, Rosanna Albertini, Chris Dercon, Jean-Paul Fargier, Anne-Marie Duguet, Christine Van Assche, Erwan Huon Depenanster, and Yves Kropf. In English and French.
- *The Future of the Object! A Selection of American Art: Minimalism and After*. Exh. cat., Galerie Ronny van de Velde, Antwerp, Belgium, 1990. Text by Kenneth Baker.
- *The Froehlich Foundation: German and American Art from Beuys and Warhol*. Exh. cat., Tate Gallery, London, 1996. Texts by Stefan Germer and Thomas McEvilley. Interview by Nicholas Serota and Monique Beudert.
- *Gary Hill, Bruce Nauman: International New Media Art*. Exh. cat., National Gallery of Australia, Canberra, 2002. Texts by Lynne Cooke, George Quasha, and Jörg Zutter.
- *Gravity & Grace: The Changing Condition of Sculpture, 1965–1975*. Exh. cat., Hayward Gallery, London, 1993. Texts by Jon Thompson, William Tucker, and Yehuda Safran.
- Goldberg, Roselee. *Performance: Live Art Since 1960*. New York: Harry N. Abrams, Inc., 1998. Foreword by Laurie Anderson.
- *Into the Light: The Projected Image in American Art, 1964–1977*. Exh. cat., Whitney Museum of American Art, New York, 2001. Texts by Chrissie Iles and Thomas Zummer.
- Levin, Thomas Y., Ursula Frohne, and Peter Weibel, eds. *CTRL [SPACE]: Rhetorics of Surveillance from Bentham to Big Brother*. Exh. cat., ZKM Center for Art and Media, Karlsruhe, Germany, 2002.
- Loeffler, Carl E., and Darlene Tong, eds. *Performance Anthology: Source Book*

- *Bruce Nauman: Versuchsanordnungen. Werke 1965–1994*. Hamburger Kunsthalle, Hamburg, 1998. Texte von Uwe M. Schneede, Joan Simon, Barbara Engelbach, Melitta Kliege, Günter Metken und Friederike Wappler. (In dt. Sprache)
- *Bruce Nauman*. (Ausst.Kat.) Museum für Neue Kunst, ZKM, Karlsruhe, 1999. Texte von Dörte Zbikowski, Reto Krüger, Ellen Heider und Ralph Melcher. (In dt. Sprache)
- *Bruce Nauman*. (Ausst.Kat.) Wilhelm Lehmbruck Museum, Duisburg, 2000. Texte von Christoph Brockhaus, Ortrud Westheider, Gottlieb Leinz, Friederike Wappler und Ursula Frohne. (In dt. Sprache)
- Brundage, Susan (Hrsg.): *Bruce Nauman: 25 Years, Leo Castelli*. (Ausst.Kat.) Leo Castelli Gallery, New York, 1994.
- *Samuel Beckett/Bruce Nauman*. (Ausst.Kat.) Kunsthalle Wien, Wien, 2000. Texte von Gerald Matt, Sabine Folie, Christine Hoffmann, Michael Glasmeier, Joan Simon, Gaby Hartel, Friederike Wappler, Raymond Federman, Steven Connor, Kathryn Chiong, Hédy Kaddour, Werner Spies und Nam June Paik. (In dt. und z.T. engl. Sprache)
- *Bruce Nauman: Selected Works*. (Ausst.Kat.) Zwirner & Wirth, New York, 2000. Text von John Yau.
- Morgan, Robert C. (Hrsg.): *Bruce Nauman*. Baltimore: Johns Hopkins University Press, 2002.
- Nauman, Bruce, Janet Kraynak und Curtis Roads: *Please Pay Attention Please: Bruce Nauman's Words: Writings and Interviews*. Boston: MIT Press, 2003.
- *AC: Bruce Nauman. Mapping the Studio / (Fat Chance John Cage)*. (Ausst.Kat.) Museum Ludwig, Köln, 2003. Texte von Kaspar König und Christine Litz. Beitr. des Künstlers. (In dt. und engl. Sprache)

Bücher und Kataloge von Gruppenausstellungen (Auswahl)

- *1965–1975: Reconsidering the Object of Art*. (Ausst.Kat.) Museum of Contemporary Art, Los Angeles, 1995. Texte von Ann Goldstein and Anne Rorimer, Lucy R. Lippard, Stephen Melville, Jeff Wall und Susan L. Jenkins.
- *Affinities and Intuitions: The Gerald S. Elliott Collection of Contemporary Art*. (Ausst.Kat.) Art Institute of Chicago, 1990. Texte von Neal Benezra, Michael Auping, Lynne Cooke, I. Michael Danoff, Douglas W. Druick, Judith Russi Kirshner, Mary Murphy, Roald Nasgaard, Mark Rosenthal, Norman Rosenthal und Charles F. Stuckey.
- *Anti-Illusion: Procedures/Materials*. (Ausst.Kat.) Whitney Museum of American Art, New York, 1969. Texte von Marcia Tucker und James Monte.
- *Art: 21 - Art in the Twenty-First Century*. Buch zur Fernsehserie von National Public Television. New York: Harry N. Abrams, Inc., 2001. Artikel von Susan Sollins, Thelma Golden, Lynn M. Herbert, Robert Storr und Katy Siegel.
- Battcock, Gregory und Robert Nickas (Hrsg.): *The Art of Performance: A Critical Anthology*. New York: E.P. Dutton, Inc, 1984.
- *Being & Time: The Emergence of Video Projection*. (Ausst.Kat.) Albright-Knox Art Gallery, Buffalo, New York, 1996. Text von Marc Mayer.
- Bismarck, Beatrice von, Diethelm Stoller und Ulf Wuggenig: *Games, Fights, Collaborations: Das Spiel von Grenze und Überschreitung. Kunst und Cultural Studies in den 90er Jahren*. Stuttgart: Cantz Verlag, 1996. (In engl. und dt. Sprache)
- *Bodyworks*. (Ausst.Kat.) Museum of Contemporary Art, Chicago, 1975. Text von Ira Licht.
- *Castelli-Sonnabend Videotapes and Films*, Vol. 1. (Verkaufskatalog) New York: Leo Castelli Gallery und Ileana Sonnabend, 1974. Nauman-Text von Nina Sundell.
- Cooke, Lynne und Michael Govan (Hrsg.): *Dia: Beacon*. New York: Dia Art Foundation, 2003.
- *DISLOCATIONS*. (Ausst.Kat.) Museum of Modern Art, New York, 1991. Text von Robert Storr.
- *Food for the Mind. Die Sammlung Udo und Anette Brandhorst*. (Ausst.Kat.) Staatsgalerie moderner Kunst, München, 2000. Texte von Robert Rosenblum und Carla Schulz-Hoffmann. (In dt. Sprache)
- *4e Semaine Internationale de Video*. (Ausst.Kat.) Saint-Gervais, Genf, 1991. Texte von Alain Vaissade, André Iten, Lysianne Léchot, Peggy Gale, David A. Ross, Catherine David, Rosanna Albertini, Chris Dercon, Jean-Paul Fargier, Anne-Marie Duguet, Christine Van Assche, Erwan Huon Depenanster und Yves Kropf. (In engl. und franz. Sprache)
- *The Future of the Object! A Selection of American Art: Minimalism and After*. (Ausst.Kat.) Galerie Ronny van de Velde, Antwerpen, 1990. Text von Kenneth Baker.
- *The Froehlich Foundation: German and American Art from Beuys and Warhol*. (Ausst.Kat.) Tate Gallery, London, 1996. Texte von Stefan Germer und Thomas McEvilley. Interview von Nicholas Serota und Monique Beudert.
- *Gary Hill, Bruce Nauman: International New Media Art*. (Ausst.Kat.) National Gallery of Australia, Canberra, 2002. Texte von Lynne Cooke, George Quasha und Jörg Zutter.
- *Gravity & Grace: The Changing Condition of Sculpture 1965–1975*. (Ausst.Kat.) Hayward Gallery, London, 1993. Texte von Jon Thompson, William Tucker und Yehuda Safran.
- Goldberg, Roselee: *Performance: Live Art Since 1960*. New York: Harry N. Abrams, 1998. Vorwort von Laurie Anderson.
- *Into the Light: The Projected Image in American Art, 1964–1977*. (Ausst.Kat.) Whitney Museum of American Art, New York, 2001. Texte von Chrissie Iles und Thomas Zummer.
- Levin, Thomas Y., Ursula Frohne und Peter Weibel (Hrsg.): *CTRL [SPACE]: Rhetorics of Surveillance from Bentham to Big Brother*. (Ausst.Kat.) ZKM | Zentrum für Kunst und Medientechnologie, Karlsruhe, 2002.
- Loeffler, Carl E. und Darlene Tong (Hrsg.): *Performance Anthology: Source Book for a Decade of California Performance Art*. San Francisco: Contemporary Arts Press, 1980.
- *Loop*. (Ausst.Kat.) Kunsthalle der Hypo-Kulturstiftung, München; P.S.1 Contemporary Art Center und The Museum of Modern Art, New York, 2001. Texte von Klaus Biesenbach, Jennifer

for a Decade of California Performance Art. San Francisco: Contemporary Arts Press, 1980.
- *Loop*. Exh. cat., Kunsthalle der Hypo-Kulturstiftung, Munich, and P.S.1/MoMA, New York, 2001. Texts by Klaus Biesenbach, Jennifer Allen, Daniel Birnbaum, Waling Boers, Heidi Fichtner, Anselm Franke, Larissa Harris, Steven Higgins, Jens Hoffmann, Anthony Huberman, Christiane Lange, Lars Kjerulf Petersen, Maika Pollack, Beatrix Ruf, Jeffrey Uslip, Frank Wagner, and Gabriele Werner. In English and German.
- *Mediascape*. Exh. cat., Guggenheim Museum SoHo, New York, 1996. Texts by Ursula Frohne, Oliver Seifert, and Annika Blunck.
- *Minimal Art dans la Collection Panza di Biumo*. Exh. cat., Musée Rath Genève, Switzerland, 1988. Text by Hal Foster. In English and French.
- Müller, Grégoire, and Gianfranco Gorgoni. *The New Avant-Garde: Issues for the Art of the Seventies*. New York: Praeger, 1972.
- *Narcissism: Artists Reflect Themselves*. Exh. cat., California Center for the Arts Museum, Escondido, 1996. Texts by Reesey Shaw and John Welchman.
- *Nauman Kruger Jaar*. Exh. cat., Daros Exhibitions, Zurich, 2002. Texts by Peter Fischer, Hans-Michael Herzog, Eva Keller, and Nicholas Serota. In English and German.
- *The New Sculpture, 1965–75: Between Geometry and Gesture*. Exh. cat., Whitney Museum of American Art, 1990. Texts by Richard Armstrong, John G. Hanhardt, and Robert Pincus-Witten.
- *Out of Actions: Between Performance and the Object, 1949–1979*. Exh. cat., Museum of Contemporary Art, Los Angeles, 1998. Texts by Kristine Stiles, Guy Brett, Hubert Klocker, Shinichiro Osaki, and Paul Schimmel.
- *Outside the Frame: Performance and the Object. A Survey History of Performance Art in the USA from 1950 to the Present*. Exh. cat., Cleveland Center for Contemporary Art, Ohio, 1994. Texts by David S. Rubin and Marjorie Talalay, Robyn Brentano, and Olivia George.
- *Percepciones en transformación: La Colección Panza del Museo Guggenheim*. Exh. cat., Guggenheim Bilbao, Spain, 2000. Texts by Giuseppe Panza di Biumo, Germano Celant, Susan Cross, Gregory Williams, Melanie Mariño, J. Fiona Ragheb, Kenneth B. Rogers, Julia Blaut, Joan Young, Craig Houser, Kara Vander Weg, Meghan Dailey, Jon Ippolito, Vanessa Rocco, and Tracey Bashkoff. In Spanish.
- *Power: Its Myths and Mores in American Art 1961–1991*. Exh. cat., Indianapolis Museum of Art, Indiana, 1991. Texts by Holliday T. Day, Brian Wallis, Anna C. Chave, and George E. Marcus.
- *Quartetto*. Exh. cat., L'Academia Foundation, Venice, 1984. Texts by Kaspar König, Achille Bonito Oliva, and Julian Heynen. Interview with Alanna Heiss by Donald Kuspit. In English, French, German, and Italian.
- *The Slant Step Revisited*. Exh. cat., Richard L. Nelson Gallery, University of California, Davis, 1983. Texts by Cynthia Charters and L. Price Amerson, Jr.
- *Transformations in Sculpture: Four Decades of American and European Art*. Exh. cat., Solomon R. Guggenheim Museum, New York, 1985. Text by Diane Waldman.
- *La 3e Biennale de Lyon*. Exh. cat., Musée d'Art Contemporain de Lyon, France, 1995. Texts by Thierry Prat, Thierry Raspail and Georges Rey, Gladys Fabre, Jean-Paul Fargier, Yann Beauvais, Friedemann Malsch, Barbara London, David A. Ross and Alice Pratt Brown, Christine Van Assche, Hans Peter Schwarz, Dan Cameron, Nicolas Bourriaud, Friedrich Kittler, Jean-Louis Boissier, and Marie Borel. In French.
- *Venice/Venezia: California Art from the Panza Collection at the Guggenheim Museum*. Exh. cat., Peggy Guggenheim Collection, Venice, 2000. Texts by Giuseppe Panza di Biumo, Germano Celant, Gregory Williams, Melanie Mariño, Susan Cross, and Meghan Dailey.
- *Video Acts: Single Channel Works from the Collection of Pamela and Richard Kramlich and New Art Trust*. Exh. cat., P.S.1 Contemporary Art Center, New York, 2002. Texts by Klaus Biesenbach, Barbara London, and Christopher Eamon.
- *Wounds: Between Democracy and Redemption in Contemporary Art*. Exh. cat., Moderna Museet, Stockholm, 1998. Texts by David Elliott, Pier Luigi Tazzi, Michael Corris, Michael Newman, Massimo Cacciari, Gertrud Sandqvist, Alain Cueff, Bojana Pejic, Marcelo E. Pacheco, Gilane Tawadros, Nancy Spector, and Paul Groot.

Articles and Reviews

- Adams, Parveen. "Bruce Nauman and the Object of Anxiety." *October*, no. 83 (Winter 1998), pp. 97–113.
- Auping, Michael. "A Thousand Words: Bruce Nauman," *Artforum* 40, no. 7 (Mar. 2002), pp. 120–21.
- Baker, Kenneth. "Nauman's Art Finds Richness in an Empty Room." *San Francisco Chronicle*, April 6, 2002, pp. D1, D8.
- Benezra, Neal. "Bruce Nauman: The Century's Twenty-Five Most Influential Artists." *ARTnews* 98, no. 5 (May 1999), p. 143.
- Benezra, Neal. "Raw Material." *Art Press*, no. 184 (Oct. 1993), pp. 10–20.
- Birnbaum, Daniel. "Samuel Beckett/Bruce Nauman." *Artforum* 38, no. 10 (Summer 2000), p. 179.
- Bonami, Francesco. "LeWitt, Nauman, Turrell." *Flash Art* 27, no. 176 (May/June 1994), pp. 106–07.
- Bruggen, Coosje van. "Bruce Nauman: Entrance, Entrapment, Exit." *Artforum* 24, no. 10 (Summer 1986), pp. 88–97.
- Cameron, Dan. "Space Cowboy." *Art & Auction* 17, no. 10 (May 1995), pp. 94-96.
- Chapuis, Y. "To be a clown: figures de clown dans l'oeuvre de Bruce Nauman." *Art Press* no 20 (1999), pp. 88–91.
- Chassey, Eric de. "Bruce Nauman, entre vidéo, son et néon (exhibit)." *L'œil*, no. 492 (Jan. 1998), p. 23.
- Chiong, Kathryn. "Nauman's Beckett Walk." *October*, no. 86 (Fall 1998), pp. 63–81.
- Criqui, Jean-Pierre. "Bruce Nauman: Kunstmuseum Wolfsburg (exhibit)." *Artforum* 36, no. 3 (Nov. 1997), pp. 112–13.

- *Mediascape*. (Ausst.Kat.) Guggenheim Museum SoHo, New York, 1996. Texte von Ursula Frohne, Oliver Seifert und Annika Blunck.
- *Minimal Art dans la Collection Panza di Biumo*. (Ausst.Kat.) Musée Rath, Genf, 1988. Text von Hal Foster. (In engl. und franz. Sprache)
- Müller, Grégoire und Gianfranco Gorgoni: *The New Avant-Garde: Issues for the Art of the Seventies*. New York: Praeger, 1972.
- *Narcissism: Artists Reflect Themselves*. (Ausst.Kat.) California Center for the Arts Museum, Escondido, 1996. Texte von Reesey Shaw und John Welchman.
- *Nauman Kruger Jaar*. (Ausst.Kat.) Daros Exhibitions, Zürich, 2002. Texte von Peter Fischer, Hans-Michael Herzog, Eva Keller und Nicholas Serota. (In engl. und dt. Sprache)
- *The New Sculpture 1961-75: Between Geometry and Gesture*. (Ausst.Kat.) The Whitney Museum of American Art, 1990. Texte von Richard Armstrong, John G. Hanhardt und Robert Pincus-Witten.
- *Out of Actions: between performance and the object, 1949 –1979*. (Ausst.Kat.) Museum of Contemporary Art, Los Angeles, 1998. Texte von Kristine Stiles, Guy Brett, Hubert Klocker, Shinichiro Osaki und Paul Schimmel.
- *Outside the Frame: Performance and the Object. A Survey History of Performance Art in the USA from 1950 to the Present*. (Ausst.Kat.) Cleveland Center for Contemporary Art, Ohio, 1994. Texte von David S. Rubin und Marjorie Talalay, Robyn Brentano und Olivia George.
- *Percepciones en transformación: La Colección Panza del Museo Guggenheim*. (Ausst.Kat.) Guggenheim Bilbao, 2000. Texte von Giuseppe Panza di Biumo, Germano Celant, Susan Cross, Gregory Williams, Melanie Mariño, J. Fiona Ragheb, Kenneth B. Rogers, Julia Blaut, Joan Young, Craig Houser, Kara Vander Weg, Meghan Dailey, Jon Ippolito, Vanessa Rocco und Tracey Bashkoff. (In span. Sprache)
- *Power: Its Myths and Mores in American Art 1961–1991*. (Ausst.Kat.) Indianapolis Museum of Art, Indiana, 1991. Texte von Holliday T. Day, Brian Wallis, Anna C. Chave und George E. Marcus.
- *Quartetto*. (Ausst.Kat.) Academia Foundation,Venedig, 1984. Texte von Kaspar König, Achille Bonito Oliva und Julian Heynen. Interview von Donald Kuspit mit Alanna Heiss. (In engl., franz., dt. und ital. Sprache)
- *The Slant Step Revisited*. (Ausst.Kat.) Richard L. Nelson Gallery, University of California, Davis, 1983. Texte von Cynthia Charters und L. Price Amerson, Jr.
- *Transformations in Sculpture: Four Decades of American and European Art*. (Ausst.Kat.) Solomon R. Guggenheim Museum, New York, 1985. Text von Diane Waldman.
- *La 3e Biennale de Lyon*. (Ausst.Kat.) Musée d'Art Contemporain, Lyon, 1995. Texte von Thierry Prat, Thierry Raspail und Georges Rey, Gladys Fabre, Jean-Paul Fargier, Yann Beauvais, Friedemann Malsch, Barbara London, David A. Ross und Alice Pratt Brown, Christine Van Assche, Hans Peter Schwarz, Dan Cameron, Nicolas Bourriaud, Friedrich Kittler, Jean-Louis Boissier und Marie Borel. (In franz. Sprache)
- *Venice/Venezia: California Art from The Panza Collection at the Guggenheim Museum*. (Ausst.Kat.) Peggy Guggenheim Collection, Venedig, 2000. Texte von Giuseppe Panza di Biumo, Germano Celant, Gregory Williams, Melanie Mariño, Susan Cross und Meghan Dailey.
- *Video Acts: Single Channel Works from the Collection of Pamela and Richard Kramlich and New Art Trust*. (Ausst.Kat.) P.S.1 Contemporary Art Center, New York, 2002. Texte von Klaus Biesenbach, Barbara London und Christopher Eamon.
- *Wounds: Between Democracy and Redemption in Contemporary Art*. (Ausst.Kat.) Moderna Museet, Stockholm, 1998. Texte von David Elliott, Pier Luigi Tazzi, Michael Corris, Michael Newman, Massimo Cacciari, Gertrud Sandqvist, Alain Cueff, Bojana Pejic, Marcelo E. Pacheco, Gilane Tawadros, Nancy Spector und Paul Groot.

Artikel und Rezensionen

- Adams, Parveen: «Bruce Nauman and the Object of Anxiety.» *October*, Nr. 83 (Winter 1998), S. 97–113.
- Auping, Michael: «A Thousand Words: Bruce Nauman», *Artforum* 40, Nr. 7 (März 2002), S. 120–21.
- Baker, Kenneth: «Nauman's Art Finds Richness in an Empty Room.» *San Francisco Chronicle*, 6. April 2002, S. D1, D8.
- Benezra, Neal: «Bruce Nauman: The Century's Twenty-Five Most Influential Artists.» *ARTnews* 98, Nr. 5 (Mai 1999), S. 143.
- Benezra, Neal: «Raw Material.» *Art Press*, Nr. 184 (Oktober 1993), S. 10–20.
- Birnbaum, Daniel: «Samuel Beckett/Bruce Nauman.» *Artforum* 38, Nr. 10 (Sommer 2000), S. 179.
- Bruggen, Coosje van: «Bruce Nauman: Entrance, Entrapment, Exit.» *Artforum* 24, Nr. 10 (Sommer 1986), S. 88–97.
- Cameron, Dan: «Space Cowboy.» *Art & Auction*, Vol. 17, Nr. 10 (Mai 1995), S. 94–96.
- Chapuis, Y.: «To be a clown: figures de clown dans l'oeuvre de Bruce Nauman» *Art Press* Nr. 20 (1999), S. 88–91.
- Chassey, Eric de: «Bruce Nauman, entre vidéo, son et néon (exhibit).» *L'œil*, Nr. 492 (Januar 1998), S. 23.
- Chiong, Kathryn: «Nauman's Beckett Walk.» *October*, Nr. 86 (Herbst 1998), S. 63–81.
- Criqui, Jean-Pierre: «Bruce Nauman: Kunstmuseum Wolfsburg (exhibit).» *Artforum* 36, Nr. 3 (November 1997), S. 112–13.
- Criqui, Jean-Pierre: «Pour un Nauman.» *Les Cahiers du Musée National d'Art Moderne*, Nr. 62 (Winter 1997), S. 4–25.
- Danieli, Fidel A.: «The Art of Bruce Nauman.» *Artforum* 6, Nr. 4 (Dezember 1967), S. 15–19.
- Danto, Arthur C.: «Bruce Nauman.» *The Nation*, Vol. 260, Nr. 18 (8. Mai 1995), S. 642–46.
- De Brugerolle, Marie: «Bruce Nauman:

- Criqui, Jean-Pierre. "Pour un Nauman." *Les Cahiers du Musée National d'Art Moderne*, no. 62 (Winter 1997), pp. 4–25.
- Danieli, Fidel A. "The Art of Bruce Nauman." *Artforum* 6, no. 4 (Dec. 1967), pp. 15–19.
- Danto, Arthur C. "Bruce Nauman." *The Nation* 260, no. 18 (May 8, 1995), pp. 642–46.
- De Brugerolle, Marie. "Bruce Nauman: Museum für Gegenwartskunst." *Art Press*, no. 288 (Mar. 2003), pp. 76–78.
- Decter, Joshua. "Bruce Nauman: Sperone Westwater." *Flash Art*, no. 143 (Nov.–Dec. 1988), p. 118.
- Goodman, Jonathan. "From Hand to Mouth to Paper to Art: The Problems of Bruce Nauman's Drawings." *Arts Magazine* 62, no. 6 (Feb. 1988), pp. 44–46.
- Gopnik, Adam. "The Nauman Principle." *The New Yorker* 71, no. 5 (Mar. 27, 1995), pp. 103–06.
- Graw, Isabelle. "Bruce Nauman: Being Is Nothing." *Flash Art* 26, no. 169 (Mar.–Apr. 1993), pp. 71–73.
- Haxthausen, Charles W. "Los Angeles: Bruce Nauman." *Burlington Magazine* 136, no. 1098 (Sept. 1994), pp. 646–47.
- Hixson, Kathryn. "Fear of Games/ Games of Fear. Nauman: Good and Bad." *The New Art Examiner* 22, no. 4 (Dec. 1994), pp. 32–35.
- Imhof, Dora. "Bruce Nauman: 'Mapping the Studio': Museum für Gegenwartskunst Basel (exhibit)." *Kunstforum International*, no. 163 (Jan./Feb. 2003), pp. 366–67.
- Jocks, Heinz-Norbert. "Bruce Nauman." *Kunstforum International*, no. 128 (Oct./Dec. 1994), pp. 391–92.
- Kastner, Jeffrey. "The True Artist." *Art Monthly*, no. 186 (May 1995), pp. 3–6.
- Kimmelman, Michael. "Bruce Nauman— 'Mapping the Studio I (Fat Chance John Cage).'" *New York Times,* July 5, 2002, p. E.2:35.
- Knight, Christopher. "Working Well with Whatever Works: Bruce Nauman's Rich Retrospective Shows an Artist Comfortable in Any Medium." *Los Angeles Times*, July 19, 1994, p. 1.
- Kraynak, Janet. "Dependent Participation: Bruce Nauman's Environments." *Grey Room* 1, no. 10 (Jan. 1, 2003), pp. 22–45.
- Lloyd, Ann Wilson. "Casting About with Bruce Nauman." *Sculpture* 13, no. 4 (July–Aug. 1994), pp. 20–27.
- MacAdam, Barbara. "Bruce Nauman: Leo Castelli (exhibit)." *ARTnews* 93, no. 5 (May 1994), p. 154.
- Michely, Viola. "Raum und Emotion. Bruce Nauman: Versuchsanordnungen. Werke, 1965–1994: Hamburger Kunsthalle (exhibit)." *Kunstforum International*, no. 142 (Oct./Dec. 1998), pp. 381–82.
- Miller, John, Pamela M. Lee, and Isabelle Graw. "Three Statements on the Recent Reception of Bruce Nauman." *October*, no. 74 (Fall 1995), pp. 123–38.
- Morgan, Robert C. "Bruce Nauman: Dia Center for the Arts." *Sculpture* 21, no. 6 (July/Aug. 2002), pp. 70–71.
- Nemser, Cindy. "Subject-Object: Body Art." *Arts Magazine* 46, no. 1 (Sept.–Oct. 1971), pp. 38–42.
- Nickas, Robert. "Artists' Films." *Flash Art* 24, no. 171 (Nov./Dec. 1991), pp. 96–102.

- Pascale, Mark. "Studies for Holograms, 1970." *Museum Studies* 25, no. 1 (1999), pp. 40–41.
- Perreau, David. "Bruce Nauman: Centre Georges-Pompidou." *Art Press* 10, no. 232 (February 1998), p. 82.
- Pincus-Witten, Robert. "Bruce Nauman: Another Kind of Reasoning." *Artforum* 10, no. 6 (Feb. 1972), pp. 30–37.
- Plagens, Peter. "Roughly Ordered Thoughts on the Occasion of the Bruce Nuaman Retrospective in Los Angeles." *Artforum* 11, no. 7 (Mar. 1973), pp. 57–79.
- Plagens, Peter, and Lane Relyea. "Head Trips: Bruce Nauman." *Artforum* 33, no. 8 (Apr. 1995), pp. 62–69.
- Potts, Alex. "Paris and London: Bruce Nauman (exhibit)." *Burlington Magazine* 140, no. 1,144 (July 1998), pp. 498–500.
- Princenthal, Nancy. "Bruce Nauman at Castelli (exhibit)." *Art in America* 82, no. 4 (Apr. 1994), p. 121.
- Prose, Francine. "The Funny Side of the Abyss." *ARTnews* 98, no. 11 (Dec. 1999), p. 143.
- Riley, Bridget. "Bruce Nauman: Squaring the Circle." *Flash Art* 32, no. 205 (Mar.–Apr. 1999), pp. 88–91.
- Rondeau, James E. "Clown Torture, 1987." *Museum Studies* 25, no. 1 (1999), pp. 62–63.
- Saltz, Jerry. "Wild Kingdom." *The Village Voice*, Feb. 5, 2002, p. 57.
- Schenk-Sorge, Jutta. "Bruce Nauman. Image/Text, 1966–1996 (exhibit)." *Kunstforum International*, no. 139 (Dec. 1997/Mar. 1998), pp. 348–50.
- Schjeldahl, Peter. "The Trouble with Nauman." *Art in America* 82, no. 4 (Apr. 1994), pp. 82–91.
- Schjeldahl, Peter. "Night Moves: The Indifferent Grandeur of Bruce Nauman." *The New Yorker* 77, no. 45, Jan. 28, 2002, pp. 94–95.
- Searle, Adrian. "In Yer Face: Bruce Nauman's Art Leaves You Deaf, Blind, Paranoid, even Suicidal—But Never Bored." *The Guardian* (Manchester), July 21, 1998, p. T010.
- Silva, Arturo. "Samuel Beckett/Bruce Nauman." *ARTnews* 99, no. 7 (Summer 2000), p. 220.
- Smith, Roberta. "Comfortable? Easy? Not for Bruce Nauman." *New York Times*, Mar. 3, 1995, pp. C1 and C25.
- Snodgrass, Susan. "Bruce Nauman at Donald Young." *Art in America* 87, no. 9 (Sept. 1999) pp. 132–33.
- Stitleman, Paul. "Bruce Nauman at the Whitney Museum." *Arts Magazine* 47, no. 7 (May–June 1973), pp. 54–55.
- Storr, Robert. "Nowhere Man." *Parkett*, no. 10 (Sept. 1986), pp. 70–90.
- Storr, Robert. "Bruce Nauman: Flashing Lights in the Shadow of Doubt." *MoMA: Magazine of The Museum of Modern Art*, no. 19 (Spring 1995), pp. 5–9.
- Tucker, Marcia. "PheNAUMANology." *Artforum* 9, no. 4 (Dec. 1970), pp. 38–44.
- Wilson, MaLin. "Look Ma, No Hands." *Art Issues*, no. 53 (Summer 1998), pp. 22–27.
- Zutter, Jörg. "Alienation of the Self, Command of the Other." *Parkett*, no. 27 (1991), pp.155–58.

- Museum für Gegenwartskunst." *Art Press*, Nr. 288 (März 2003), S. 76–78.
- Decter, Joshua: «Bruce Nauman: Sperone Westwater.» *Flash Art*, Nr. 143 (November–Dezember 1988), S. 118.
- Goodman, Jonathan: «From Hand to Mouth to Paper to Art: The Problems of Bruce Nauman's Drawings.» *Arts Magazine* 62, Nr. 6 (Februar 1988), S. 44–46.
- Gopnik, Adam: «The Nauman Principle.» *The New Yorker*, Vol. 71, Nr. 5 (27. März 1995), S.103–106.
- Graw, Isabelle: «Bruce Nauman: Being Is Nothing.» *Flash Art*, Vol. 26, Nr. 169 (März–April 1993), S. 71–73.
- Haxthausen, Charles W.: «Los Angeles: Bruce Nauman.» *Burlington Magazine*, Vol. 136, Nr. 1098 (September 1994), S. 646–47.
- Hixson, Kathryn: «Fear of Games/Games of Fear. Nauman: Good and Bad.» *The New Art Examiner*, Vol. 22, Nr. 4 (Dezember 1994), S. 32–35.
- Imhof, Dora: «Bruce Nauman: 'Mapping the Studio': Museum für Gegenwartskunst Basel (exhibit).» *Kunstforum International*, Nr. 163 (Januar/Februar 2003), S. 366–67.
- Jocks, Heinz-Norbert: «Bruce Nauman.» *Kunstforum International*, Nr. 128 (Oktober/Dezember 1994), S. 391–92.
- Kastner, Jeffrey: «The True Artist.» *Art Monthly*, Nr. 186 (Mai 1995), S. 3–6.
- Kimmelman, Michael: «Bruce Nauman – 'Mapping the Studio I (Fat Chance John Cage)': [Review].» *New York Times* (Spätausgabe, US-Ostküste), New York, 5. Juli 2002, S. E.2:35.
- Knight, Christopher: «Working Well With Whatever Works: Bruce Nauman's Rich Retrospective Shows an Artist Comfortable in Any Medium.» *The Los Angeles Times*, 19. Juli 1994, S. 1.
- Kraynak, Janet: «Dependent Participation: Bruce Nauman's Environments.» *Grey Room*, Vol. 1, Nr. 10 (1. Januar 2003), S. 22–45.
- Lloyd, Ann Wilson: «Casting About with Bruce Nauman.» *Sculpture* 13, Nr. 4 (Juli–August 1994), S. 20–27.
- MacAdam, Barbara: «Bruce Nauman: Leo Castelli (exhibit).» *ARTnews*, Vol. 93, Nr. 5 (Mai 1994), S. 154.
- Michely, Viola: «Raum und Emotion. Bruce Nauman: Versuchsanordnungen. Werke 1965–1994: Hamburger Kunsthalle (exhibit).» *Kunstforum International*, Nr. 142 (Oktober/Dezember 1998), S. 381–82.
- Miller, John, Pamela M. Lee und Isabelle Graw: «Three Statements on the Recent Reception of Bruce Nauman.» *October*, Nr. 74 (Herbst 1995), S. 123–38.
- Morgan, Robert C.: «Bruce Nauman: Dia Center for the Arts.» *Sculpture* 21, Nr. 6 (Juli/August 2002), S. 70–71.
- Nemser, Cindy: «Subject-Object: Body Art.» *Arts Magazine* 46, Nr. 1 (September–Oktober 1971), S. 38–42.
- Nickas, Robert: «Artists' Films.» *Flash Art*, Vol. 24, Nr. 171 (November/Dezember 1991), S. 96–102.
- Pascale, Mark: «Studies for Holograms, 1970.» *Museum Studies*, Vol. 25, Nr. 1 (1999), S. 40–41.
- Perreau, David: «Bruce Nauman: Centre Georges-Pompidou.» *Art Press* 10, Nr. 232 (February 1998), S. 82.
- Pincus-Witten, Robert: «Bruce Nauman: Another Kind of Reasoning.» *Artforum* 10, Nr. 6 (Februar 1972), S. 30–37.

- Plagens, Peter: «Roughly Ordered Thoughts on the Occasion of the Bruce Nauman Retrospective in Los Angeles.» *Artforum* 11, Nr. 7 (März 1973), S. 57–79.
- Plagens, Peter und Lane Relyea: «Head Trips: Bruce Nauman.» *Artforum* 33, Nr. 8 (April 1995), S. 62–69.
- Potts, Alex: «Paris and London: Bruce Nauman (exhibit).» *Burlington Magazine*, Vol. 140, Nr. 1144 (Juli 1998), S. 498–500.
- Princenthal, Nancy: «Bruce Nauman at Castelli (exhibit).» *Art in America* 82, Nr. 4 (April 1994), S. 121.
- Prose, Francine: «The Funny Side of the Abyss.» *ARTnews*, Vol. 98, Nr. 11 (Dezember 1999), S. 143.
- Riley, Bridget: «Bruce Nauman: Squaring the Circle.» *Flash Art*, Vol. 32, Nr. 205 (März–April 1999), S. 88–91.
- Rondeau, James E: «Clown Torture, 1987.» *Museum Studies*, Vol. 25, Nr. 1 (1999), S. 62–63.
- Saltz, Jerry: «Wild Kingdom.» *The Village Voice*, 5. Februar 2002, S. 57.
- Schenk-Sorge, Jutta: «Bruce Nauman. Image/Text 1966–1996 (exhibit).» *Kunstforum International*, Nr. 139 (Dezember 1997/März 1998), S. 348–50.
- Schjeldahl, Peter: «The Trouble with Nauman.» *Art in America* 82, Nr. 4 (April 1994), S. 82–91.
- Schjeldahl, Peter: «Night Moves: The indifferent grandeur of Bruce Nauman.» *The New Yorker*, 28. Januar 2002, Vol. 77, Nr. 45, S. 94–95.
- Searle, Adrian: «In Yer Face: Bruce Nauman's Art Leaves You Deaf, Blind, Paranoid, even Suicidal – But Never Bored.» *The Guardian*, Manchester, 21. Juli 1998, S. T010.
- Silva, Arturo: «Samuel Beckett/Bruce Nauman.» *ARTnews*, Vol. 99, Nr. 7 (Sommer 2000), S. 220.
- Smith, Roberta: «Comfortable? Easy? Not for Bruce Nauman.» *New York Times*, 3. März 1995, S. C1, C25.
- Snodgrass, Susan: «Bruce Nauman at Donald Young.» *Art in America* 87, Nr. 9 (September 1999) S. 132–33.
- Stitleman, Paul: «Bruce Nauman at the Whitney Museum.» *Arts Magazine* 47, Nr. 7 (Mai–Juni 1973), S. 54–55.
- Storr, Robert: «Nowhere Man.» *Parkett*, Nr. 10 (September 1986), S. 70–90.
- Storr, Robert: «Bruce Nauman: Flashing Lights in the Shadow of Doubt.» *MoMA* (Zeitschrift des Museum of Modern Art), Nr. 19, Frühling 1995, S. 5–9.
- Tucker, Marcia: «PheNAUMANology.» *Artforum* 9, Nr. 4 (Dezember 1970), S. 38–44.
- Wilson, MaLin: «Look Ma, No Hands.» *Art Issues*, Nr. 53 (Sommer 1998), S. 22–27.
- Zutter, Jörg:«Alienation of the Self, Command of the Other.» *Parkett*, Nr. 27 (1991) S. 155–58.

Works in the Exhibition and Illustrations

Ausgestellte Arbeiten Illustrationen

Works in the Exhibition

Plate 1
Lighted Center Piece, 1967–68
Aluminum plate, four 1,000-watt
halogen lamps
Plate: 2 1/2 x 36 x 36 inches
(6.4 x 91.4 x 91.4 cm)
Solomon R. Guggenheim Museum,
New York, Panza Collection, Gift, 1992
92.4161

Plate 2
Device to Stand In, 1966
Steel, blue lacquer
8 3/4 x 17 1/4 x 27 1/4 inches
(22.2 x 43.8 x 69.2 cm)
The Panza Collection, Lugano

Plates 3–6
Art Make-Up, No.1: White, 1967
Art Make-Up, No. 2: Pink, 1967–68
Art Make-Up, No. 3: Green, 1967–68
Art Make-Up, No. 4: Black, 1967–68
Installation with four 16-mm films
(color, silent)
400 feet, approx. 10 minutes each
Courtesy Electronic Arts Intermix (EAI),
New York

Plate 7
Bouncing in the Corner, No. 1, 1968
Video (black and white, sound)
60 minutes, repeated continuously
Courtesy Electronic Arts Intermix (EAI),
New York

Plate 8
First Hologram Series: Making Faces (K),
1968
Holographic image on glass
8 x 10 inches (20.3 x 25.4 cm)
The Panza Collection, Lugano
(exhibition copy)

Plate 9
*Second Hologram Series: Full Figure
Poses (A)*, 1969
Holographic image on glass
8 x 10 inches (20.3 x 25.4 cm)
The Panza Collection, Lugano
(exhibition copy)

Plate 10
Walk with Contrapposto, 1968
Video (black and white, sound)
60 minutes, repeated continuously
Courtesy Electronic Arts Intermix (EAI),
New York

Plate 11
Performance Corridor, 1969
Wallboard, wood
96 x 240 x 20 inches
(243.8 x 609.6 x 50.8 cm)
Solomon R. Guggenheim Museum,
New York, Panza Collection, Gift, 1992
92.4162

Plates 12–13
*Video Corridor for San Francisco
(Come Piece)*, 1969
Video installation, two cameras and
two monitors

Dimensions variable
Solomon R. Guggenheim Museum,
New York, Panza Collection, Gift, 1992
92.4169

Plate 14
*Corridor Installation with Mirror—
San Jose Installation (Double Wedge
Corridor with Mirror)*, 1970
Wallboard, wood, mirror
Approx. 120 x 336 x 72 inches
(304.8 x 853.4 x 182.9 cm)
Solomon R. Guggenheim Museum,
New York, Panza Collection
91.3829

Plate 15
Mean Clown Welcome, 1985
Neon mounted on aluminum monolith
72 x 82 x 13 1/2 inches
(182.9 x 208.3 x 34.3 cm)
Brandhorst Collection, Cologne
(exhibition copy)

Plate 16
Double No, 1988
Two channel video installation
(color, sound)
Dimensions variable
Froehlich Collection, Stuttgart

Plate 17
Raw Material—BRRR, 1990
Video installation, projector and two
monitors (color, sound)
Dimensions variable
ZKM / Center for Art and Media
Karlsruhe, Museum of Contemporary Art
167/92

Illustrations

Page 13
Lighted Performance Box, 1969
Aluminum, 1,000 watt lamp
78 x 20 x 20 inches
(198.1 x 50.8 x 50.8 cm)
Solomon R. Guggenheim Museum,
New York, Panza Collection
91.3820

Page 15
*Walking in an Exaggerated Manner
Around the Perimeter of a Square*,
1967–68
16-mm film (black and white, silent)
400 feet, approx. 10 minutes
Courtesy Electronic Arts Intermix
(EAI), New York

Page 16
South American Square, 1981
Steel beams, steel cable, cast-iron chair
138 x 138 inches (350.5 x 350.5 cm) sus-
pended 60 inches (152.4 cm) above floor
Collection Ydessa Hendeles,
Courtesy the Ydessa Hendeles
Foundation, Toronto

Page 17
Clown Torture, 1987
Four channel video installation, four
projectors, four monitors (color, sound)
Dimensions variable

Ausgestellte Arbeiten

Kat. Nr. 1
Lighted Center Piece, 1967–68
Aluminiumplatte,
vier 1000-Watt-Halogenlampen
6,4 x 91,4 x 91,4 cm
Solomon R. Guggenheim Museum,
New York, Panza Collection
92.4161

Kat. Nr. 2
Device to Stand In, 1966
Stahl, blauer Lack
22,2 x 43,8 x 69,2 cm
Panza Collection, Lugano

Kat. Nr. 3-6
Art Make-Up, No.1: White, 1967
Art Make-Up, No. 2: Pink, 1967–68
Art Make-Up, No. 3: Green, 1967–68
Art Make-Up, No. 4: Black, 1967–68
Installation mit vier 16-mm-Filmen
(Farbe, ohne Ton)
122 m, je ca. 10 Minuten
Mit Genehmigung von Electronic Arts
Intermix (EAI), New York

Kat. Nr. 7
Bouncing in the Corner, No. 1, 1968
Video (schwarzweiß, Ton)
60 Minuten
Mit Genehmigung von Electronic Arts
Intermix (EAI), New York

Kat. Nr. 8
First Hologram Series: Making Faces (K),
1968
Hologramm auf Glas
20,3 x 25,4 cm
Panza Collection, Lugano
(Ausstellungskopie)

Kat. Nr. 9
*Second Hologram Series: Full Figure
Poses (A)*, 1969
Hologramm auf Glas
20,3 x 25,4 cm
Panza Collection, Lugano
(Ausstellungskopie)

Kat. Nr. 10
Walk with Contrapposto, 1968
Video (schwarzweiß, Ton)
60 Minuten
Mit Genehmigung von Electronic Arts
Intermix (EAI), New York

Kat. Nr. 11
Performance Corridor, 1969
Wandkonstruktion, Holz
243,8 x 609,6 x 50,8 cm
Solomon R. Guggenheim Museum,
New York, Panza Collection, Schenkung,
1992
92.4162

Kat. Nr. 12-13
*Video Corridor for San Francisco (Come
Piece)*, 1969
Videoinstallation, zwei Kameras und zwei
Monitore
Abmessungen variabel
Solomon R. Guggenheim Museum,

New York, Panza Collection, Schenkung,
1992
92.4169

Kat. Nr. 14
*Corridor Installation with Mirror – San
Jose Installation (Double Wedge Corridor
with Mirror)*, 1970
Wandkonstruktion, Spiegel
ca. 304,8 x 853,4 x 182,9 cm
Solomon R. Guggenheim Museum,
New York, Panza Collection
91.3829

Kat. Nr. 15
Mean Clown Welcome, 1985
Neonröhren auf Metallblock
182,9 x 208,3 x 34,3 cm
Sammlung Brandhorst, Köln
(Ausstellungskopie)

Kat. Nr. 16
Double No, 1988
Zweikanal-Videoinstallation (Farbe, Ton)
Abmessungen variabel
Sammlung Froehlich, Stuttgart

Kat. Nr. 17
Raw Material – BRRR, 1990
Videoinstallation, Projektor und zwei
Monitore (Farbe, Ton)
Abmessungen variabel
ZKM | Zentrum für Kunst und Medien-
technologie, Museum für Neue Kunst

Illustrationen

Seite 13
Lighted Performance Box, 1969
Aluminium, 1000-Watt-Lampe
198,1 x 50,8 x 50,8 cm
Solomon R. Guggenheim Museum,
New York, Panza Collection
91.3820

Seite 15
*Walking in an Exaggerated Manner
Around the Perimeter of a Square*, 1967–68
Einzelbild aus dem 16-mm-Film
(schwarzweiß, ohne Ton)
122 m, ca. 10 Minuten
Mit Genehmigung von Electronic Arts
Intermix (EAI), New York

Seite 16
South American Square, 1981
Stahlträger, Stahlseil, Gusseisenstuhl
350,5 x 350,5 cm, hängt 152,4 cm
über dem Boden
Collection Ydessa Hendeles, mit
Genehmigung der Ydessa Hendeles
Foundation, Toronto

Seite 17
Clown Torture, 1987
Vierkanal-Videoinstallation, vier
Projektoren, vier Monitore (Farbe, Ton)
Abmessungen variabel
The Art Institute of Chicago
Watson F. Blair Prize Fund; Stiftung W. L.
Mead; Twentieth Century Purchase Fund;
Frühere Schenkung von Joseph
Winterbotham; Schenkung von Lannan
Foundation, 1997.162

The Solomon R. Guggenheim Foundation